Treasures

of ROYAL MUSEUMS
GREENWICH

First published in 2018 by the National Maritime Museum, Park Row, Greenwich, London
SE10 9NF

At the heart of the UNESCO World Heritage Site of Maritime Greenwich are the four
world-class attractions of Royal Museums Greenwich – the National Maritime Museum,
the Royal Observatory, *Cutty Sark*, and the Queen's House.
www.rmg.co.uk.

ISBN 978-0-948065-20-0
A CIP catalogue record for the book is available from the British Library.

Designed by Richard Carr
Printed and bound in the United Kingdom.

Front cover: Astronomical table clock (see p.22, ZAA0011, Caird Collection).
Back cover: detail from *No Title*, Richard Wright (see p.206); Telescope (see p.42, NAV1547,
Caird Collection); Nelson's coat (see p.116, UNI0024, Greenwich Hospital Collection);
Mars globe (see p.162, ZBA5460).

Treasures

of ROYAL MUSEUMS GREENWICH

National Maritime Museum | *Cutty Sark*

Royal Observatory | The Queen's House

Edited by Robert Blyth

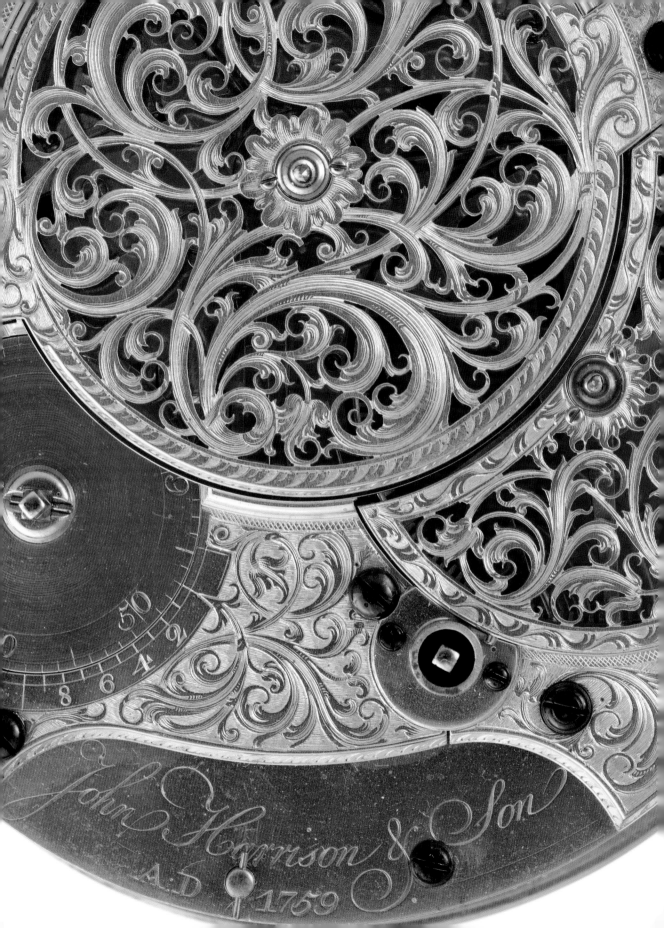

John Harrison & Son
A.D 1759

Contents

Foreword

It is more than 80 years since George VI and Queen Elizabeth, accompanied by the 11-year-old Princess Elizabeth, opened the National Maritime Museum (NMM) on 27 April 1937. Since then, the Museum has steadily expanded and transformed its collections. Now, as Royal Museums Greenwich (consisting of the NMM, the Royal Observatory, the *Cutty Sark* and the Queen's House), it lies at the heart of Maritime Greenwich, a UNESCO-inscribed World Heritage Site.

The Museum's curators were given the challenge of selecting 100 items to provide a sense of the treasures of the collection. Eagle-eyed readers will notice that the curators have exceeded their target by adding a few extra items for good measure – an indication of the difficulty of the task. Some of the chosen objects are famous, others may be unfamiliar to most readers; some are included for their individual significance, others represent rich and much larger collections of material. While many of the items here have long been associated with the Museum, it is gratifying to note that a significant number are much more recent acquisitions like *Elizabeth I, the Armada Portrait* or even the *Cutty Sark*, which is by some distance our largest object. This continuing development of the collection is an essential part of the Museum's work. Equally important, as this book demonstrates, is the often hidden work that takes place 'behind the scenes' conserving objects for future generations and fully cataloguing them to ensure that the fruits of research are available to all.

Of course, what is shown here represents merely the tiny tip of an enormous iceberg. As we discover more about the Museum's vast collections, and add further to its riches, a future choice of 'treasures' will doubtless be different. Perhaps talk on the next selection has already begun, but until that discussion has concluded I hope you enjoy these treasures of Royal Museums Greenwich.

Dr Kevin Fewster AM
Director
Royal Museums Greenwich
January 2018

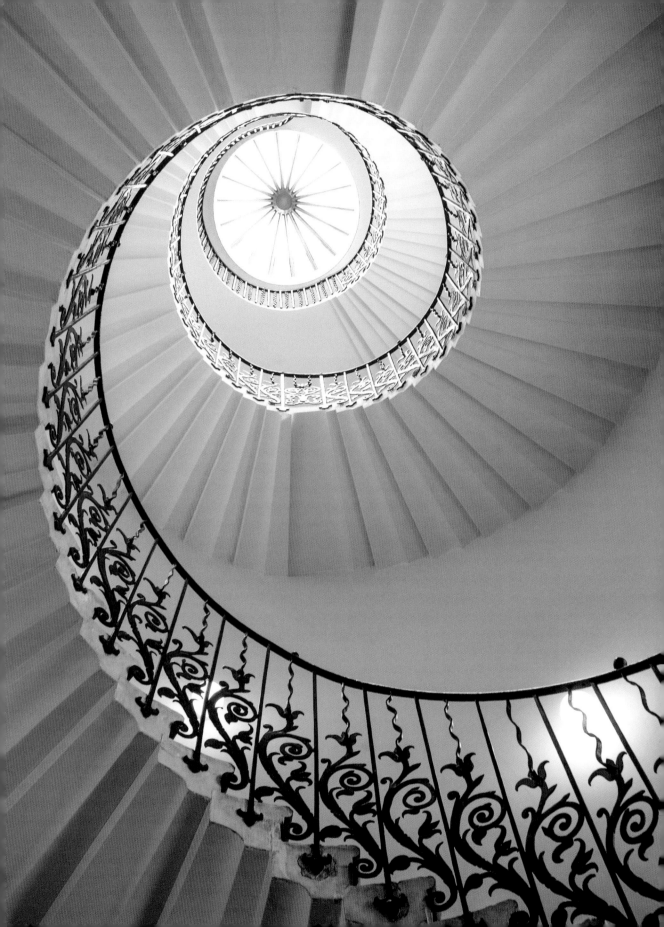

Introduction

The collections of Royal Museums Greenwich

The collections of Royal Museums Greenwich are extensive and varied, encompassing a wide range of subjects from Elizabethan seafaring to twenty-first-century astronomy. The breadth of materials and media ranges from paintings, drawings, photography and sculpture to heavy machinery, precision timekeepers and textiles. The Caird Library and Archive manages over 100,000 books and nearly six kilometres (3½ miles) of shelved manuscripts. Given the scale of these paper-based materials, it is not surprising that they make up a large proportion of the more than 2.6 million items in the Museum's care.

Some objects have an iconic status, like Lord Nelson's Trafalgar coat or relics from the mutiny of the *Bounty*; others provide a glimpse into everyday life, such as the service records of ordinary seamen or historic photographs of the British seaside. The 100 items selected for this book were chosen to represent the collection's diversity and quality, and its ability to illuminate the past and present. While they are all 'treasures' in their own right, a visit to Greenwich will reveal many more, including architectural riches. The Queen's House, begun in 1616 as a 'house of delight' for Anne of Denmark, James I's queen consort, was the first neo-classical building in Britain. Designed by Inigo Jones, it also features the 'Tulip Stairs' (shown left), the first spiral staircase in the country with cantilevered steps, allowing it to 'float' elegantly without the need of a central support. The Royal Observatory, based around Sir Christopher Wren's Flamsteed House, was completed in 1676 as a purpose-built centre for the improvement of navigation at sea.

When the National Maritime Museum, the intellectual heart of Royal Museums Greenwich, finally opened in 1937, it already had extraordinary collections to draw upon for its displays and exhibitions. The Greenwich Hospital Collection of art and naval relics, previously displayed from 1824 in the Painted

Hall of what is now the Old Royal Naval College, was transferred on permanent loan, providing core material for the Museum's grand narratives and world-class art holdings: this, for example, is how J.M.W. Turner's *Battle of Trafalgar* arrived.

Further vast resources were assembled by Sir James Caird, a shipowner who was a dedicated supporter of the Museum from the 1920s until his death in 1954. He was able to use his wealth, especially during the 1930s and '40s when prices were low as a result of economic depression and war, to buy an astonishing number of treasures, including entire pre-existing collections. They range

from rare books and manuscripts to ship models and oil paintings; from navigational instruments and globes to thousands of prints and drawings, and even poison-tipped arrows from South America. The scale of his philanthropy would be hard to imagine today and even harder to match, given prices in the current art market. Nearly a quarter of the objects gathered here are in the Museum's collection thanks to Caird's generosity and his commitment to high quality.

While acquisition like Caird's is now out of reach, it remains an important activity, deepening and extending the range of the

collections. Objects come in by a variety of routes. They may be gifts or bequests from generous individuals or institutions. New works are also commissioned – for example, the Richard Wright ceiling for the Great Hall of the Queen's House – and other things are still bought, despite limited resources. Major purchases – like *Elizabeth I, the Armada Portrait* – help to save important items for the nation but now usually require the support of grants from bodies such as the Heritage Lottery Fund, the Art Fund and other trusts and foundations, as well as generous public contributions in some cases. Sometimes an acquisition may be a one-page letter, but occasionally a substantial tranche of material can arrive at once. In 2017, for instance, large numbers of objects from the Ministry of Defence Collection were transferred to the Museum, many having been on loan to it since the 1930s, including a rare seventeenth-century Commonwealth standard and paintings by William Hodges from Captain James Cook's second great voyage to the Pacific. For the Museum's curators, an unexpected find or a surprising gift can frequently transform the way an old story is told, or allow new narratives to be woven together. A lifetime spent with the collections would merely scratch their surface.

Behind the Scenes at Royal Museums Greenwich

The Museum is committed to making its collections as visible and accessible as possible. New displays and exhibitions allow the public to see a changing selection of objects, while ever-greater numbers can be viewed online at www.collections.rmg.co.uk. Of course, it is impossible for museums with large collections to display everything. Collections frequently contain 'reserve' material that forms an important source of reference. In the case of Royal Museums Greenwich, the collection also encompasses impressive paper-based materials. The Caird Library, the largest dedicated maritime library in the world, not only houses the Museum's vast archival collection, its rare books and other reference materials, but also gives direct access to many of the Museum's prints, drawings and sea charts.

But putting objects on display and providing material for readers in the library requires a great deal of work behind the scenes. The Museum's conservation

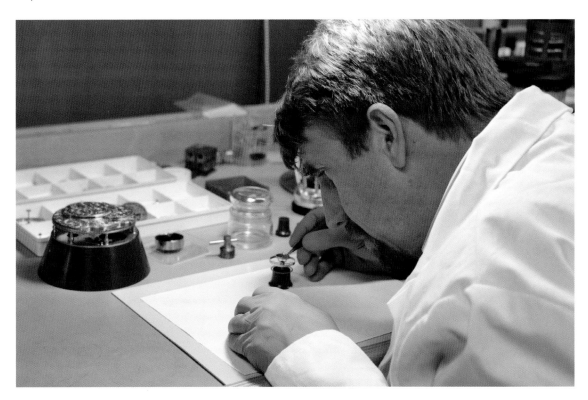

Curator of Horology Rory McEvoy working on K1, Larcum Kendall's 1769 copy of Harrison's famous marine timekeeper H4.

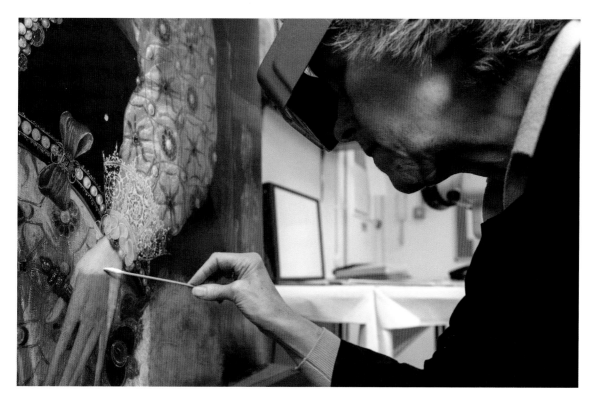

Elizabeth I, the Armada Portrait undergoing conservation work by Senior Paintings Conservator Elizabeth Hamilton-Eddy

teams are continuously engaged in work to preserve items and extend their life for future generations. Objects need to be both stored and exhibited in conditions that aid preservation, meaning that humidity, light levels and temperature are constantly monitored and items are regularly inspected. Paper and textiles, for example, are vulnerable to light damage and are displayed for shorter periods and in lower lighting than more robust objects. Preparing items for display allows an unrivalled opportunity for conservators and other specialists to investigate them and understand how they were made. Careful cleaning of old and degraded varnish from an oil painting, for example, can reveal previously unseen details and hidden damage for skilled repair. The opportunity to conduct microscopic study of the paint layers will give an insight into the artist's technique, allowing comparisons to be made with other works. Chemical analysis of the pigments can help date a painting, especially if a particular compound only came into use after a known date. X-ray photographs, and other modern techniques, provide evidence of what lies under the visible surface. Sometimes they show changes the artist has made, altering the position of a hand or the angle of the head in a portrait. In some instances, an entirely different painting has been found beneath, as in the case of *View of Pickersgill Harbour, Dusky Bay, New Zealand* by William Hodges, which was

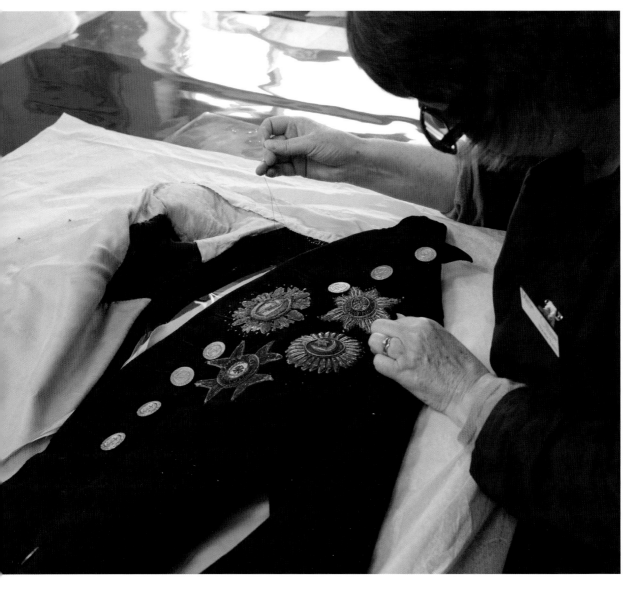

Nicola Yates, Senior Textile Conservator, works on Nelson's undress uniform coat, worn at Trafalgar

painted over an earlier scene of Antarctic icebergs. Similar work is undertaken by conservators of paper, or items including it (such as globes); of textiles, caring for flags and uniforms; of metals and other inorganic materials, and of organic objects like ship models. In the last case, the use of medical technology like endoscopes and MRI scanners allows conservators and curators to see inside some of the models, which can provide clues about the makers or lead to the discovery of hidden decoration, unseen for centuries.

The Museum's archive team works closely with the paper conservators to ensure visitors to the Caird Library can continue to consult historic manuscripts, charts and

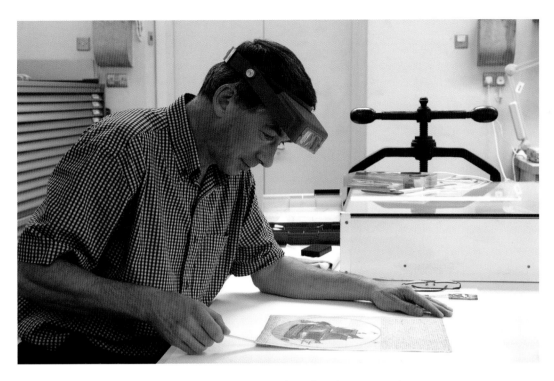

Senior Paper Conservator Paul Cook working on Edward Barlow's journal

rare books. A particular example of this collaboration relates to the conservation and preservation of the journal of Edward Barlow, a seventeenth-century seaman. The journal was presented to the Museum in 1939 by the sailor and maritime historian Basil Lubbock. He had already transcribed the manuscript and published it in two volumes in 1934. The paper-conservation team undertook a painstaking repair and new arrangement of its individual leaves, which has greatly improved not only its physical condition but also its intellectual integrity. The journal has two sets of page-numbering. The original number was in red ink in the top right corner: this ordering is kept, except where there is no red ink number. Lubbock's transcription and arrangement then becomes very useful in providing the correct narrative sequence

and scholars will now be able to work on the Barlow journal as never before.

The major library challenge, however, is archival cataloguing. Knowing what is in the Museum's huge manuscript and related paper collections is essential if those coming to use them are to find what they seek – be they academic researchers, family historians or other subject enthusiasts. The life of all researchers in the library is made easier, and less time wasted, as more and better information can be made available about these holdings. To make this process as efficient as possible, the Museum's online request system, Aeon, is used to monitor the ordering of documents that so far have minimal description, allowing archivists to target their cataloguing efforts towards public demand. The task is huge but the effort is outweighed by the benefit it brings.

The Caird Astrolabe

Named after the National Maritime Museum's single greatest benefactor, Sir James Caird (1864–1954), this scientific instrument is a magnificent embodiment of Ancient Greek, Islamic, Hebrew and European scholarship. The astrolabe (meaning 'star-catcher' in Greek) is a medieval astronomical calculator that was originally devised by Ancient Greek astronomers and later developed by scholars across the Islamic world. It was an essential tool both for teaching astronomy and for practical purposes such as determining the times of the five daily prayers in Islam according to the Sun, or calculating the date of Easter according to the Moon.

The astrolabe is composed of a series of thin metal discs, each one designed for use at a specific latitude between southern Spain and northern France, nestled together into a solid plate ('mater'). The uppermost plate ('rete') is an elaborate array of Islamic-style dagger shapes, the tips of which represent the positions of certain bright stars. As the user rotates the rete from left to right, the movement of the dagger tips across the curved lines mimics the motion of the stars as they appear to rise and set from east to west. For medieval scholars, these timings were essential in casting astrological horoscopes that could influence decisions made by royalty and other rulers.

This astrolabe is particularly fascinating as it shows the transition from using Roman numerals to the more familiar Arabic numerals that we rely on today. Around the edge we can see the medieval Gothic-style numeral system: for example, the inverted 'V' shape denotes the number '7'. On the reverse of the instrument, the maker has included a set of calendar scales and a shadow square that enabled the user to measure the height of buildings and hills.

Like the majority of surviving astrolabes, the Caird Astrolabe was an expensive and specialist instrument that was used by an educated and numerate elite, while simplified versions were created for specific users. For example, mariners at sea used a single-plate astrolabe to measure the height of the Sun and stars above the horizon as a means of determining their local time and latitude. Several examples of these 'mariner's astrolabes' have been recovered from shipwrecks, providing us with a glimpse into how the instrument was modified for use at sea: a weighted base kept it steady despite the motion of the ship while a cross-shaped cut-out profile enabled the wind to pass through easily.

Spain, c.1230
Brass; 211 × 155 mm
AST0570; Caird Collection

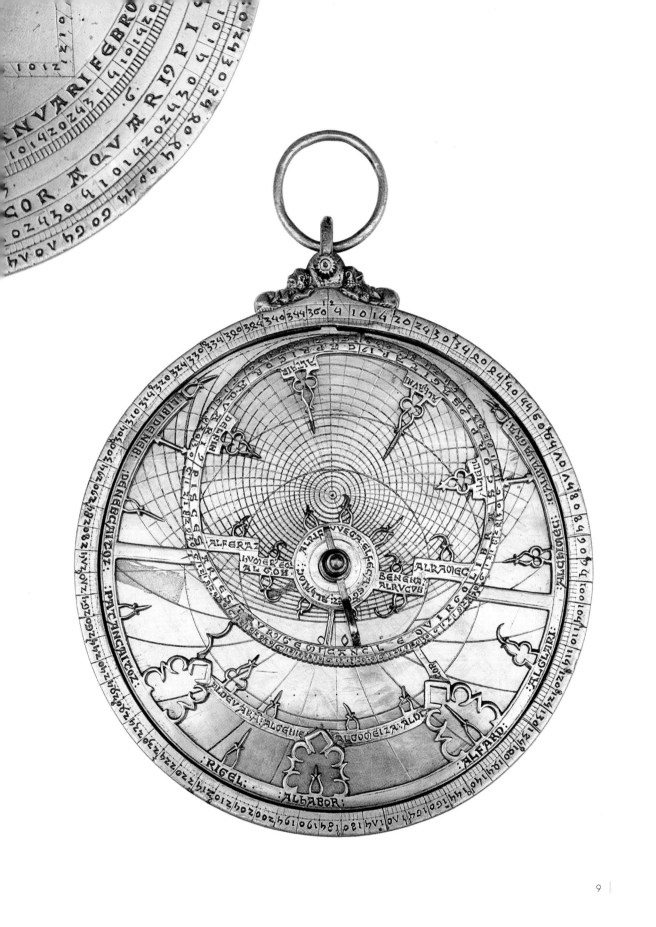

Portolan chart

Jacopo Bertran and Berenguer Ripol

Cartographers Jacopo Bertran and Berenguer Ripol finished this chart in 1456, making it the earliest loose chart in the collections of the Museum. It is a type known as a 'portolan', a term used for early navigational charts that developed in the Mediterranean from the thirteenth century, partly from written sailing directions called *portolani*. Portolans are made from vellum (calf skin); in this chart, something of the former shape of the animal can clearly be seen, with the neck extending to the west.

These charts have many common characteristics. Place names are written at right angles to the coast, so that the chart can be read from different angles. There are ornate cities, particularly Venice, Genoa, Barcelona, Santiago de Compostela, Jerusalem, Cairo and Fez, indicating important centres of commerce or pilgrimage. Heraldic devices cover the chart, and there are elaborate compass roses with crisscrossing 'rhumb' lines, which show the bearings between places that navigators had used since the introduction of the compass into the Mediterranean in the twelfth century. The Red Sea is, rather literally, coloured red.

Bertran and Ripol were based in Barcelona when some of the most sophisticated charts were being produced mainly by Jewish Catalan makers. This chart bears many hallmarks of the Catalan school of cartography. These include the waves on the Red Sea (portolans from other traditions tend not to have waves), and the snake-like feature that extends across North Africa, representing the Atlas Mountains. The circles in each corner are 'discs of the winds', based on the eight-wind Mediterranean compass: *Greco* the north-east, *Silocho* (sirocco) the south-east, *Libeco* the south-west, *Ponente* the west and *Maestro* the north-west. Catalan makers made use of the extensive trade networks in the Mediterranean to compile the cartographic material that went into their charts. The impressive detail demonstrates a navigational knowledge and stylistic flair developed over generations in the fourteenth and fifteenth centuries, but the specific tradition of Catalan cartography was brought to an end by the expulsion of the Jews from Spain in 1492.

Barcelona, 1456
Ink on vellum; 980 × 630 mm
G230:1/7; Caird Collection

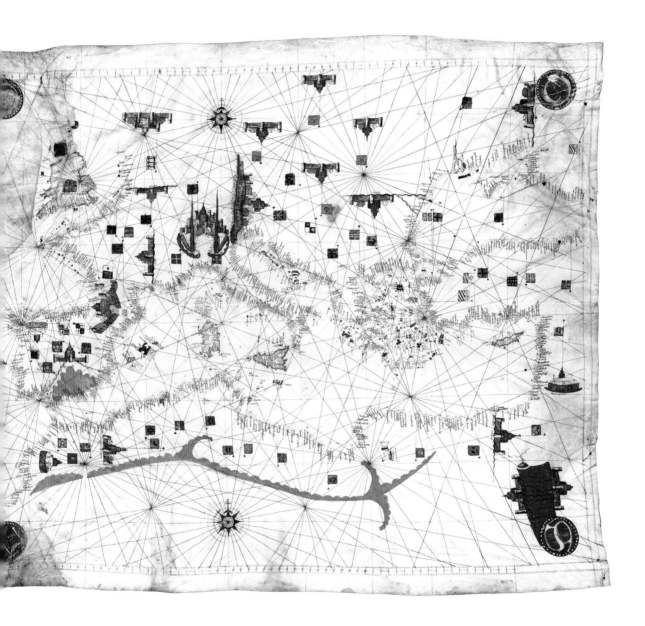

Ptolemy's *Geographia*

Leinhardt Holle, Claudius Ptolemy

Produced in 1482, shortly before knowledge of the American continent or the route round the Cape of Good Hope reached Europe, the easiest things for us to read from this map are its limitations. The map was based on the geographical writings of Claudius Ptolemy (*c.*100–*c.*170), a Greek scholar based in Alexandria in the second century AD, whose work was translated into Latin in the early fifteenth century. However, for Renaissance cartographers, their interest in Ptolemy's work was based on the principles of cartography outlined in his text rather than on the existence of continents or the shape of particular landmasses. These include suggestions of how to project a map so that a spherical surface could be represented on a flat sheet and the introduction of a system of coordinates, which gave places specific locations based on a mathematical framework. As European understandings of global geography continued to change, maps based on Ptolemy's coordinates became more and more of a scholarly curiosity. The mathematical principles on which they were based, however, were a lasting legacy.

The map in this volume of the *Geographia*, published in Ulm in southern Germany in 1482, was drawn by a German Benedictine monk in the mid-fifteenth century. The map was printed from a woodblock, cut by a man called Johannes Schnitzer (the 'cutter') from Armsheim to the west of Germany. He was commissioned by Leinhardt Holle, an ambitious printer with a newly acquired press, who hoped to capitalise on the Renaissance interest in classical learning and mathematical geography that had spread north from Italy. Printing with moveable type was a novel technology, and printers were still mastering this technique. Cities like Ulm, which was situated on major trade routes and flourished as a production centre for luxury textiles, were good places to set up printing presses, but many printers went out of business quickly. Holle was no exception. The *Geographia* was the first book he produced, and he spared no expense in creating the finest work he could. The maps in this volume are woodcuts on a scale not seen before in a printed book. Fine paper was bought specially from Milan. Most strikingly, the rich colour of the sea was produced using ultramarine, a blue made from ground lapis lazuli, which came from the Hindu Kush mountains, in modern-day Afghanistan and northern Pakistan. This pigment could be more expensive than gold. Continuing his publishing venture in this luxurious vein, Holle bankrupted himself with his impressive volumes. Four years later, the same printing blocks were used by another Ulm printer, but the sea would never be so blue again.

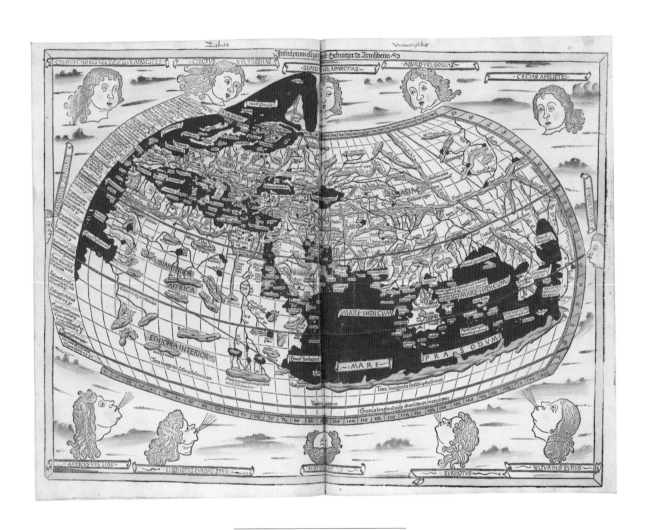

Ulm, Germany, 1482
Ink and pigment on paper; 980 × 630 mm
PBE5109; Caird Collection

Terrestrial and celestial globes

Gerard Mercator

When Gerard Mercator (1512–94), the most famous cartographer of the sixteenth century, made his terrestrial and celestial globes, they were the largest printed examples made up to that point. Completed in 1541 and 1551 respectively, he made them against a backdrop of increasing cartographic sophistication and mathematical learning, as well as deep religious strife. In the years before 1541, Mercator was educated at the University of Leuven, immersing himself in the study of geography, cosmography and mathematics, while also developing his considerable talents as an engraver. In 1543, Mercator was imprisoned for seven months for suspected heresy but released because of a lack of evidence. Between the production of the two globes he was in touch with some of the most prominent mathematicians in Europe, and continued to develop his reputation as a talented cartographer.

And talented he was: the detailed cartography on these globes shows his engagement with contemporary geographical knowledge. The fine engraving, done by Mercator himself, and large size of the globes mean that they provide great detail about both heavens and Earth. The lines that diagonally circle the terrestrial globe, crossing each meridian at the same angle, are known as 'loxodromes' – important to mariners because they are lines of constant bearing. It is a clear sign of Mercator's skill that when these were engraved and then printed on paper segments ('gores'), they would match up and sit correctly on the sphere, making a perfect globe.

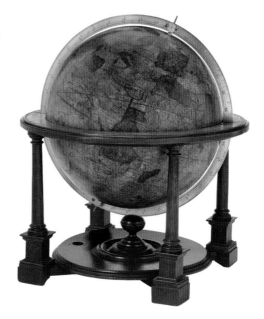

But globes in this period were more than simply spherical maps: they were also sophisticated calculating devices. Their fittings, in metal and wood, are divided into degrees of latitude and longitude. On terrestrial globes, these allow for the calculation of the times of sunrise and sunset, or the calculation of local time. On celestial globes, they facilitated calculations of the rising and setting of stars, and important astrological moments. In the sixteenth century, cosmography – the study of such relationships in the cosmos – was a key concern in many branches of scholarship. As a pair, a terrestrial and a celestial globe demonstrate the relationship of the Earth within the heavenly sphere, inviting the user to consider the place of Earth and man in creation. Printed globes, functioning variously as demonstration models, calculating devices and geographical depictions, were a scholarly, technical and artistic achievement of the sixteenth century.

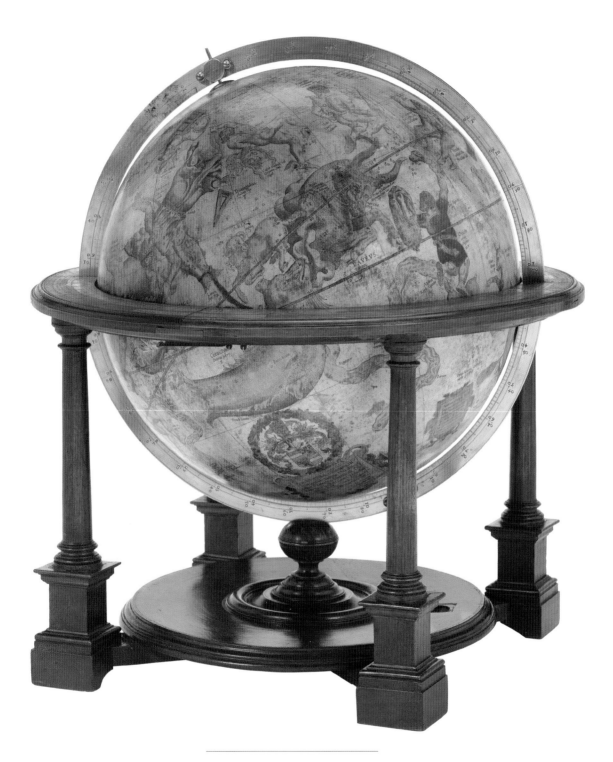

Leuven, Belgium, 1541 (terrestrial) and 1551 (celestial)
Papier-mâché, wood, varnish, paper; 420 mm diameter
GLB0096 and GLB0097; Caird Collection

Nautical almanac

Guillaume Brouscon

Devised and produced in the Breton port of Le Conquet, this almanac was printed in part from wood blocks on vellum and in part by handwritten symbols highlighted using coloured ink. It formed part of Samuel Pepys's personal library and is thought to have once belonged to Henry VIII. Its purpose was to provide Breton seamen with practical information for their daily lives and, in particular, the time of the tides and the dates of church festivals and feasts. These events were used for arranging future appointments. The numbers of surviving copies are few and it is an important work in the history of navigation. Made in sign-language form, it was an innovative way of providing essential data to unlettered mariners, regardless of their nationality.

Guillaume Brouscon (fl.1543–48) was a Breton cartographer of the Dieppe school in the sixteenth century and his signature can be seen, letter by letter, in the centre of the tidal dials on pages one to eight, with each letter coloured red. Ian Trodec, whose name is also included within, seems to have been the printer working with Brouscon.

The chart of the coasts of north-west Europe is entirely hand-drawn on vellum folded into the back of the book, with south positioned upwards, which was French practice at the time. The portolan chart, showing ports, harbours and sailing directions, is very much in the conventional style

of the period and seems to have been well used over the course of its life, changing hands between sailors and dignitaries alike, such as Henry VIII and Samuel Pepys.

When in Pepys's possession, the book was arranged as 'number 1' in his library. He numbered his books in height order, starting with the smallest – an arrangement that persists today in the Pepys Library at Magdalene College, Cambridge. Unlike most modern-day book collectors, Pepys was not especially interested in the age or provenance of a volume, but merely its utility. In other words, he was keen to ensure the books he collected were the most up to date and therefore the most useful. When he acquired an almanac that had reputedly belonged to Francis Drake, this made it a newer edition than the one Henry VIII may have owned. The older volume was removed from the formal library and was acquired at auction in 1931.

Le Conquet, France, 1546
Manuscript, vellum; 104 × 77 mm
NVT/40; Caird Collection

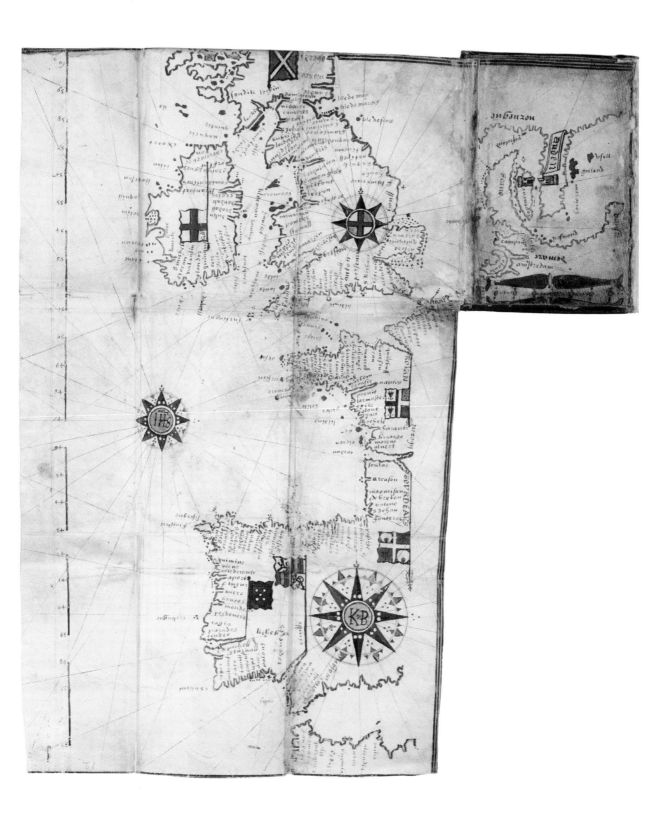

17

Map showing the coast between Hormuz and Calicut

Angelo de Conte Freducci

With each hill edged with gold, each river and lake carefully coloured in a rich blue, this map – part of a bound set – was clearly produced for a luxury market. Although made in the portolan style, complete with rhumb lines and scooped-out bays, it was probably not intended as a practical navigational document, being too extravagant in its decoration and too detailed in its inland features. The map was made by Angelo Freducci, a member of a cartographic dynasty in Ancona on the Adriatic coast of Italy, when that city was at its commercial height. Maps and charts were not only required for practical navigation, but they were also prestigious objects for the wealthy, particularly those individuals who invested in the long-distance trade routes depicted.

The set follows the route from the Mediterranean to India, through the Red Sea. The map shown here, oriented with north to the bottom, depicts the coastline from the Persian Gulf to Gujarat, on the north-west coast of the Indian subcontinent. Gujarat had been an important trading centre in the Indian Ocean for centuries, and Gujarati merchants were experienced traders. The region exported spices, fine cottons, hardwoods and precious stones to western Asia and also into the Mediterranean. Following Vasco da Gama's voyage round the Cape of Good Hope to India in the late fifteenth century, the Portuguese tried to establish control of trade between Gujarat and Europe by that route, but in the mid-sixteenth century commerce also flourished via the Red Sea to Egypt, the Ottoman Empire and the Italian city states.

Although that route was an important one, this map does not much reflect the cartographic knowledge of the period. The detail shown suggests that its major source was much earlier, since it bears a striking resemblance to a world map made in 1460 by an Italian monk, Fra Mauro. The text on the scroll to the upper right, for example, which describes the circulation of the Indian Ocean according to a number of classical authorities, is almost exactly the same as the text on Fra Mauro's map, and the land forms are also very similar. But the history of cartography has always been one of copying, and in making these maps for an audience that had no need for the very latest geographical information, Angelo Freducci could give more attention to its sumptuous form.

Ancona, Italy, 1555
Vellum; 470 × 350 mm
P/36(3–4); Caird Collection

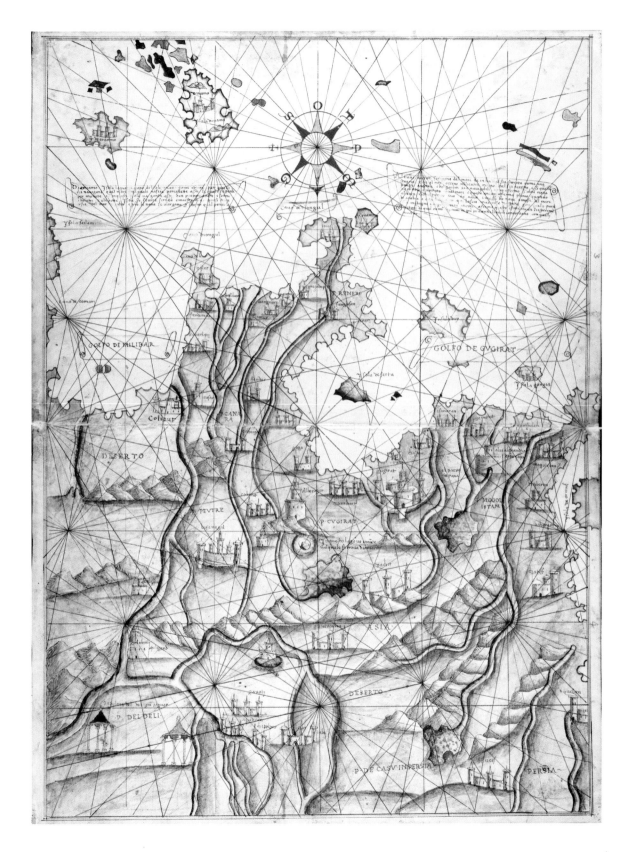

Humfrey Cole's astronomical compendium

Made by England's first native scientific instrument maker, Humfrey Cole (*d*.1591), this multifunctional device is an exquisite piece of Renaissance mathematics and craftsmanship. We know little about Cole himself, other than that he trained as a goldsmith and worked at the Royal Mint within the Tower of London as a die-sinker. During the late 1560s he began to produce scientific instruments for wealthy noblemen and explorers. In particular, he supplied navigational instruments for the voyages that Martin Frobisher organised to seek the North-West Passage during the 1570s.

Given the complexity and fine craftsmanship of this instrument, it is unlikely that it was used at sea. It was more probably intended as an intricate mathematical jewel, designed to demonstrate one's elevated status in society and knowledge of both the terrestrial and the celestial worlds. The oval-shaped instrument consists of five metal leaves held together by small brass pegs. The elaborate design on the outer leaves hints at a customer with fine tastes, since Cole has taken inspiration from a series of ornamental prints produced by the French engraver Étienne Delaune. The Roman god Jupiter is shown holding his sceptre while standing on an eagle clasping a thunderbolt in its claws. The other side of the case features Jupiter's sister and wife, Juno, shown with her recognisable attributes of a peacock.

Inside the compendium we can see Cole's mastery of astronomy and mathematics through a range of scientific instruments. A cross-shaped bar in the middle can be set up as a sundial for any European location, using the table of latitudes for cities between southern Spain and Scotland. Other calendars and rotating discs (known as 'volvelles') enabled the user to calculate the date of Easter, observe saints' feast days and keep track of the Moon's phases. A magnetic compass set within the middle leaf helped the user align the sundial correctly and estimate the time of high tide according to the position of the Moon. On land, the compendium could be used for surveying purposes, thanks to a removable theodolite and a shadow square for measuring the height of buildings and mountains. For many years the compendium was mistakenly thought to have belonged to Sir Francis Drake. It eventually came into the possession of a Robert Bigsby, who presented it to William IV in 1831. The king accepted the gift on the condition that the compendium should be deposited at the Royal Hospital for Seamen in Greenwich.

London, 1569
Brass and glass; 82 × 57 mm
AST0172; Greenwich Hospital Collection

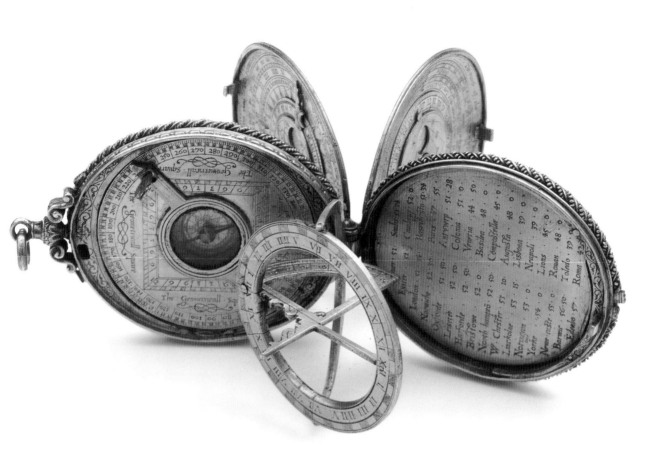

Astronomical table clock

Caspar Buschman

This magnificent and complicated astronomical clock is the oldest mechanical horological item in the Museum's collection. The upward-facing main dial has over ten separate functions and even tells the time with a 24-hour indication. The outermost ring on this dial makes a full rotation once a year and is engraved with the names of the saints for each day. Originally, there were two pointers to indicate the date according to the Gregorian and Julian calendars.

The astrolabe indicates the position of the bright stars in the sky for the latitude of Paris, with each star represented by the tip of a tendril-like piece on the 'rete' (the outermost disc), on which the magnitude, or brightness, of the stars is marked. The Moon's position and age are shown with a graphic representation of its phase as well as the nodes, for the prediction of eclipses. There are six further dials placed around the sides of the clock case. These give extra calendric information, allowing calculation of the Moon's phases, the dates for Easter and the times of sunrise and sunset, alongside astrological indications to help the owners plan their day. All of these dials are driven by a 30-hour movement that is hidden within the case. It sounds the hours and quarters on bells with the unusual option to select from either a 12- or 24-striking system. The clock also has an alarm with a setting dial on the side of the case. This clock would not only have required winding every 24 hours, but also constant adjustment. Sixteenth-century examples were not great timekeepers

and in order to set the clock, the lower cover plate serves a dual purpose. It can be unclipped and taken off the body of the clock, revealing a collection of small sundials. At its centre is a compass, used to orientate the dials correctly, and various adjustments and tables that help to read the time precisely in different latitudes.

To own such a clock in the 1500s was a symbol of considerable wealth and meant that you quite literally had the cosmos in your hands. A booklet published by an anonymous Swiss antiques dealer in 1704 stated that it had formerly been the property of John II Casimir Vasa, king of Poland, 1648–68. Having abdicated the throne, he spent the remainder of his life exiled in Paris.

A recent study of this clock has revealed some scratch markings in French on the components of the case. These markings were put on to help a clockmaker reassemble the piece. There are also various washers and spacers that were cut from an old playing card. Fortunately the clockmaker used a picture card and a clear portion of the jack of diamond's head was visible, identifying the card as Parisian from the mid-seventeenth century. This provides further evidence that the clock was in France at the time of John II's exile.

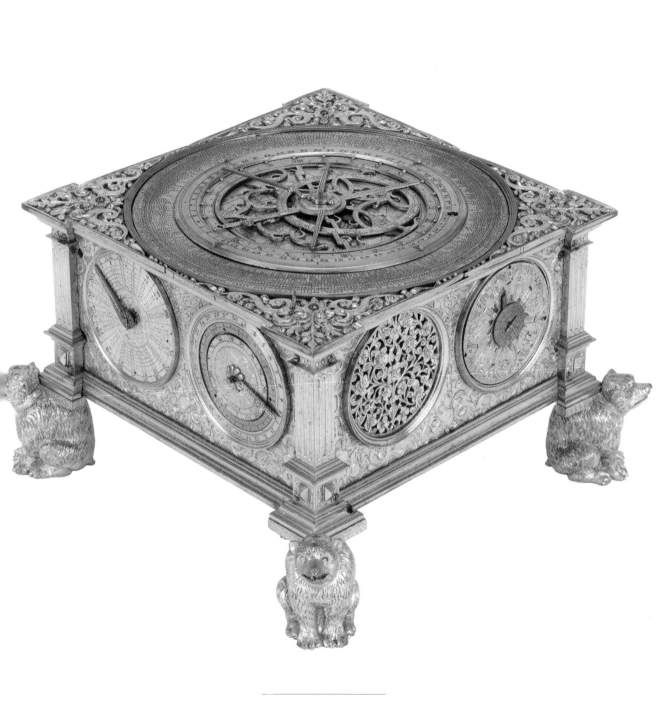

Augsburg, Germany, about 1586
Gilt brass, steel; 167 × 268 × 266 mm
ZAA0011; Caird Collection

Elizabeth I, the Armada Portrait

English school, unknown artist

Created by 1590, the 'Armada Portrait' commemorates the most celebrated event of Elizabeth I's reign: the failed invasion of England in the summer of 1588 by Philip II's 'invincible' Armada. As such, it summarises not only the achievements but also the hopes and aspirations of the monarch and state at a watershed moment. Furthermore, this supremely powerful and confident image has come to represent, anachronistically, the now seemingly irresistible rise of the English Navy and the making of Britain as a maritime superpower.

Far from displaying any of the anxiety and vulnerability she undoubtedly felt at the time, Elizabeth is shown dominating the composition, her eyes turned towards us, her expression composed, almost otherworldly, and her demeanour commanding. In a richly embroidered and bejewelled dress, the queen is the epitome of royal magnificence, her right hand resting on a terrestrial globe showing the Americas, an imperial crown on the table behind, and beside her a chair of state. The seascapes in the background represent two events from the campaign: on the left, the English fleet lies in calm waters with fire-ships approaching the Armada; and on the right, Spanish ships are wrecked on the western coast of the British Isles in a menacing storm.

In the aftermath of the Armada, poems and pamphlets extolled Elizabeth as the vanquisher of the Catholic threat. Medals and prints celebrating the Spanish defeat proclaimed it a Protestant victory; the storms that lashed the enemy fleet were evidence of divine intervention. In this regard, the juxtaposition of 'calm' and 'storm' in the seascapes within the portrait also utilises the classical 'ship of state' analogy: the effect of good governance under Protestant Elizabeth on the left, juxtaposed with that of tyrannical rule under Catholic Philip on the right.

An unusual aspect of the portrait is its representation of Elizabeth, or indeed any British monarch prior to 1588, in a naval and maritime context. During the 1570s, images of the queen began to make use of the iconography of empire such as globes, crowns, swords and columns. At the same time, the representation of globes became indispensable accoutrements within portraits of Elizabethan proto-imperialist explorers, such as Sir Francis Drake. Indeed, Drake may well have commissioned or owned this version of the 'Armada Portrait' (of which two others are known, one significantly cut down). The idea of Elizabeth as the 'Empresse of the World' was complemented by a second layer of symbolism representing her as the Virgin Queen, the destined Protestant defender and protector of her people. Furthermore, art historians have highlighted the Armada of 1588 and the earlier Battle of Lepanto of 1571 – during which the Holy League led by Don John of Austria, Philip II of Spain's half-brother, inflicted a major defeat on the Ottoman Empire – as key moments in the development of European marine painting. In effect, these major fleet actions drove the creation of maritime imagery, particularly the focus on and eventual dominance of battle painting from 1600 onwards.

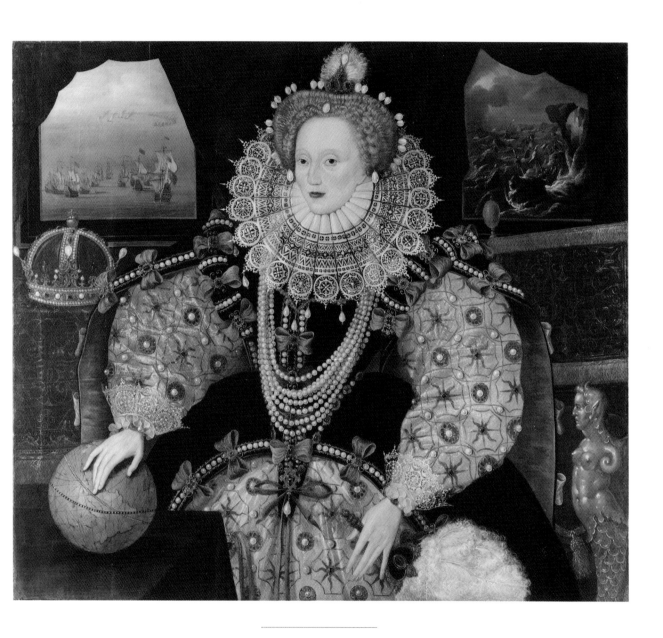

c.1590
Oil on oak panel; 1125 × 1270 mm
ZBA7719; acquired with the support of the Heritage Lottery Fund, Art Fund, Linbury
Trust, Garfield Weston Foundation, Headley Trust and other major donors, together with
contributions from over 8000 members of the public following a national appeal.

George Clifford, 3rd Earl of Cumberland

Nicholas Hilliard

Nicholas Hilliard (1547–1619), the queen's limner (miniaturist) and goldsmith, was one of the most important English artists of Elizabeth I's reign. As a young man Hilliard apprenticed himself to the queen's jeweller, Robert Brandon, also a goldsmith and Chamberlain of the City of London. Hilliard quickly became an outstanding painter of portrait miniatures and is appreciated today as the first notable English artist in this medium. Indeed, his exquisite representations of the queen and her courtiers not only exemplify their artistic tastes and lifestyles, but also collectively constitute a jewel-like microcosm of the entire Elizabethan age.

Portrait miniatures were popular during the sixteenth century for a number of reasons. At court, they were commissioned as intimate tokens for friends and family, as official gifts to foreign monarchs, nobility and dignitaries, and to show to prospective suitors, being far more portable and accessible than large-scale portraits. Courtiers acquired representations of the queen to wear at court to demonstrate their devotion and loyalty. Elizabeth had her own collection of miniatures kept locked in a cabinet in her bedroom, wrapped in paper and labelled. She also made gifts of portraits to favoured courtiers, some of which were executed by Hilliard, that were incorporated into pieces of jewellry: the so-called 'Armada Jewel' was given to Sir Thomas Heneage, and the 'Drake Jewel' to Sir Francis Drake (both on loan to the Victoria and Albert Museum) are the best-known examples. Some of these miniatures

show the queen's head and shoulders in a similar pose to the 'Armada Portrait' (see page 25), with comparable headdress, circular ruff and the same arrangements of bows and pearls, suggesting that the origin of this iconic pattern may lie with Hilliard.

While Hilliard mostly painted small oval miniatures, he also created some larger cabinet ones and at least three half-length panel portraits of Elizabeth I. This cabinet miniature is a full-length portrait of George Clifford, 3rd Earl of Cumberland (1558–1605). It is generally thought to commemorate his assumption of the role of the queen's champion (in succession to Sir Henry Lee) in 1590 and his first appearance as such in that year's Accession Day tilts at Whitehall, on 17 November. The elaborate 'star' armour was undoubtedly made for Clifford in Henry VIII's armoury at Greenwich Palace, a royal residence that also included a permanent tiltyard (an enclosed area for jousting). The queen's glove, with a crown visible on the embroidered fingers, is pinned to his plumed bonnet by a rose jewel with a pendant pearl. The left background shows a mythical castle or palace set in a fertile coastal landscape, perhaps meant to evoke Arthurian legend and the chivalric focus of Elizabeth's court. Given that Clifford was a naval officer and had commanded the *Elizabeth Bonaventure* against the Spanish Armada in 1588, this one object neatly underlines the multilayered significance of Greenwich, its history and its collections.

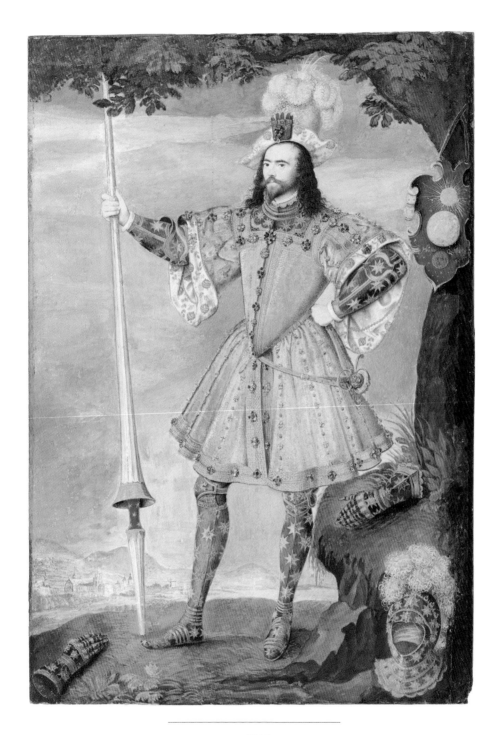

c.1590
Watercolour and gouache with gold and silver leaf on vellum,
laid on a fruitwood panel; 258 × 176 mm
MNT0193; Caird Collection

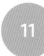

The Siege of Malta: Turkish Bombardment of Birgu, 6 July 1565

Matteo Perez da Leccia

In 1565, Suleiman I ('the Magnificent'), Sultan of Turkey, attempted to seize the island of Malta, headquarters of the Order of the Knights of St John of Jerusalem, as part of an expansionist policy that had already brought most of the Balkans under Ottoman control. The Turks had previously evicted the Order from Rhodes, in 1522, and repeating this success at Malta would have given them an advanced Mediterranean base for threatening south-western Europe. They landed a substantial force on 18 May but met resolute and sustained resistance, as the knights and local people endured a bitter four-month siege under the heroic command of the Order's elderly Grand Master, Jean Parisot de la Valette. On 11 September, faced with mounting losses and no immediate prospect of victory, the Turks finally abandoned the siege and left.

In 1576, Matteo Perez da Leccia (c.1547–c.1628), an Italian painter specialising in historical and devotional subjects, was invited to Valletta to decorate the Great Hall in the new palace of the Grand Master. Perez was experienced in fresco work, having earlier assisted Michelangelo in decorating the Sistine Chapel. He painted 13 frescoes, still in place in the Hall, showing scenes from the dramatic siege. Subsequently, eight of the principal pictures were reproduced as oil paintings, for an unknown client, and there is also a related set of engravings. The reverse of each canvas bears the royal cipher of Charles I and it is possible that he inherited them: tantalising but inconclusive evidence comes from a visitor to Greenwich Palace, who reported seeing a picture of the siege there in 1598. However, Charles's voracious art collecting put pressure on royal wall space and, to make room for newer works, they were given to Edward Sackville, 4th Earl of Dorset, who was lord chamberlain to Queen Henrietta Maria. They later passed to the North family and were bought for the Museum by Sir James Caird at their Wroxton Abbey sale in 1933.

This painting is the fifth in the series. It shows Ottoman batteries assaulting the Castilian and German knights defending Birgu on the southern side of Valletta's Grand Harbour (upper left). Ottoman vessels are shown in the upper right of the painting, attacking from the sea. The foreground is dominated by Turkish troops and their commanders. The perspective seeks to combine action and identifiable topographical information, although the resulting effect can seem crude and jarring to the modern eye. Nevertheless, there can be no doubt of the artist's skill in capturing the details of armour and clothing, or in giving the viewer a sense of the scale of the military operations.

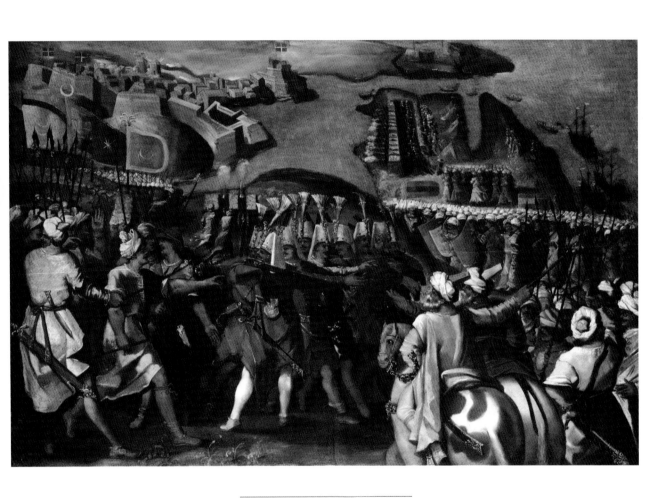

c.1580
Oil on canvas, 1372 × 2057 mm
BHC0256; Caird Collection

Princess Elizabeth, later Queen of Bohemia

Robert Peake the Elder

Princess Elizabeth (1596–1662) was the eldest and only surviving daughter of James VI of Scotland and his wife Anne of Denmark. This portrait was painted shortly after the death of Elizabeth I, when the Scottish royal family travelled south on James's accession to the English throne. It shows the young Elizabeth aged seven – an inscription on the handle of her fan reads 'Æ 7' – standing in a traditional static pose and richly dressed in white. The wooded landscape and river form the background, with a hunt in the distance.

During the Gunpowder Plot of 1605, the conspirators intended to kidnap Elizabeth and place her on the throne as a puppet monarch before marrying her to a Catholic bridegroom. The plot failed, of course, and Elizabeth's future was determined by European politics rather than the destruction of Parliament. At 16 she married Frederick V, Count Palatine of the Rhine, and moved to Heidelberg. In 1619, Frederick was offered the throne of Bohemia. This followed the death of King Matthias and the decision of Bohemian noblemen not to choose the heir apparent, Archduke Ferdinand, who was a fervent Roman Catholic. Frederick, a staunch Protestant, eventually accepted and was crowned on 4 November that year. Elizabeth's coronation as Queen of Bohemia took place three days later. But with Ferdinand now the Holy Roman Emperor

and determined to have the Bohemian crown, Frederick's reign was very brief. After only a year, he and Elizabeth were forced to flee to The Hague after their forces were defeated at the Battle of White Mountain on 8 November 1620.

Frederick died in 1632 and Elizabeth spent the next 30 years largely at The Hague, only returning to England in 1661. She died the following February. However, future constitutional changes in the form of the 1701 Act of Settlement meant that English and Scottish thrones were settled on her youngest daughter, Sophia of Hanover, as the closest Protestant claimant. Upon the death of Queen Anne, the last reigning Stuart monarch, Elizabeth's grandson George of Hanover ascended to the throne in 1714 as George I, ushering in the new Hanoverian dynasty.

The English artist Robert Peake (c.1551–1619) initially trained as a goldsmith, but by 1576 he was working as a 'paynter' in the office of revels, producing materials for Elizabethan court festivities. Peake's earliest known portrait, also dated 1603, is of Elizabeth's elder brother Henry, Prince of Wales (now in the Metropolitan Museum of Art, New York). It has a similar background to that of Elizabeth and it is likely the two were conceived as a pair and probably commissioned by Lord Harington, a guardian of the royal children.

1603

Oil on canvas; 1359 × 953 mm

BHC4237; acquired with the assistance of the Art Fund and the National Heritage Memorial Fund.

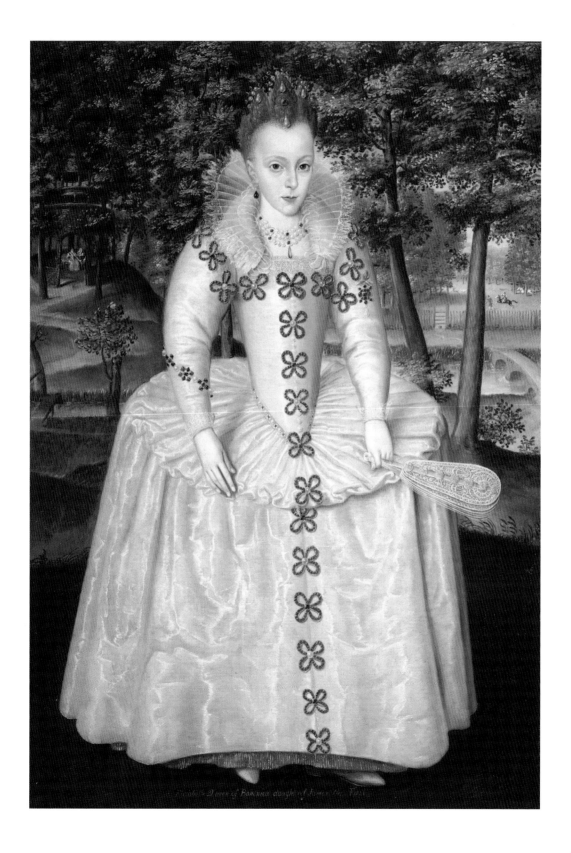

Elizabeth Queen of Bohemia daughter of James the First

Peter Pett and the Sovereign of the Seas

Peter Lely

Charles I's Principal Painter, Sir Anthony van Dyck, dominated and transformed British portraiture in the 1630s. When he died in 1641, the obvious person to succeed him was the recently arrived Dutch artist Peter Lely (1618–80), though he was only finally appointed Principal Painter by Charles II in 1661. Throughout his career, Lely worked in emulation of van Dyck, and his portraits of naval officers, such as the famous 'Flagmen of Lowestoft' series, follow his example. Such portraits surround officers with accoutrements that denote their court status and naval responsibilities, including representations of warships, utilising poses intended to exude innate and effortless powers of command.

This glamourising formula in visual culture not only enhanced officers' personal reputations but also that of the Royal Navy, including its ships and shipwrights, and by extension, that of the monarchy. This portrait of Peter Pett with the *Sovereign of the Seas* is the most pre-eminently ambitious British example in this trend, but it was not the first to portray a royal shipwright with a prestigious vessel. In 1610, the *Prince Royal*, named in honour of Henry, Prince of Wales, was launched. Overseen by Phineas Pett (Peter's father), the *Royal Prince* was the largest, most powerful and splendid warship in England. As in this example, it was conceived as a national symbol, decorated with the Prince of Wales's feathers and cypher

'HP', and a figurehead of St George, the patron saint of England. The launch was commemorated in a portrait of Phineas Pett with the *Royal Prince* represented in the background (in the collection of the National Portrait Gallery).

By the 1630s, Charles I was seeking to redefine the Stuart monarchy, not as the prosecutor of war and empire in emulation of the Elizabethans, and his deceased elder brother Prince Henry, but as the guardian of peace. In 1637, the *Sovereign of the Seas*, which superseded the *Prince Royal* as the most powerful and spectacular English warship, was launched. Its complex iconographic scheme combined legendary British history, classical references and royal symbolism to promote Charles I's claim to rule the oceans using naval power as an instrument of global peace. The supreme irony of that claim is underscored by Lely's portrait, which was probably painted during the English Civil War that lost Charles his throne and, in 1649, his head. In the portrait, Pett's sober dress and relatively modest pose and gesture is contrasted with the ship's awesome scale and the richness of the gilded stern carvings. In every sense a work of art within a work of art, the *Sovereign* dominates the composition in a manner that is unprecedented in British portraiture, anticipating the grand-manner ship portraiture of Willem van de Velde the Younger.

c.1645–50

Oil on canvas; 1395 × 1560 mm

BHC2949; Caird Collection

Commonwealth standard

Following the execution of Charles I in 1649 and the abolition of the monarchy, the royal standard was redundant and the Union flag fell out of use. During the Commonwealth, a variety of different flags were adopted at sea to identify ships in the service of the British state. In a letter dated 23 February 1649 (now in the Museum's Caird Library), Oliver Cromwell, as President 'pro tempore' of the Council, tried to establish guidelines for a new flag to be used at sea. It would employ a conjoined cross of St George and the Irish harp. This example betrays a degree of confusion in manufacture. The design, consisting of shields and a wreath border, is appliquéd on to a red background. However, despite the harp being correctly aligned, the shields are upside down, lending the flag a rather haphazard appearance.

Under Cromwell, the Navy expanded considerably thanks to an extensive shipbuilding programme. The office of Lord High Admiral was abolished and naval command rested with a number of Generals at Sea. Three colonels in the Parliamentary army – Robert Blake, Richard Deane and Edward Popham – were the first appointed to this rank. Blake in particular played a prominent role in the development of the Navy, despite his previous lack of seafaring experience. Cromwell was keen to use naval power to advance the national interest. One of the consequences of the Civil War was the disruption of English trade, which handed a significant advantage to

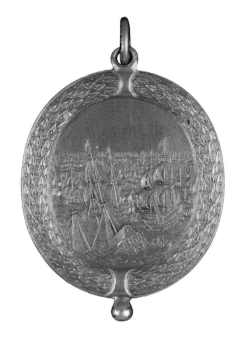

the country's Dutch rivals. The return of peace at home allowed for the pursuit of war abroad. The First Anglo-Dutch War, 1652–54, was principally fought to wrest control of English trade from the Dutch. By the end of the conflict, England's fleet had gained the upper hand, and successful commanders received gold naval reward medals (above), which show a scene of Dutch defeat. Cromwell then set his sights further afield with his 'Western Design'. In 1655, during its war with Spain, England gained the significant prize of Jamaica. The Cromwellian Navy was making its mark.

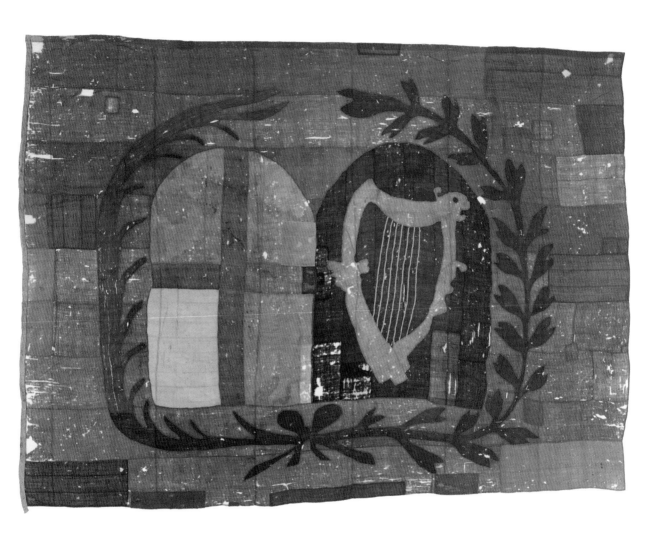

England, 1652–54
Wool and linen; 4521 × 6248 mm
AAA0800

Unnamed warship in the 'Navy Board' style, 58 guns

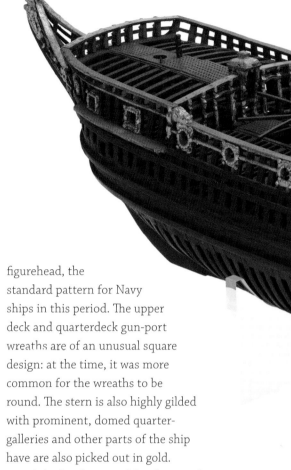

Although not identified as a specific ship, this is the oldest 'true-scale' model in the Museum. It depicts a fast warship of the mid-seventeenth century, characterised by fine lines and long raking stem- and stern-posts. This kind of warship was based on the shape of the swift-sailing Dunkirk privateers that preyed on British shipping during the wars with France. This is also the earliest known example of a model built in the 'Navy Board' style, whereby the hull frames have been assembled in a stylised fashion, rather than as actually built. The external planking has been omitted to give a sense of the construction and internal layout of the hull. There is a capstan on the upper deck of the ship, with bars set at different heights passing right through the barrel.

The model is adorned with ornate gold-painted carved decoration. At the bow there is a lion

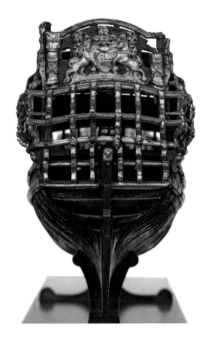

figurehead, the standard pattern for Navy ships in this period. The upper deck and quarterdeck gun-port wreaths are of an unusual square design: at the time, it was more common for the wreaths to be round. The stern is also highly gilded with prominent, domed quarter-galleries and other parts of the ship have are also picked out in gold.

While the identity of the ship is unknown, the scale used means that the model represents a ship with a gun deck 147 feet long and 34 feet across. The proportions agree closely with the third-rate frigates built during the Commonwealth (1649–60) such as the *Fairfax*, which was launched in 1650 and carried 50 guns. However, the model conspicuously displays the Stuart coat of arms on the stern. This suggests that it was either made, or that the arms were added, after the restoration of the monarchy in 1660. This was also the practice with the ships themselves, which often saw their Parliamentary names changed. For instance, the *Naseby* became the *Royal Charles*.

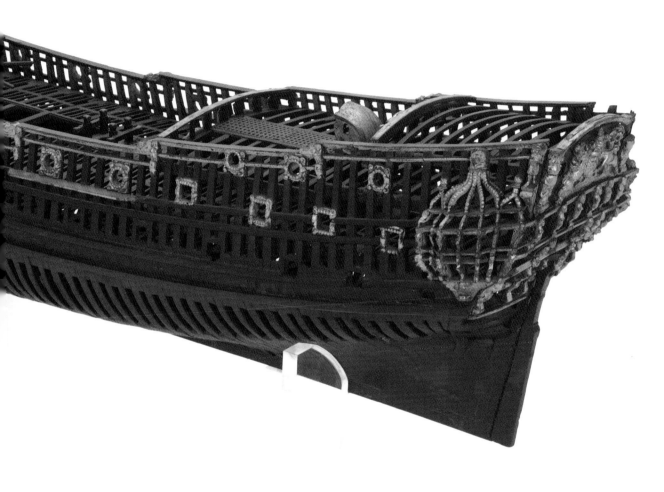

England, c.1655
Scale: 1:48 (¼-inch to the foot)
Wood, paint, gilt; 311 × 1140 × 230 mm
SLR0217

A Dutch Bezan Yacht and Many Other Vessels in a Crowded Harbour Beside a Tavern

Willem van de Velde the Elder

Marine painting began as a distinct genre in the Netherlands during the late sixteenth and early seventeenth centuries, in parallel with the emergence of the United Provinces as a dominant maritime and imperial power. As a result, it was primarily Netherlandish artists who brought a visual culture of ships and the sea to England from the 1590s. Those who came to London in the 1600s include Jan Porcellis, a pupil of Hendrick Vroom, Isaac Sailmaker and Adriaen van Diest, and the market for Netherlandish marine painting, whether parades of ships, coastal scenes or seascapes, thrived across Europe during the entire seventeenth century. Though the talented and itinerant artists named above were instrumental in the development of marine painting, none of them achieved the enduring fame or impact of Willem van de Velde the Elder (1611–93) and his eldest son, Willem the Younger, whether on contemporary taste, on the development of a British maritime identity or on the subsequent history of British art.

While Willem the Younger is now recognised as the more innovative and influential artistically, Willem the Elder, who was primarily a draughtsman, forged new ground in his method of researching maritime subjects, particularly naval conflict. He is believed to be one of the earliest artists to accompany fleets into action to record these events, and did so officially with the Dutch navy from 1653. Using these 'eyewitness'

drawings, he created works of art known as grisaille drawings, or more accurately as pen-paintings (*penschilderingen*), which were executed in pen and ink on prepared lead-white panels or canvases. This technique enabled van de Velde's work to be full of detail and to show his peerless knowledge of naval architecture and domestic shipping. He originally applied a cross-hatching technique to show darkness and shade but from the 1650s he increasingly used a brush to indicate shadows, clouds or waves.

The Museum's art collection contains outstanding examples of Willem the Elder's pen-paintings that represent specific fleet actions, such as the Battles of Scheveningen and the Sound, or scenes of Dutch shipping in the shallow waters of the Zuiderzee, all of which were created while van de Velde was still based in Amsterdam. This example from about 1660 is a *tour de force* in this most painstaking of techniques, demonstrating why Willem the Elder was the leading Dutch master in marine grisailles. Light, shade and reflections in the still water are used to create a sense of moist atmosphere and filtered sunlight. The soldiers shown on the lower left suggest that the scene is meant to represent a military event, such as an embarkation. The resonance of such a painting for his contemporaries, however, would have been in its ability to project so vividly a generalised image of the commercial prosperity and social order of the Dutch Republic, which was based on its sea power.

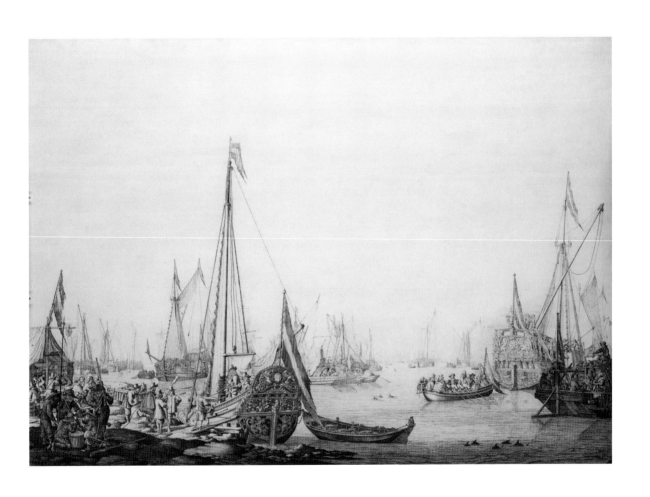

c.1660
Grisaille on panel; 757 × 1068 mm
BHC0862; Caird Collection

An early experimental marine timekeeper

attributed to John Hilderson

Despite its unassuming appearance, this clock movement is of tremendous significance to the history of navigation. It is a remnant of the seventeenth-century collaboration between a Dutch mathematician, Christiaan Huygens, and a Scottish earl, Alexander Bruce, with whom he became acquainted while Bruce was living in exile in the Low Countries. The two men tried to produce a timekeeper that would enable mariners to determine their longitude at sea with certainty. Its production followed on from the ground-breaking application of the pendulum to the mechanical clock, which was described in 1658 by Huygens in his pamphlet, *Horologium*. The pamphlet states that he and others intended to utilise the nascent technology to produce 'the most exquisitely constructed timepieces free from all error' for use at sea.

Initially, Bruce commissioned two timekeepers from Huygens's preferred clockmaker, Severijn Oosterwijck. One of these was damaged during a rough crossing to England and Bruce ordered another in London. It is possible that this timekeeper is the replacement, made by London clockmaker John Hilderson (*c*.1630–65) and mentioned in Huygens's *Oeuvres Complete*. The distinct shaping of the brass pillars that hold the clock's plates together is very similar to other clocks made by Hilderson at that time.

An intriguing feature found on this and another surviving example is the chapter ring on the back of the movement, graduated from 1 to 60. This dial once had a pointer. The ratios of the clock's wheels suggest that if the clock was set so the main dial showed regular time, the hand on the rear dial would make a full rotation in four minutes and 37 seconds. As this also applies to the other clock, it seems unlikely that the gearing has been altered. The use of this dial is not described and we can only guess its purpose. It is tempting to think that the clock was regulated to match the apparent motion of the stars, with a full rotation of the hand indicating one degree of the Earth's rotation. Given the ratios of the gearing, however, it seems more likely that the dial was used for a different purpose.

After encouraging reports on the performance of these sea clocks in European waters, a French scientific voyage in 1670 provided an opportunity for a transatlantic trial. The timekeepers were entrusted to the astronomer Jean Richer but the vessel met with stormy weather early in the voyage, causing the clocks to stop. Much to Huygens's displeasure, Richer chose not to continue the trial, dashing any hopes of the design's endorsement. In any case, Richer probably understood that this technology could not be relied upon at sea. The pendulum clock requires constant gravity to keep time reliably and attempts to adapt it for use at sea came to nothing. The first promising innovation came over 60 years later, when John Harrison employed springs to provide an artificial and constant gravity in his first sea clock. The clock is now mounted in a conventional long case.

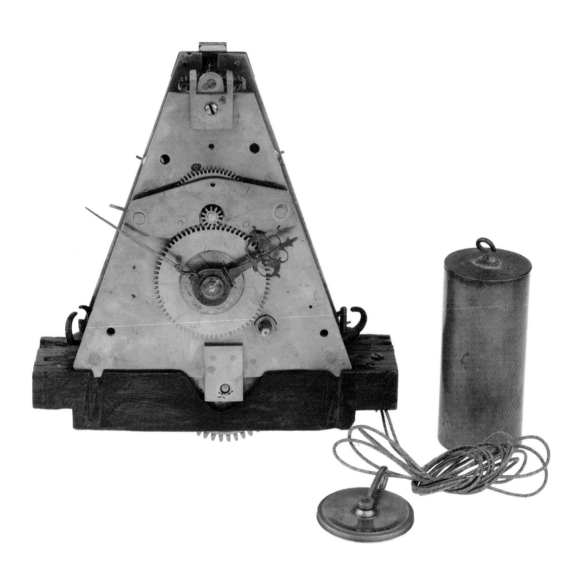

Probably London, early 1660s
Brass, steel; 220 × 120 × 120 mm
ZBA6944; purchased in 2015 with assistance from the Art Fund

Telescope

attributed to Johan van der Wyck

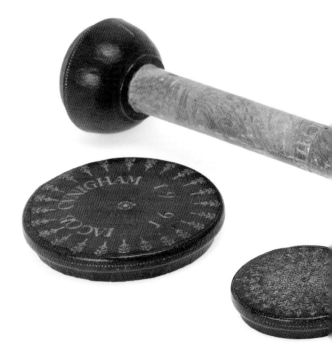

Inscribed with the name 'Iacob Cunigham' and the date 1661, this distinctively shaped telescope is the oldest dated example in the Museum's collection. The barrel and lens caps are made of wood covered in red leather and adorned with fine gold-tooled decoration, while the wooden draw-tubes are covered with marbled paper. The thinnest of these has gold-tooled extension marks with the north German words 'NAHE' (near), 'WEITH' (far) and 'OVERSICHTIG' (farsighted), indicating three possible focusing lengths to suit different observers.

Several illustrations of telescopes with this trumpet-shaped barrel exist, yet very few examples survive. The shape seems to have been more common in the first decades of the seventeenth century, just after the invention of the telescope. It was needed to accommodate a large objective lens, since at this time it was only possible to grind lenses of sufficient quality if they were large. To compensate for the irregularities produced during grinding, brass diaphragms cover each lens to reduce their apertures and so improve optical resolution. The telescope has just two lenses – a convex objective lens and a concave eyepiece lens. This form is called the Galilean telescope, after Galileo Galilei (1564–1642), the Italian university teacher and polymath who made ground-breaking discoveries with telescopes of this type at the beginning of the seventeenth century. Galileo shocked the world in 1610 with the publication of the *Sidereus Nuncius*, which described what his

telescopes revealed: that the Moon had mountains and that Jupiter had moons of its own.

Recent research suggests that this telescope's maker was Johan van der Wyck (1623–79), who was born near Münster and educated in the Dutch Republic, where he became a prominent maker of optical instruments and a military engineer. The name in gold on the objective lens cap indicates that the telescope was made for a Jacob Cunigham. A man with this same name and spelling, born in 1619, was the parson of Horslunde (a village on the Danish island of *Lolland*). The two men would probably have met during the late 1650s when van der Wyck was working as a military engineer not far from Horslunde.

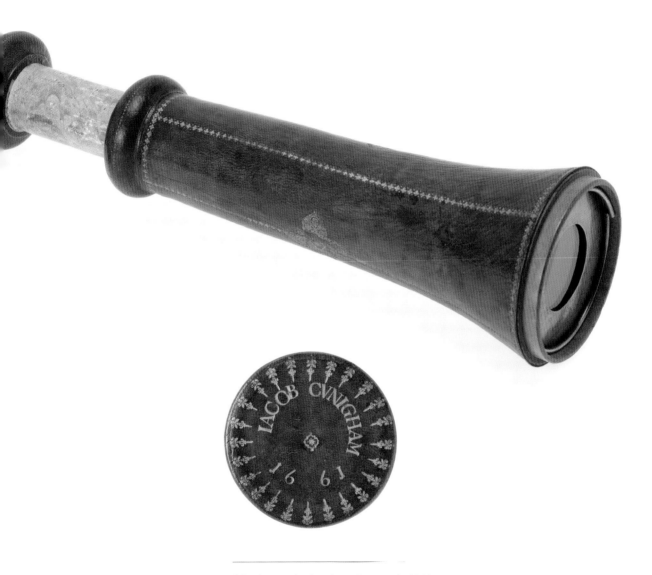

Possibly the Netherlands or Denmark, 1661
Leather, wood, brass, paper, glass; 325 mm (closed); 105 mm max. diameter
NAV1547; Caird Collection

James, Duke of York, later James II

Samuel Cooper

James, Duke of York (1633–1701), was the second surviving son of Charles I and Henrietta Maria. With the Royalist defeat in the English Civil War, and their father's execution in 1649, he and his brothers lived as exiles in France, the Dutch Republic and Germany. During this time, James proved a brave and effective soldier.

Charles II's restoration to the throne in 1660 presented an opportunity to emphasise continuity with his father's reign – James, for example, resumed the position of Lord High Admiral originally conferred on him in 1638 – and to promote the legitimacy and achievements of the new regime in art and culture. The cosmopolitan artistic scene that developed in the capital and beyond was exploited at court, not least by James himself. Importantly, he had a personal investment in the visual culture surrounding the Navy, both as Lord High Admiral and through his command of the English fleet during the Second and Third Anglo-Dutch Wars. Furthermore, the plethora of subject matter that emanated from the bloody encounters between the Dutch and English navies resulted in an unprecedented boom in maritime-related imagery. Between 1665 and 1668, for example, the King's Principal Painter Sir Peter Lely undertook a major commission from James for a series of naval portraits, the so-called 'Flagmen of Lowestoft': 13 portraits of prominent naval officers, including James himself, who had fought at the Battle of Lowestoft (1665). Eleven of these are in the Museum's collection; the other two remain in the Royal Collection.

Part of the rationale behind such commissions was the desire to represent the triumphant rise of the English Navy under the restored Stuart monarchy, and to confirm the Stuarts as the rightful heirs to the naval and imperial successes of the Elizabethans. Thus, while this sensitive and skilful portrait miniature by Samuel Cooper (1607/8–72), showing the prince in armour (with his blue Garter ribbon), may seem relatively conventional, such courtly imagery was in fact calculated to project the sitter's prowess in command and, by extension, to suggest his fitness to rule the nation, should the need arise. Here the prince's classical dress shows him as successor to the commanders of Imperial Rome, and at the same time, to the daring exploits of those who wore Greenwich armour, as seen in Nicholas Hilliard's exquisite portrait of George Clifford (see page 27).

1670–72
Watercolour on vellum; 78 × 64 mm
MNT0191; Caird Collection

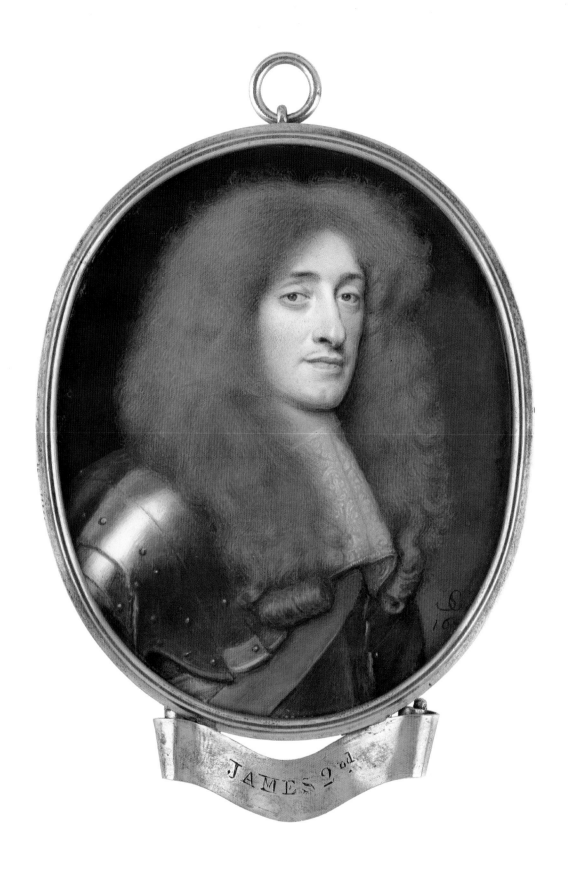

JAMES 2ᵈ

The Burning of the Royal James at the Battle of Solebay, 28 May 1672

Thomas Poyntz

This signed tapestry commemorates an incident in the Battle of Solebay (Southwold Bay) on the Suffolk coast, the first battle of the Third Anglo-Dutch War. On 28 May 1672, 140 ships of the combined English and French fleets, under the command of James, Duke of York and the Comte d'Estrées, met the Dutch fleet of 91 ships, 54 fireships and 23 tenders under De Ruyter. This was the last time a future British king led a fleet in battle. The tapestry depicts the burning by Dutch fireships of the *Royal James*, flagship of the Earl of Sandwich. Sandwich refused to abandon the ship and drowned; his body was later washed up and identified by the Garter star on his breast.

This is one of a set of six Solebay tapestries commissioned by Charles II and woven at the famous Mortlake tapestry factory near Richmond, Surrey, after drawings by Willem van de Velde the Elder, who was present at the battle. Tapestry was an important art form in seventeenth-century Britain, particularly under the patronage of James I, who wished to emulate the great European Renaissance collectors. The Mortlake factory was established by Francis Crane in 1619. He enticed talented émigré weavers and their families from Flanders. For the next 20 years, the factory produced the finest and most technically accomplished tapestries of the period.

It was not unusual for celebrated artists to design tapestries – Raphael, Rubens and van Dyck created cartoons to be translated into large-scale, figurative hangings. From 1672–73, the Willem van de Veldes (father and son) had their studio in the south-west parlour of the Queen's House and were allowed space to lay out the large designs for the tapestries on the upper floor. Charles I and his son, Charles II, understood the cultural significance of tapestry within European courts. They were costly commissions, and these sumptuously woven hangings were often presented by royal patrons as diplomatic gifts. They were also portable and as such would have been carried between royal residences, such as Greenwich Palace and Hampton Court, when the monarch was in residence.

The first three tapestries were made under the direction of Francis Poyntz, appointed Yeoman Arrasworker by Charles II on his restoration to the British throne. They are now in the Royal Collection at Hampton Court. This tapestry is one of the second three, which were ordered to complete the set but were apparently never delivered. They are signed by Thomas Poyntz (*fl*.1660–88), younger brother of Francis. The other two of the second set are also at Hampton Court.

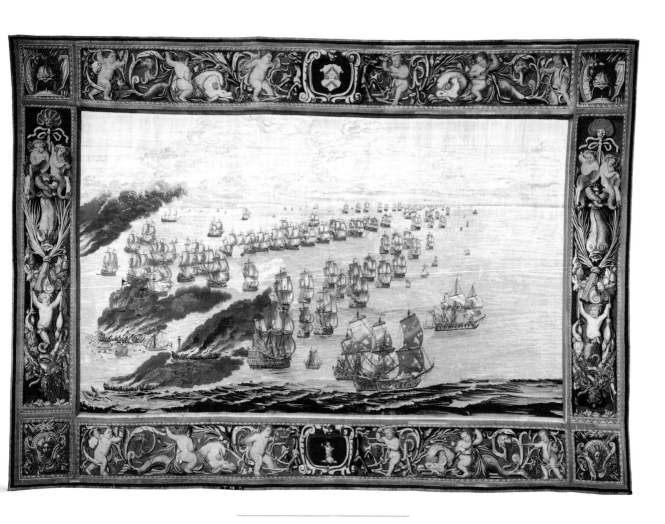

Mortlake, after 1672
Woven wool and silk; 3935 × 5630 mm
TXT0106; purchased with the assistance of the Art Fund, 1968

21

Journal of Edward Barlow

Barlow's journal is considered one of the most important first-hand accounts of life at sea in the seventeenth century. Although he entered the Navy in 1659 as an apprentice in the *Naseby*, Barlow began writing retrospectively in early 1673, while held captive by the Dutch at Batavia (modern-day Jakarta). The account is unique because of his rich and varied career at sea, offering insight and commentary on a variety of places in both naval and merchant ships. It is richly illustrated throughout with watercolours, which include images of an elephant and a rhinoceros as well as many English and Dutch ships and places he visited. The journal also refers to events of historical importance. For example, the *Naseby* was chosen to bring Charles II back to England at the restoration of the monarchy in 1660. On 3 May that year Barlow witnessed the on-board proclamation of Charles as King of England, when every member of the crew was given a pint of wine to drink the king's health.

Edward Barlow (1642–1706) had a curiosity about the world that prompted his need to explore. After a period of two years as an apprentice in the warships *Augustine* and *Martin Galley*, he entered the merchant service for a further two years. During the Second Anglo-Dutch War he returned to the Navy, seeing action in all major engagements, including the Battle of Lowestoft (1665) and the Four Days' Fight (1666), when a cannonball struck his right leg, from which he made a remarkable recovery. Looking back on the humiliation of the Dutch raid on the Medway (1667), it is clear that Barlow was far from impressed by the new commanders taken into the Navy during the war,

stating that they were 'inexperienced gentlemen, cowardly, and more fit to command dung boats than the King's ships'.

In 1670, Barlow sailed in the *Experiment* to the East Indies, where he was captured by the Dutch in autumn 1672 and held prisoner until he was transported back to Europe in 1674. The following year he joined the *Florentine* as a gunner, which was bound for Bergen but wrecked on Goodwin Sands on the return voyage. He superstitiously blamed the incident on a quarrelsome Norwegian landlady, who swore they would never reach the next port, and the fact that a black cat had boarded the ship.

Between 1675 and 1682, Barlow made several voyages as a member of the crew on East India Company merchantmen, and rose to the rank of chief mate. He succeeded in his lifelong ambition to become captain when he commanded the *EI Liampo*, which sailed for Mocha in the Red Sea in January 1706, and in which he was lost when the ship sank in storm off Mozambique. The final entry of the journal details Barlow's earlier return voyage in the frigate *Kingfisher*, as a passenger from St Helena to England in December 1703. It is fortunate that he kept his journal at home.

Being Com: vp to the Citey wee had two of the kinges waiters sent a bord of us at the Custam is to see that no goods should bee caried one shore privatley to save the Custam paying so Delivring out all the gues which wee had one bord being for the most part Cloath and saryers with black and white lives and som other small Comodties the goodes being out wee stared for a licence to bee granted from the kinge for over going to brasile but none Could as then at present bee granted and not longe after wee filed over ship for to Saile for wee wer tired of a privat Desire for which reason none of us knew prevent over Comander and shiping ten men more in over ship having but forty before which wee had out of a virginid ship which was laad in there which was notely Com from virginia and by tud one ther was foure in there and being out and nearely leaky shee was not thought Sufishant to goe for Contam and so all the men wer paid and Cleared there and all thinges being Redey there Came one man a Portegaire one bord of us to goe a Pasenger for wee were bound up the straightes and meaing over ankcer wee set Saile from Lisborne and bore I thought it best to set you the morced of the shipps that shee was then in which you must note that both shee and all the rest that shallestene in are made in the semes sarhen that Ever shee wear in or Could make them selver one the greatest holey Dayes or when there wear som greate yarson to Com one bord to Luke vpon them or som great feast when many strangers are Gruited one bord of them

having leapt over Curmes at Luserne and now Deparling from thine over voige we stertes over thur sa Cape St: vincent but the wine not Permiting us for to see it once Berested over Cowse for the Straight mouthand after Many Crest number at last wee had the sight of Cippo Spral and having Com Letters to Delivere at Tanger wee Come to anchoure

England, 1673–1703

Manuscript; 358 × 235 mm

JOD/4

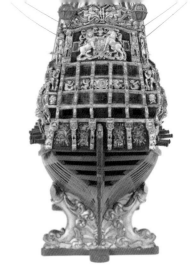

St Michael, first rate, 98 guns

A truly remarkable example of seventeenth-century craftsmanship, this model of the *St Michael* is noted for being the world's earliest identifiable ship model. This has been verified by comparing key measurements, such as the length of the main gun deck, against the known dimensions of the actual ship, both of which agree exactly. Its identification is further confirmed by the existence of three contemporary drawings of the *St Michael* by the famous Dutch marine artist, Willem van de Velde the Younger. The larger finished drawing of *c.*1676 shows the port broadside, while the other two show a series of working sketches of the bow, quarter gallery, gunports and the cathead decorations. The sketch showing the figurehead is inscribed 'Mighal'.

The hull is built in the 'Navy Board' fashion, in which the stylised open-hull frames are left unplanked below the main wales (main longitudinal reinforcements). It is thought that this style of construction allows the human eye to understand the complex curves of the underwater hull shape better than from an intricate two-dimensional ship's plan. The upper decks are partially planked, allowing light into the hull to see some internal features, and provides decking on which to mount the gun carriages. By far the most noticeable feature of the model is its extensive painted and gilded carved decoration. Apart from the obvious areas around the bow and stern, a typical hallmark of later seventeenth-century warships are the carved wreaths around the gunports of the upper, quarter and forecastle decks. The model is fully rigged but while the masts and spars are largely original, the rigging was replaced in the 1930s.

The *St Michael* was launched in 1669, originally as an 80–90-gun second rate under the direction of John Tippits, the Master Shipwright at Portsmouth Royal Dockyard. It was later re-classified as a 90-gun first rate in 1672, the same configuration as the model. The ship had a very active career taking part in the battles of Solebay in 1672 and Barfleur of 1692, before it was rebuilt in 1706 and renamed *Marlborough*.

There is a strong possibility that this model may once have belonged to Sir Robert Holmes, a former captain of the *St Michael*. In his will, dated 1692, Holmes states that he owned 'two moddles of shipps'. The whereabouts of the model from the eighteenth century until it re-surfaced in the hands of a dealer in the 1920s are not known. It was later entered into an auction in 1939 by the artist, sculptor and ship-model maker Robert Spence, and purchased by Sir James Caird, the founding benefactor of the National Maritime Museum.

England, c.1669
Scale: 1:48 (¼-inch to the foot)
Wood, metal, gold leaf, cordage, mica, paint, varnish; 1295 × 1350 × 600 mm
SLR0002; Caird Collection

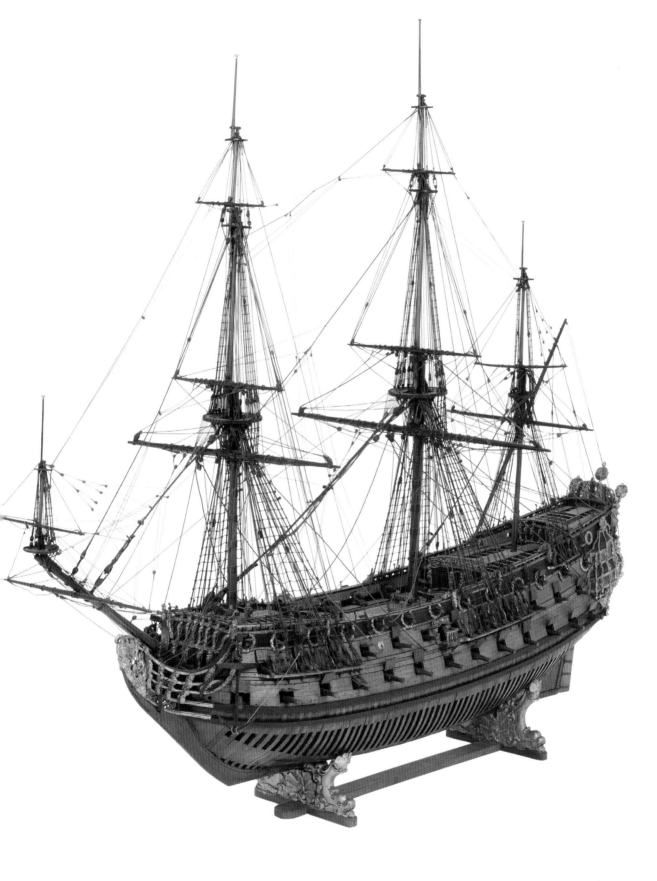

23

Year-going pendulum clock

Thomas Tompion

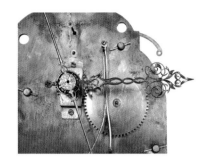

This is one of a pair of year-going clocks, known to have been made for John Flamsteed by Thomas Tompion (1639–1713), and installed at the newly built Royal Observatory in 1676. The clocks were highly innovative for the time and employed pendulums that beat every two seconds. In order to achieve this rate, they had to be over 13 feet in length and were suspended above the clock movement, situated behind the panelling in the north-eastern corner of the 'Great Room' (now called the Octagon Room). It was the length of the pendulums that dictated the height of the impressive decorative ceiling.

The clock movement was deliberately designed to maintain the swing of the long and heavy pendulums with a low-powered push from the escapement, so as to give greater stability in timekeeping. While these clocks were at the cutting edge of timekeeping technology, the low-powered impulse meant that they were very susceptible to airborne dust particles that very quickly clogged the delicate mechanism.

Flamsteed wrote that when the clocks behaved, they ran 'very regularly and kept pace with the heavens'. Using them, he was able to prove, by regularly timed observations of Sirius, that the Earth's speed of rotation was constant. This

assertion was fundamental to the Observatory's ensuing work in providing the astronomical data that enabled mariners to find their position at sea – specifically, their longitude.

Both clocks shared the same unique way of displaying the time: the hour hand, as is common, made a full revolution in twelve hours but the minute hand made a full revolution every two hours. Another unique feature of these clocks was that the pendulums swung from front-to-back rather than side-to-side. This unusual arrangement required the viewing windows to project into the room, hence the existence of the oriel windows above the clock dials.

After Flamsteed's death in 1719, his widow Margaret removed the clocks and all other instruments from the Royal Observatory. She was entitled to do so, as her husband had either supplied his own instruments or, as with this clock, they were provided by his patron, Sir Jonas Moore. This clock was then sold and converted to run with a shorter pendulum so that it could be housed in a more conventional clock case. It stood in Holkham Hall, Norfolk – the ancestral home of the Earls of Leicester – until the mid-1990s when it was acquired by the Museum.

London, 1676

Brass, steel, silver, velvet, oak, glass; 1342 × 200 × 102 mm (movement), 3120 × 645 × 295 mm (case)
ZAA0885; acquired with the assistance of the Art Fund, National Heritage Memorial Fund,
the Friends of the National Maritime Museum, Save and Prosper Educational Trust, The Worshipful
Company of Clockmakers, J. Paul Getty Charitable Trust, The Monument Trust, Christie's,
Peter Moores Foundation, and others.

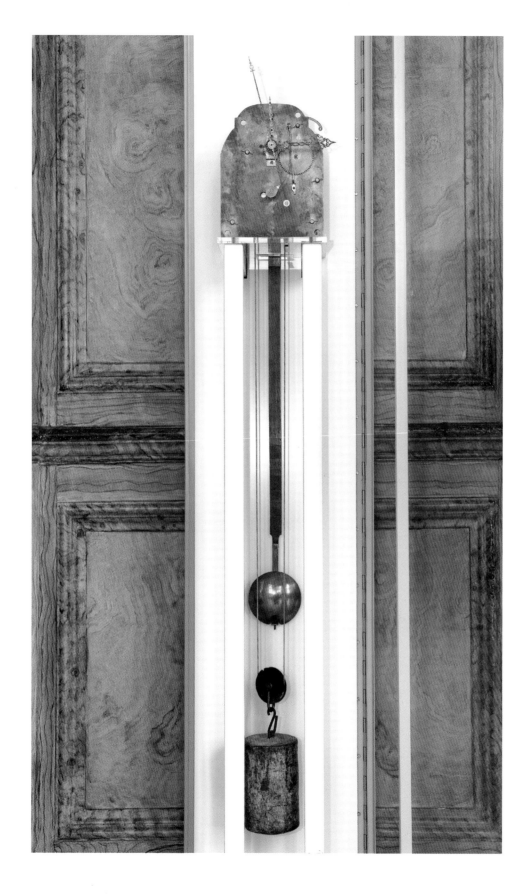

The Gouden Leeuw at the Battle of the Texel, 21 August 1673

Willem van de Velde the Younger

At the time of their migration to England, during the winter of 1672–73, the van de Veldes enjoyed an unrivalled reputation that was closely aligned with the military and commercial fortunes of the Dutch Republic. Furthermore, both had a lifelong engagement with maritime affairs and the intricacies of naval architecture – factors that greatly enhanced their artistic standing across Europe. Over and above assisting his father in a thriving studio practice, Willem the Younger (1633–1707) had secured his own reputation from the late 1650s as a painter of 'calms' – sunlit maritime scenes often shown on the shallow waters of the Zuiderzee, which vividly projected an image of the commercial prosperity and social order of the Dutch Republic as a maritime nation. He would return to this theme in his portrayal of royal warships, yachts and other vessels. Preeminent examples are *The Royal Visit to the Fleet in the Thames Estuary, 1672* and *The English ship Royal Sovereign with a Royal Yacht in a Light Air* of 1702, both in the Museum's collection.

Although settled in England under British royal patronage, Willem the Younger continued to paint for Dutch clients. This painting, one of his acknowledged masterpieces, was painted long after the event itself, in 1686–87 and in Amsterdam, for the Dutch admiral Cornelis Tromp: his flagship, *Gouden Leeuw* (Golden Lion) is represented in the centre of the composition. The extraordinary artistic skill of this dramatic, panoramic scene

encapsulates exactly why Willem the Younger was to exert such a profound and sustained influence over British marine painting throughout the eighteenth century and beyond. The battle itself was the last attempt by combined English and French forces to destroy the Dutch fleet in preparation for an invasion. In van de Velde's painting, the prominence of Tromp's ship – seen firing at the enemy – can be read as a symbol of national defiance. Tromp, who was a friend of Charles II, visited London in 1675 and had his

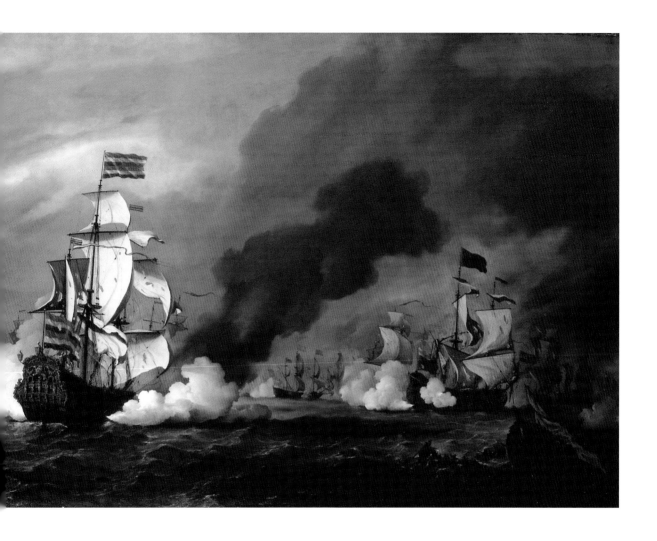

portrait painted by Peter Lely, which included
a similar representation of the *Gouden Leeuw*
in the background. The relaxation in Anglo-Dutch
relations that made this possible followed the
Treaty of Westminster (1674), which ended the
Third Anglo-Dutch War and saw England withdraw
from its alliance with France against the Dutch.

 The direction of political travel was cemented
in 1677 by the marriage of James, Duke of York's
eldest daughter Mary to his nephew William III
of Orange (then Admiral-General of the Dutch

1687
Oil on canvas; 1498 × 1997 mm
BHC0315; purchased with the assistance of the
Art Fund and the Society for Nautical Research
Macpherson Fund

fleet). The event seems to have resulted in James
commissioning in 1682 this marine painting
representing the Battle of the Texel – arguably the
finest hour of the Dutch navy since the audacious
raid on the Medway in 1667.

Cross-staff and backstaff

Thomas Tuttell

Ivory has long been a luxury material, but it is not the best choice for making accurate measuring instruments, since its sensitivity to changes in humidity makes it liable to distort and crack over time. It is unlikely that any of this beautiful presentation set of ivory navigational instruments went to sea: they are remarkably well-preserved for their age and would certainly not have survived prolonged shipboard use. They were almost equally certainly made as a prestige set, for high-status display and to show their maker's skill. Comprising a cross-staff and backstaff, a sector and two Gunter rules (not shown), they are beautifully decorated with strapwork, sea creatures and floral motifs. By contrast, on working instruments, any decorative elements would be minimal, since the most important markings were the graduated scales.

The cross-staff and backstaff are angle-measuring instruments that were common among navigators of the seventeenth and early eighteenth centuries, and which were normally made of wood. The cross-staff can be used to measure angles in any plane by moving one of four vanes along the main staff to line up each end of the vane with one of the chosen targets, then reading the angle from a scale inscribed on the staff. The chosen angle might be between the horizon and a heavenly body, two celestial objects or two terrestrial objects. The backstaff is used solely to measure the height of the Sun above the horizon in order to find local time and latitude. It is also possible to configure the cross-staff so that it can operate like a backstaff, with the angle read by standing so that the Sun

casts a shadow onto the instrument while the horizon is sighted.

As well as the fine decoration, each instrument is inscribed in French and Latin with the name of its maker, Thomas Tuttell (*c.*1674–1702), who worked in Charing Cross, London, in the late seventeenth century. The inscriptions describe him as '*Ingenieur de sa Majesté Britanique pour les Instruments Mathematiques*'. As they suggest, Tuttell was a prominent designer and maker of mathematical instruments who gained royal patronage, initially as instrument maker and then also as hydrographer to the king. Ironically, he drowned while carrying out a survey of the Thames in 1702.

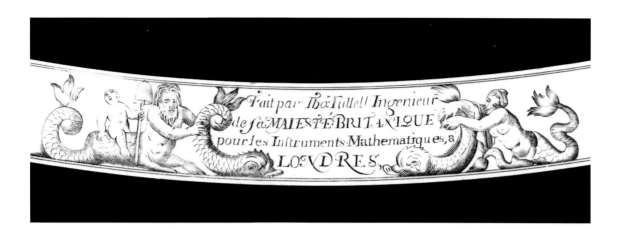

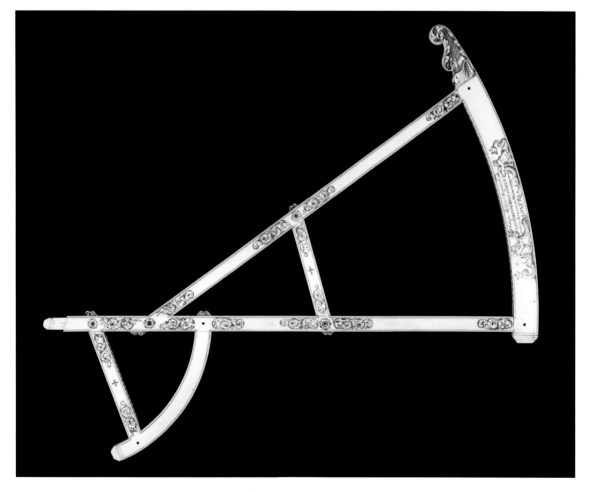

London, c.1700
Cross-staff: ivory, brass; 796 × 502 [longest vane] x 55 mm, backstaff: ivory, brass; 350 × 689 × 65 mm
NAV0505, NAV0040; Caird Collection

Persian astrolabe

Muhammad Khalil and Muhammad Baqir Isfahani

Originally devised by Ancient Greek astronomers, the astrolabe is an astronomical calculator that was later developed by Islamic scholars. In a tradition that continues today, these scholars relied on astronomy for their work. For example, the Islamic calendar is based upon the monthly cycle of the Moon, while the times and direction of prayer are determined by the Sun. Used in conjunction with astronomical textbooks and other instruments, the astrolabe was a powerful tool for measuring and predicting the apparent motion of the Sun and stars to make these essential calculations.

Like many astrolabes, this instrument is an elaborate combination of artistic flair and mathematical precision. It is composed of a series of thin metal discs, each one designed for use at a specific latitude, nested together into a solid base plate ('mater'). Designed to be used by Shi'a Muslims in Persia (present-day Iran), the engraving around the rim of the mater is an invocation to the Prophet, his mother Fatima and the 12 Imams of Twelver Shi'ism. The uppermost plate ('rete') is an elaborate array of floral shapes and leaves, the tips of which represent the positions of certain bright stars. When the rete is turned from left to right, the tips moving across curved lines recall the motion of rising and setting stars.

On the reverse of the mater, additional scales and engravings demonstrate the versatility of this remarkable instrument. For example, Islamic scholars could use the astrolabe to determine the direction of the holy city of Mecca and hence the direction of prayer ('qibla'). One quarter of the mater's reverse side features a grid of concentric quarter circles that indicate the date according to the position of the Sun against the background stars of the zodiac. Another set of lines, one for each significant city in the region, cuts across from the centre to the edge. The astronomer finds the intersection between the relevant city line and date line to determine a value for the Sun's altitude (height above the horizon). He then measures the Sun as it moves across the sky from east to west, knowing that the direction of Mecca corresponds to the point on the horizon directly below the Sun when it reaches the specific altitude.

On the lower half of the reverse side lies a shadow square, used for measuring the height of mountains and buildings. The cartouche in the middle bears the maker's signature: 'Made by the humble and wretched in front of God the Magnificent, Muhammad Khalil ibn Hasan 'Ali'. Beneath this lies the signature of the decorator: 'Muhammad Baqir Isfahani'. These signatures have been identified on several astrolabes and reveal how these two craftsmen worked together within the wider community of skilled instrument makers in Isfahan during the late seventeenth century.

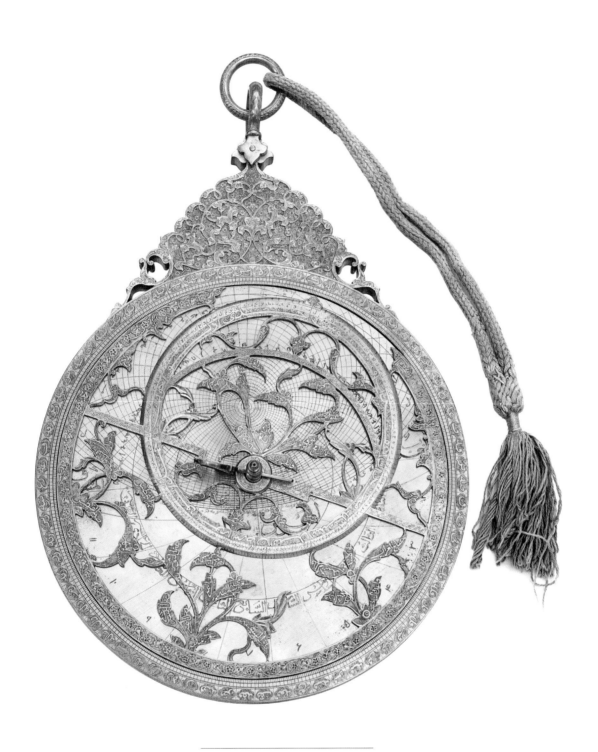

Isfahan, Iran, 1707–08
Gilt-brass; 246 × 185 mm
AST0535; Caird Collection

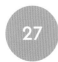

The arms of the South Sea Company

Robert Jones

The South Sea Company was established in 1711 and given a monopoly over British trade with South America. At the time, Britain was at war with Spain, the major colonial power there, and there was little immediate prospect of increasing trade in the region. The Treaty of Utrecht, which ended the War of the Spanish Succession, granted Britain the *Asiento*, or the right to supply enslaved Africans to Spanish colonies for the next 30 years. This was given to the South Sea Company, providing some commercial underpinning for its operations, until a new war began with Spain in 1718, once more making trade and profit impossible. However, the Company had another purpose: to consolidate and reduce Britain's national debt. In a series of complex and flawed financial transactions, it and its shareholders took on government debt, which was converted into stock. In 1720, there was a frenzy of speculation in this Company stock as wild rumours of huge profits seized the public imagination and loosened the nation's purse strings. The price of stock rose and rose until it reached the astronomical sum of almost £1,000 a share by early August. At this stage, the South Sea 'bubble' burst and share prices plunged to £150 the following month. Individual speculators were ruined. Fortunes had been invested by the wealthy in the hope of fabulous returns; others had borrowed heavily to buy shares and were left bankrupt. The government stepped in, confiscating the estates of the Company's fraudulent directors, which were used to give some relief to those left destitute by the collapse. New and safer mechanisms to manage the government's debt were introduced, eventually establishing a sound financial system under the Bank of England – which has had to counter similar crises of over-blown speculation in recent times.

The South Sea Company was granted its coat of arms on 31 October 1711. These are represented in the central cartouche with a crest of a ship in full sail. The supporting figures are Britannia, with her shield and spear, and a fisherman with his net, holding aloft a string of fish (now lost). This version hung in the Company's headquarters in the City of London. It was made by Robert Jones, who was a ship carver at Woolwich Dockyard from 1710 to 1721. He also did a great deal of work, in wood and stone, at Greenwich Hospital (now the Old Royal Naval College), which can still be seen there.

Possibly Woolwich, 1711–12
Wood and polychrome decoration; 2184 × 1346 mm
HRA0043

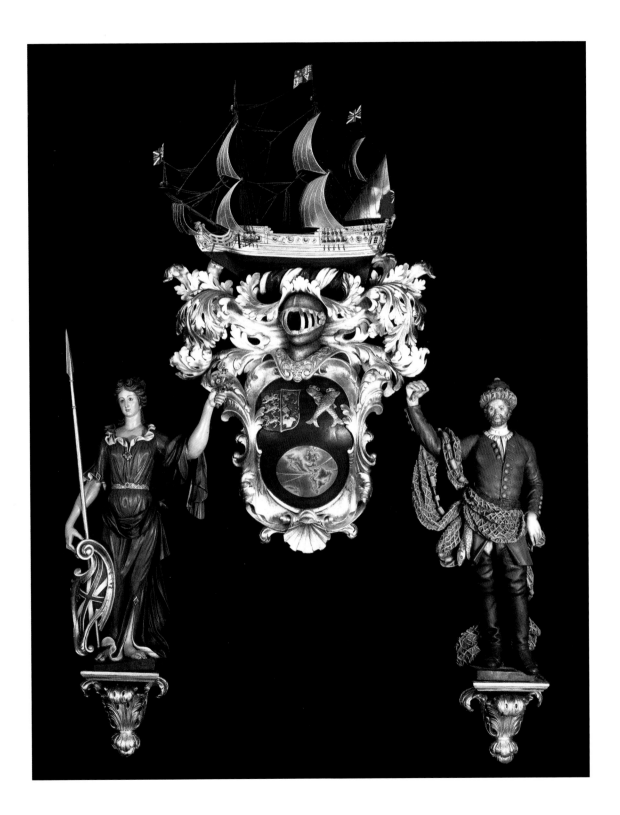

The astronomers' alarm clock

George Graham

This clock was first used at the Royal Observatory by the third Astronomer Royal, James Bradley. He purchased the 'chamber alarum' in 1748 from George Graham (c.1673–1751), then London's most distinguished maker of clocks, watches and scientific instruments. As with nearly all of Graham's output, this clock is marked with a unique serial number, 667, suggesting that it was made in the mid-1720s. Therefore, it was either an item that had been in stock for a long time or it was bought as a refurbished one.

This type of brass-framed timepiece is usually referred to as a lantern clock, a commonplace type in the seventeenth century. They were often made by blacksmiths and are generally considered the cruder cousin of the longcase clock. However, this particular example is of exceptional quality and the gearing is so carefully made that there is very little evidence of wear. Its beating heart is a verge escapement, which is fairly conventional for clocks of this type. However, the verge found in Graham 667 has two empty threaded holes that would have originally been fitted with tiny steel springs to reduce the volume of the ticking – an added luxury to aid sleep.

The alarm clock was an essential part of the astronomers' inventory. Their observation work involved recording the precise times of the passage of bright stars across the view of their telescopes (otherwise known as transit instruments). As there were potentially several hours between observations, the alarm clock could be used to ensure that they managed to get some sleep in between fulfilling their nightly duties.

This is the oldest alarm clock in the Museum collection to have been used at the Royal Observatory, but it is not the only example. In the early 1800s Thomas Taylor, an assistant at the Observatory, invented a new form of astronomers' alarm clock that tracked the Earth's rotation (or, in other words, was rated to sidereal time). Taylor's clock featured a series of peg holes, each representing the position of a star, running around a 24-hour dial. His design allowed the user to program the alarm for all of the nightly observations by placing pegs in the appropriate holes.

In 1932, Graham 667 was sold to an antiques dealer, along with other redundant clocks and watches, as part of a rationalisation of the instruments kept at Greenwich. The fast-paced technological developments of the twentieth century, particularly the introduction of quartz timekeepers, had led to the rapid obsolescence of historic mechanical clocks. The Museum purchased the alarm clock in 2013 and it returned once more to Greenwich.

London, mid-1720s
Brass, steel; 224 × 105 × 118 mm
ZBA5479

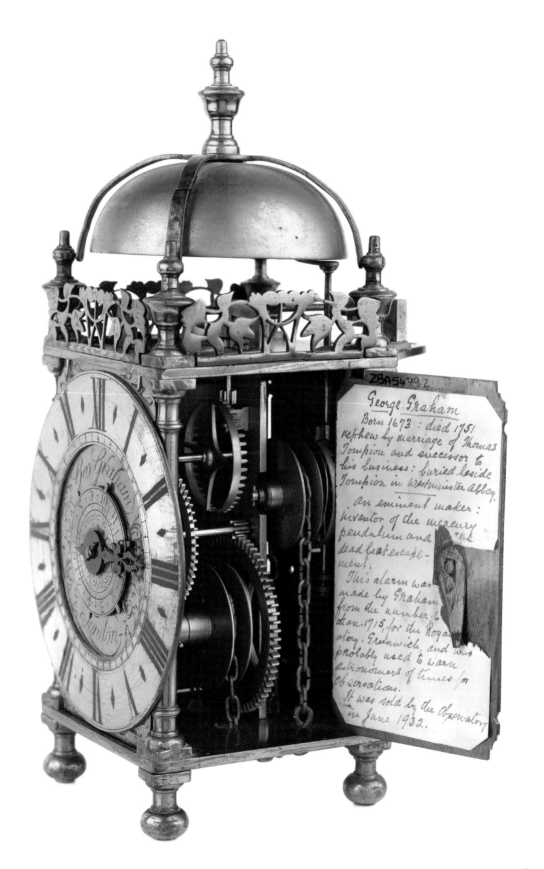

The handwritten label reads:

George Graham
Born 1673 : died 1751
nephew by marriage of Thomas
Tompion and successor to
his business : buried beside
Tompion in Westminster Abbey.

An eminent maker :
inventor of the mercury
pendulum and the
dead beat escape-
ment.

This alarm was
made by Graham
from the number
than 1715, for the Roy...
atory. Greenwich. and was
probably used to warn
astronomers of times for
observations.

It was sold by the Observatory
in June 1932.

ZBA 5479.2

Sir Isaac Newton

Louis-François Roubiliac

The natural philosopher, astronomer and mathematician Sir Isaac Newton (1642–1727) is a major figure in the history of science. His *Principia Mathematica* of 1687 is a founding text for understanding mechanics and sets out laws of motion and universal gravitation. Newton also devised the first reflecting telescope and worked out the properties of light, publishing his findings in *Optiks* (1704). It is highly appropriate, therefore, that the Royal Observatory at Greenwich should have possessed a bust of the great man and equally appropriate that it should be one by Louis-François Roubiliac (1702–62) – arguably the greatest sculptor working in eighteenth-century Britain. However, the story of this important object is one of accident, misattribution and rediscovery.

When Newton died in 1727, his nephew Henry Conduitt allowed the sculptor Michael Rysbrack to take casts of his face. Roubiliac, a Frenchman working in Britain, was commissioned by Conduitt in 1731 to produce this terracotta bust using the casts. The bust found its way into the collection of the surgeon John Belchier, who reported that Roubiliac 'made [it] under the Eyes of Mr Conduit[t] and several of Sir Isaac Newton's particular friends … and esteemed [it] more like than anything

extant of Sir Isaac'. When Belchier died in 1785, he bequeathed it to the Royal Society with instructions that it should be placed in the Royal Observatory. Some years later, the head was broken off in an accident, then mended and painted white, presumably to mask the repair. As time passed, the staff of the Observatory naturally assumed it was a cheap plaster bust of Newton and that the terracotta original was lost. During the Second World War, it remained *in situ*, occasionally sporting a tin helmet. The error was not realised until 1961, by which time the working Royal Greenwich Observatory (RGO) had relocated to Herstmonceux in Sussex. The bust was then stripped of paint and expertly restored at the British Museum. When the RGO closed in 1998, the bust of Newton was one of many items returned to Greenwich to join the Museum's collections.

Roubiliac made his name with portrait busts and cemented his reputation in 1738 with his large statue of Handel, produced for the Vauxhall Pleasure Gardens in London and now in the Victoria and Albert Museum's collections. His career continued to flourish, and he went on to produce the monument to Handel in Westminster Abbey. Roubiliac is buried at St Martin-in-the-Fields church in Westminster, near his studio.

London, c.1731
Terracotta; 740 × 500 × 290 mm
ZBA1640; Royal Greenwich Observatory Collection

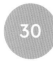

Prince Frederick's barge

William Kent, John Hall and James Richards

This royal barge was built in 1731–32 for Frederick, Prince of Wales (1707–51), the eldest son of George II and Queen Caroline. It is a truly remarkable, and largely original, example of eighteenth-century craftsmanship.

Frederick was a keen patron of the arts and employed only the top artisans of the period. The celebrated architect William Kent (c.1686–1748) played a large part in designing the layout, cabin structure and overall decoration of the barge. James Richards, who had succeeded Grinling Gibbons as Master Carver to the crown in 1721, undertook the beautiful and profuse carving work. The hull and cabin were constructed by the well-known boat-builder John Hall, whose yard was located at Lambeth on the Thames just opposite Whitehall.

The hull is an enlarged version of a Thames wherry – the river taxi of its day. Measuring 63 feet in overall length and with a beam of 6 feet and 6 inches (19.2 x 2 m), it is clinker-built (of overlapping planks) with a fine, narrow and upright stern and a long, raking flared bow. The overhanging bow design allowed passengers to embark and disembark directly from the bank. It was originally rowed by 12 royal watermen, six on each side, but this was increased during Queen Victoria's reign to 21 (10 on one side and 11 on the other).

As a mark of Frederick's enthusiasm for this project, he used the barge on its day of launch, 8 July 1732. That evening it took the Prince, Queen Caroline and five princesses from Chelsea Hospital to Somerset House. During Frederick's lifetime the barge was used on numerous occasions: in particular when he welcomed his bride, Augusta of

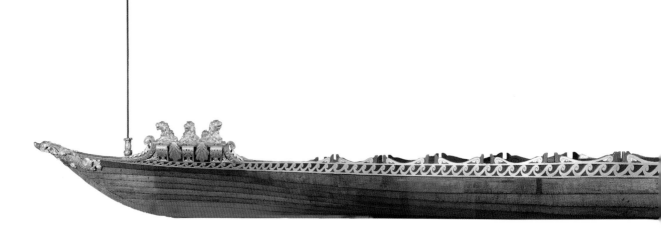

Saxe-Gotha, to Britain on her arrival at Greenwich, where she spent two nights in the Queen's House. After his death in 1751, it became the principal royal barge and took part in Nelson's funeral procession from Greenwich to Whitehall on 8 January 1806. Its last public appearance afloat was in October 1849 when Prince Albert, together with two royal children, attended the opening of the London Coal Exchange.

After a number of years in storage at Deptford, the barge was restored for Queen Victoria in 1863 and moved to Virginia Water in Windsor Great Park. It fell into disrepair and by 1873 was reported to be in poor condition. By 1892 it was presumably restored and then moved on loan to the South Kensington Museum, and then to its successor, the Victoria and Albert Museum. In 1951, George VI lent it to the National Maritime Museum, where it has since remained.

Lambeth, London, 1731–32
Wood, paint, gold leaf, varnish, metal, textile, glass, varnish; 19200 × 2000 mm
BAE0035; on loan from Her Majesty The Queen.

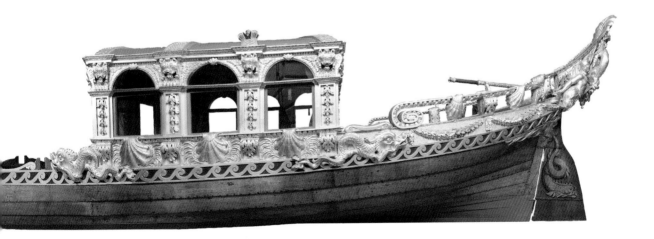

Marine timekeeper, 'H1'

John Harrison

This remarkable machine would never have been made had it not been for the good advice of the second Astronomer Royal, Edmond Halley. John Harrison (1693–1776) first came to London in the late 1720s with an idea for a longitude timekeeper. Halley encouraged Harrison to take his ideas to George Graham, then London's foremost clock, watch and instrument maker.

Harrison formulated his ideas during the construction of a series of highly accurate pendulum clocks made almost entirely of wood. By careful use of the material he was most familiar working with, he managed to make the clocks run without lubrication. A further innovation was his invention of the gridiron pendulum. By alternating brass and steel rods of differing length, he was able to create a pendulum that always remained the same length – even though the rods expanded in heat and contracted in cold. It was probably the invention of the gridiron pendulum that so impressed Graham and encouraged him to sponsor the construction of Harrison's first marine timekeeper.

This machine took Harrison around five years to make. Like his earlier pendulum clocks, the wheels were almost all made of oak. The clock was unique, both visually and conceptually. The twin balances moved in opposition to each other and thereby cancelled out the effects of any physical forces from the side. Their oscillation was maintained by Harrison's virtually frictionless grasshopper escapement.

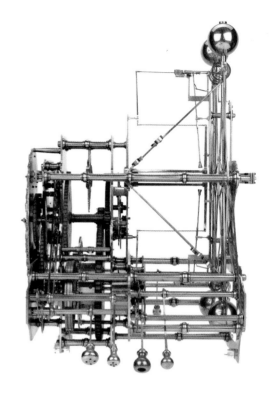

The machine met with the approval of London's scientific elite and a sea trial to Lisbon was arranged. The outward voyage was very rough and the timekeeper did not perform well. The return, however, was much calmer and Harrison used it to identify correctly the first sighting of land. Differentiating the Lizard from Start Point, he pinpointed the flotilla's position in relation to the hazardous Eddystone Rocks – correcting the navigator's reckoning by one degree and 26 minutes.

A certificate to this effect was presented in London to the Commissioners of Longitude, who agreed to pay Harrison to construct an improved timekeeper. Harrison continued to develop his ideas under their patronage for over 20 years. During this period he produced a further two large timekeepers and the watch, known as 'H4' (see page 78), which ultimately overcame the problems of keeping accurate time on a lengthy sea voyage.

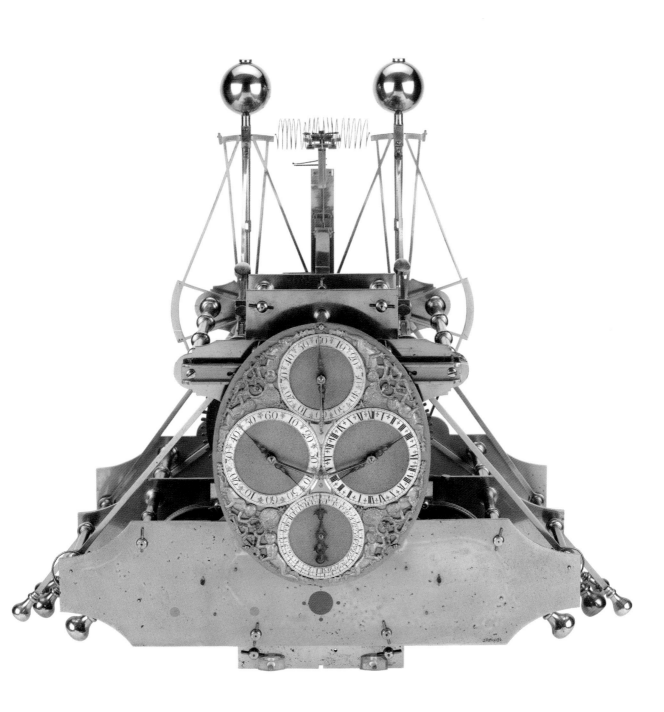

Barrow-upon-Humber, completed 1735
Brass, steel, oak, lignum vitae; 673 mm (height)
ZAA0034

Captain Lord George Graham in his Cabin

William Hogarth

This painting exemplifies the chief characteristics of one of the most important and innovative branches of Hogarth's art, the conversation piece. The pictorial format had its origins in relatively small-scale Dutch and French group portraiture, and typically shows groups of figures who have come together for a social or family occasion. Conversation pieces tend to show the male and female members of a single family, often with their relations, friends and servants, or to represent groups of male companions conducting business, socialising and occasionally carousing. The settings for such gatherings range from grand interiors and private parklands to public venues such as taverns. The setting of this painting, on board ship, is on current evidence unique in the artist's work.

Captain Lord George Graham (1715–47), an aristocratic naval officer, was the youngest son of the 1st Duke of Montrose. Seated in an elegant captain's cabin, Graham is shown on the right, surrounded by a group of male companions. Hogarth (1697–1764) represents him as a very dashing but somewhat detached individual, his silk turban cap at a jaunty angle, his red fur-lined cloak draped over his shoulders, while he puffs on his pipe and listens to a song. One of the ship's crew in the background sings to the tune played on pipe and tabor by the black musician on the right. Another more soberly dressed figure, the captain's secretary or companion, sits at the table opposite him, holding an open logbook with blank pages. His expression and manner suggests that he has been attempting to discuss the day's business with Graham, who seems instead to be preoccupied. On the left, a steward or cook, who looks out cheerfully at the spectator, approaches with dinner for the seated men; his concentration lapsing, he has failed to notice that the sauce from his dish is beginning to spill down the back of the man sitting directly in front of him.

As so often in his work, Hogarth integrates dogs into the narrative. One, sitting next to the secretary, howls along with the music, while another, bolt upright on a chair and wearing Graham's wig, is represented as another performer, playfully dressed up to sing from the sheet of music resting against an empty wine beaker.

The context for this complex and nuanced representation relates to a difficult period in Graham's short but active life. During the early 1740s, Graham had major disagreements with fellow officers during voyages, swiftly followed by a possible emotional breakdown. In which case, the efforts of his companions in Hogarth's painting, to entertain him with food, music and canine antics, are additionally meaningful as attempts to raise his spirits and furthermore to encourage him to reengage with his professional duties.

1742–44
Oil on canvas, 685 × 889 mm
BHC2720; Caird Collection

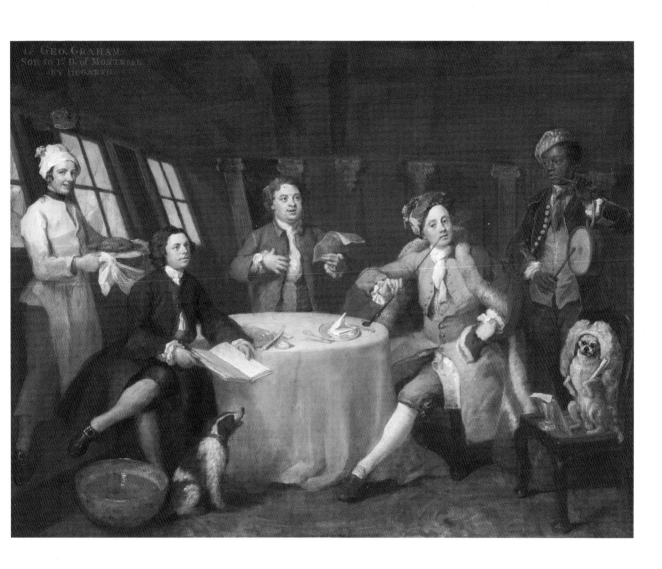

Greenwich Hospital from the North Bank of the Thames

Giovanni Antonio Canal (known as Canaletto)

Giovanni Antonio Canal (1697–1768), better known as Canaletto, was an Italian artist famed in Britain for his city views (*vedute*) of Venice, his birthplace, and imaginary views (*capricci*) based on it. During the eighteenth century, Venice was one of the cultural destinations in Italy, along with Rome and Florence, that formed part of wealthy travellers' standard itinerary on the Grand Tour. Canaletto's success with British tourists resulted in part from his elegant and atmospheric representations of famous Venetian sites and canals, which he packed with the details of everyday life. It also resulted from the agency of his great friend and patron Joseph Smith, a prosperous art connoisseur, who was British Consul in Venice from 1743.

When Canaletto arrived in London in 1746, he was very familiar with the artistic tastes and lifestyle of the British social elite, who were likely to be attracted to the Venetian artist's interpretation of their capital city. He remained in England for most of the next nine years. During this time, he produced a series of 48 English subjects, 35 of which were of London. These include numerous Thames views that incorporate significant landmarks, such as St Paul's Cathedral. Canaletto first painted Greenwich Hospital from the Isle of Dogs in the late 1730s when still in Venice, using a topographical print as a guide. This view of the Hospital may have been commissioned by Joseph Smith for his residence on the Grand Canal.

In comparison to his earlier depiction of Greenwich, the present painting has a more realistic low viewpoint and is a more accurate representation of the site. This strongly suggests that Canaletto visited Greenwich and sketched from the north bank of the Thames – a spot that is associated with the artist even to this day. Aside from any practical reasons for visiting in person, Canaletto was clearly aware of the artistic and architectural grandeur of Greenwich.

Canaletto creates variety in the composition by juxtaposing the symmetry of the classical façade with the asymmetric lines of the shipping

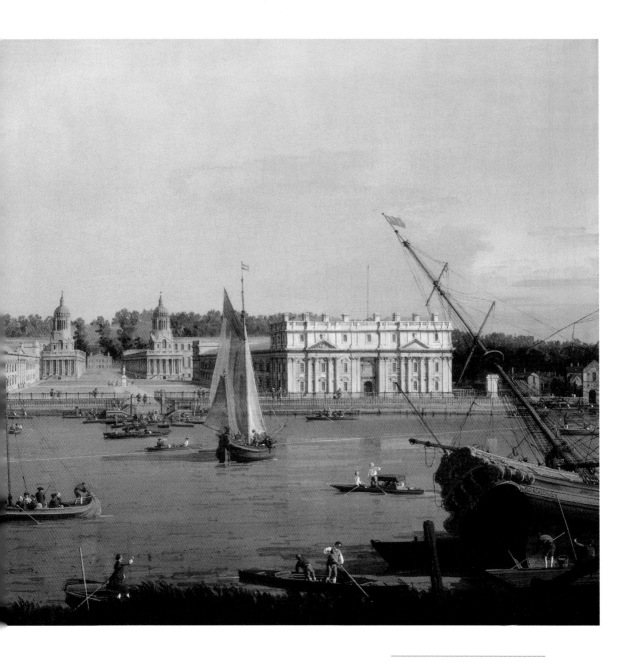

in the foreground. A variety of craft, including
Thames skiffs, are shown on the river, but
Canaletto also uses the visual devices of his
Venetian paintings, such as oars and poles, while
the vessel heeled over in the right foreground is
fancifully un-English. Finally, like other London
views, Canaletto has extended the distance of
the central vista and darkened the foreground to
contrast with the sunlit scene beyond.

1750–52
Oil on canvas; 686 × 1067
BHC1827; Caird Collection

Captain the Honourable Augustus Keppel

Sir Joshua Reynolds

During his early career in the 1740s in Plymouth Dock (now Devonport), Joshua Reynolds (1723–92) specialised in portraits of naval officers who lived locally. By the 1760s, he was the leading portrait painter working in Britain and in 1768 became the first President of the Royal Academy. This celebrated full-length portrait of Augustus Keppel (1725–86), Reynolds's lifelong friend and patron, launched the artist's London career in the early 1750s. This was in part due to his choice of sitter – an aristocrat and celebrated naval hero – and his portrayal of Keppel as a fearless man of action. It was painted immediately after Reynolds's return from Italy in 1752, having already extended a stay in Rome, then the ultimate destination of the aristocratic Grand Tour and a thriving hub for European artists. There Reynolds had immersed himself in classical and Renaissance culture, and in contemporary art. In 1749, he met and befriended Claude-Joseph Vernet, who was widely acknowledged as the most important French landscape and marine painter of his day, and whose influence can be clearly seen in this portrait of Keppel.

For those on the Grand Tour, the Italian artist Pompeo Batoni was to portraiture what Vernet was to landscape and marine art, and in Keppel, Reynolds might be said to have assimilated the practices of both. Keppel's pose is based on a seventeenth-century statue of the Greek god Apollo, itself a reference to the Apollo Belvedere, the revered classical sculpture that is emblematic of the art and architecture that Batoni incorporated into his portraits of Grand Tourists. Keppel is seen striding across a barren, rocky shoreline, as dramatically conceived as any storm scene

by Vernet or Willem van de Velde the Younger. According to the artist James Northcote, Reynolds's biographer, an incident in 1747 informed the narrative of this painting: Keppel's ship, *Maidstone*, in pursuit of French privateers, was wrecked off the coast of Brittany. The portrait thus neatly underlines the intimate connection between national rivalry, conflict and maritime disaster, while demonstrating how such dramatic themes could be visually exploited using the conventions of European marine painting. All the more so given that this was a deliberate change: X-rays show the original background was one of conventional classical architecture.

The effect underlines Reynolds's awareness of the viewer standing before this large-scale portrait – a consideration that is particularly pertinent since the work was displayed for many years in the relative intimacy of his London studio. There, visitors would have encountered the illusion of a life-sized figure of Keppel walking purposefully toward them out of the storm. The extent to which Reynolds was breaking new ground in his fusion of two highly successful but seemingly distinct strands of contemporary art becomes apparent when the Keppel portrait is compared with that of Commodore Augustus Hervey (1768–69, at Ickworth House, Bury St Edmunds) by Thomas Gainsborough. There the subject is shown as the epitome of the officer-gentleman, leaning on a ship's anchor and surrounded by the habitual accoutrements of naval portraiture first seen in Anthony van Dyck's seminal portrait of Algernon Percy, 10th Earl of Northumberland (1636, at Alnwick Castle, Northumberland).

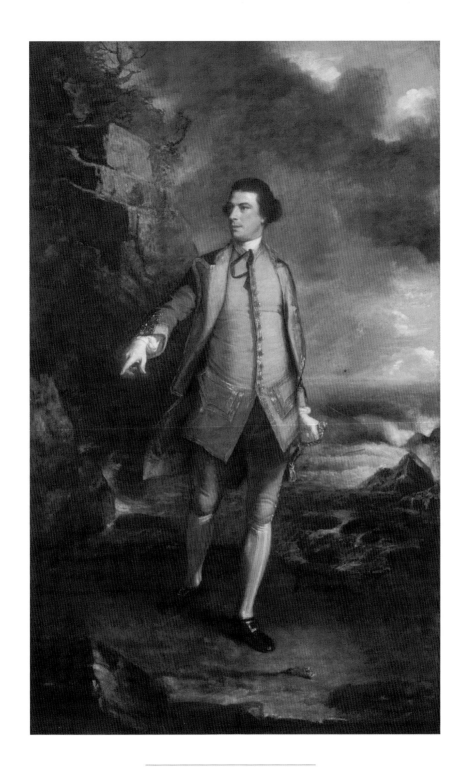

1752–53

Oil on canvas; 2390 × 1475 mm

BHC2823; Caird Collection

35

Sir Walter Ralegh

Johannes Michiel Rysbrack

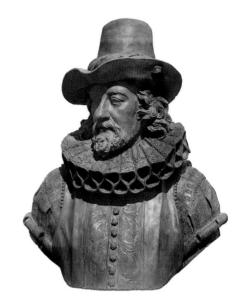

The Whig politician Richard Temple, the 1st Viscount Cobham, expended a great deal of time and money improving his house and estate at Stowe during the first half of the eighteenth century. This work was undertaken by the prominent designer William Kent and was to be a physical manifestation of Cobham's political creed: opposition to the prime minister, Sir Robert Walpole. Part of Kent's scheme was the construction of the Temple of British Worthies in 1734–35: a folly containing 16 niches to accommodate busts of individuals who, through thought or deed, embodied Cobham's beliefs. Two of the leading sculptors of the day – Michiel Rysbrack and Peter Scheemakers – divided the worthies between them, each sculpting eight. Rysbrack undertook the monarchs Elizabeth I and William III, the philosophers Francis Bacon and John Locke, the writers William Shakespeare and John Milton, the architect Inigo Jones and the mathematician and natural philosopher Sir Isaac Newton. Scheemakers was assigned Alfred the Great and the Black Prince, the explorers Sir Walter Ralegh and Sir Francis Drake, the poet Alexander Pope (a friend of Cobham's), the Tudor merchant and benefactor Sir Thomas Gresham, and the politicians John Hampden and Sir John Barnard. Above each niche an inscription set out the qualities of each individual, essentially explaining their inclusion. That above Ralegh reads: 'A valiant Soldier, and an able Statesman; who endeavouring to rouze the Spirit of his Master, for the Honour of

his Country, against the Ambition of Spain, fell a Sacrifice to the Influence of that Court, whose Arms he had vanquish'd, and whose Designs he oppos'd.'

This bust of Sir Walter Ralegh (1554–1618) was part of a similar suite of eight busts produced by Rysbrack for his client Sir Edward Littleton. Arranged in four pairs, they were part of the neoclassical decorative scheme for Teddesley Hall, his new house near Stafford. Ralegh was paired with Bacon (shown above); Oliver Cromwell, not Stowe worthy, was appropriately twinned with Milton; Shakespeare with Pope; and Newton with Locke. Littleton was also a politician, of rather undecided but vaguely Whig views. During his nearly 30 years as an MP, he spoke only once in the House of Commons, opposing the brick tax.

Johannes Michiel Rysbrack (1694–1770) was born in Antwerp but moved to London in 1720, aged 26, where he was known and signed himself as 'Michael'. He quickly developed a reputation as a sculptor of note, his work in terracotta being particularly praised. Its quality is ably demonstrated in this bust – a late example by him. Those of Bacon and Cromwell are also in the Museum's collection.

76

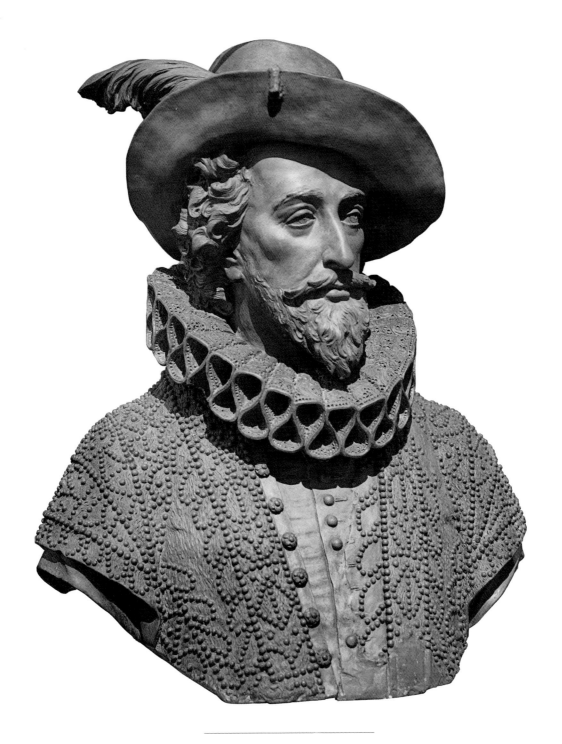

1757

Terracotta, 610 × 508 mm

SCU0043; Caird Collection

Marine timekeeper, 'H4'

John Harrison

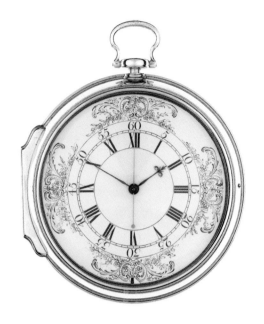

Looking at John Harrison's first four marine timekeepers, it is understandable to assume he developed his ideas in the first three and then somehow created a miniature version of his design. However, this is not the case. H4 represents a radical change in Harrison's approach to the problem, and its basic design is unrelated to the earlier timekeepers. Outwardly, compared to an average contemporary pocket watch, H4 is much larger. Behind the beautifully decorated enamel dial is a movement that, technologically speaking, is a close relation of the standard verge pocket watch movements of the day, but with some fundamental differences.

One change related to the balance – a smooth rimmed wheel that oscillates back and forth, controlling the speed of the watch. Harrison's design incorporated a balance with a larger diameter and a faster rate than average. With these adjustments, the balance had a higher stored energy when it was running and was therefore more resilient to external forces. Another concerned the remontoire mechanism, which rewinds the watch every 7.5 seconds. Harrison used this device in both H1 and H2. In H2 the remontoire rewinds around every 3¾ minutes, whereas in H3 it is every 30 seconds. This mechanism lessens the effects of engaging friction on the timekeeping and delivers a near-constant torque to the escapement, allowing for greater stability and accuracy.

These small technical innovations led to a dramatic change in the quality of the watch's timekeeping. Over the course of the 1764 trial to Barbados, it showed an error of only 54 seconds after 156 days. This incredible achievement demonstrated that a timekeeper could be made to serve as a reliable sea-going navigational instrument. But for John Harrison, it was not the end of the story. The Board of Longitude was unsatisfied that the watch's exceptional performance was not mere chance, so they asked for copies to be made to test whether or not the design could be replicated and perform just as well. The copy of H4 made by Larcum Kendall, known as K1, was taken on Captain James Cook's second voyage to the Pacific of 1772–75. Its performance helped to prove the viability of the timekeeper method of determining longitude. Cook referred to K1 as his 'trusty friend' and 'never-failing guide'.

H4 embodies a remarkable technical achievement that resonates with us today through its enduring influences in the design of modern mechanical watches. Moreover, it remains a testament to the strength of John Harrison's character. By the mid-1700s he was evidently very concerned about the practicality of his large, heavy and slow timekeepers: to be able to draw many years of work on them to a close and start afresh is truly inspirational.

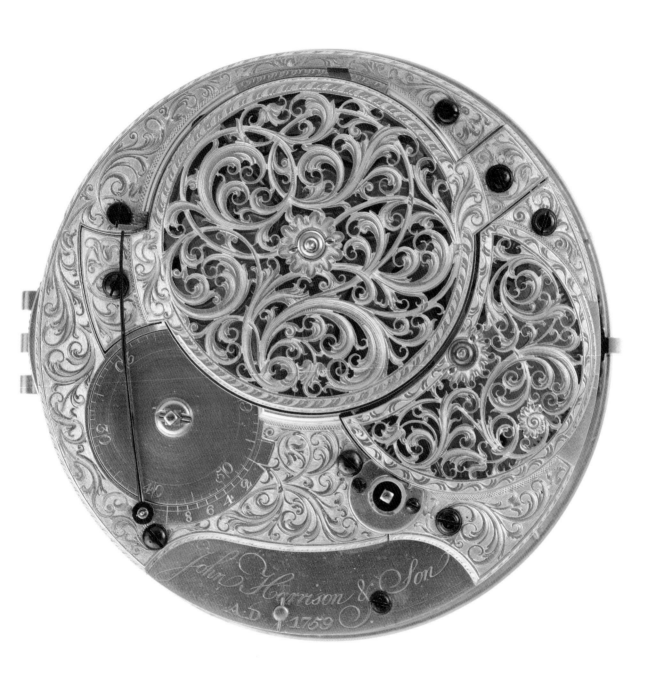

London, 1759
Silver, vitreous enamel, brass, ruby, steel, copper, diamond, glass; 132 mm diameter
ZAA0037

Model of the original figurehead of the *Victory*

Possibly by William Savage

Victory, Nelson's famous flagship, was launched in 1765, and this carver's model from the period shows the detail of the original figurehead. Its design is as much a political as an artistic statement, symbolising Britain's victory over France and Spain in the Seven Years War (1756–63). It makes reference to the global nature of the conflict and to Britain's expectation of peace and prosperity. At the top is a figure in classical dress, wearing a laurel wreath and armour. On the figurehead as built, this was the young George III, but the model shows an unidentified older man. Below is a carved shield bearing the Union flag, surrounded by cherubs' heads representing the four winds. According to the original written order these cherubs were shown 'gently blowing out successes over the four quarters of the globe'.

On the starboard side (shown right) is a figure of Britannia sitting on a triumphal arch, being crowned with laurels by a figure representing Peace. She steps on the defeated figures of Envy, Discord and Faction and is supported by figures representing Europe and America, and another holding a cornucopia. The British lion stands on top of trophies of war at the back of the arch. The port side (shown left) depicts the figure of Victory, supported by others representing Asia and Africa, trampling on Rebellion, represented by a hydra with five heads. Behind Victory is Fame with a crown, and beneath her a crowned escutcheon bearing the royal coat of arms. A further figure, holding compasses and a globe, represents Navigation.

This carving has long been attributed to William Savage (*fl.*1765–83), although direct evidence is elusive. The original Navy Board contract for the carved figurehead was given to the Chichley family. Richard Chichley was Master Carver at Chatham and Sheerness Dockyards from 1713 to 1770, and was assisted by Abigail Chichley (most likely his wife) and Elizabeth Chichley (probably his daughter). The records show that Richard was in partnership with Elizabeth from 1764, before they took on William Savage to assist when they secured the contract for *Victory*'s carved work on 14 August 1765. Part of the original contract stipulated that the carvers produce 'a very rich model of the head piece of the Victory done in clay', for which the Navy Board paid £15. That model and who made it are no longer known, but it is possible that this carving was copied from it or, if made at a later date, from the ship, which remained laid up in reserve at Chatham until it was first fitted for sea in 1777. After *Victory*'s rebuild, 1800–03, it was fitted with the much simpler figurehead design that adorns the ship's bow today.

Probably Chatham, c.1765
Scale: 1:24 (½-inch to the foot)
Boxwood; 200 × 65 × 80 mm
SLR2530; Caird Collection

Nevil Maskelyne's observing suit and his wife Sophia's purple silk brocade dress

Keeping warm while watching the stars during cold, clear nights is a constant challenge for all astronomers, but for the fifth Astronomer Royal Nevil Maskelyne (1732–1811) this eighteenth-century thermal suit made his work more bearable. Maskelyne arrived at the Observatory in 1765 and began the laborious task of measuring the positions of the stars to help navigators determine their longitude (east–west) position at sea. Each clear night, he and his assistant would observe the required stars through a telescope set up on a meridian (north–south line), patiently listening for the beat of the nearby clock to time the precise moment at which the star crossed the field of view. This red and yellow quilted suit, made from Indian silk and lined with wool, linen and cotton wadding, offered much-needed insulation from the cold, while additional padding on the seat of the trousers must have helped the astronomer endure many hours on the telescope's observing chair. Despite the hardship of the observations, the effort was certainly worthwhile: once the data had been reduced and published as the *Nautical Almanac*, navigators could calculate their longitude within half an hour, rather than several hours.

As Astronomer Royal, Maskelyne was required to live on-site at the Observatory and the 'dwelling rooms' of Flamsteed House became his home. But his lifestyle changed significantly during the summer of 1784 when he attended the wedding of his cousin, the Reverend Sir George Booth, to Miss Letitia Rose, a young woman from Northamptonshire. Acting as a witness to the ceremony, Maskelyne met the bride's sister, Miss Sophia Rose (1752–1821), and within a month, the astronomer and Sophia held their own wedding at St Andrew's, Holborn on 21 August 1784. The elaborate brocade dress shown here was most probably worn by Sophia on her wedding day. The style was an old-fashioned choice for 1784, perhaps as a consequence of Sophia's limited funds at the time of her marriage. Given the expense of purchasing silks during the late Georgian period, it is highly likely that Sophia repurposed an existing dress, extending its lifespan afterwards by wearing it as an evening gown and replacing worn sections with spare brocade panels. As wife of the Astronomer Royal, however, with a more secure income, Sophia could indulge in her love of fashion and subsequent portraits clearly illustrate how she endeavoured to keep up to date with the latest trends.

The newlyweds returned to live at the Observatory and a year later Sophia gave birth to their daughter, Margaret, who was named after her aunt Margaret, Lady Clive. Maskelyne kept meticulous records of Margaret's development, from her first steps and weaning through to childhood illnesses and her education, providing us with a detailed glimpse into the domestic world of the Observatory during the Georgian period. The family continued to live at Greenwich until Maskelyne's death on 9 February 1811, after which Sophia and Margaret relocated to the family estate in Wiltshire.

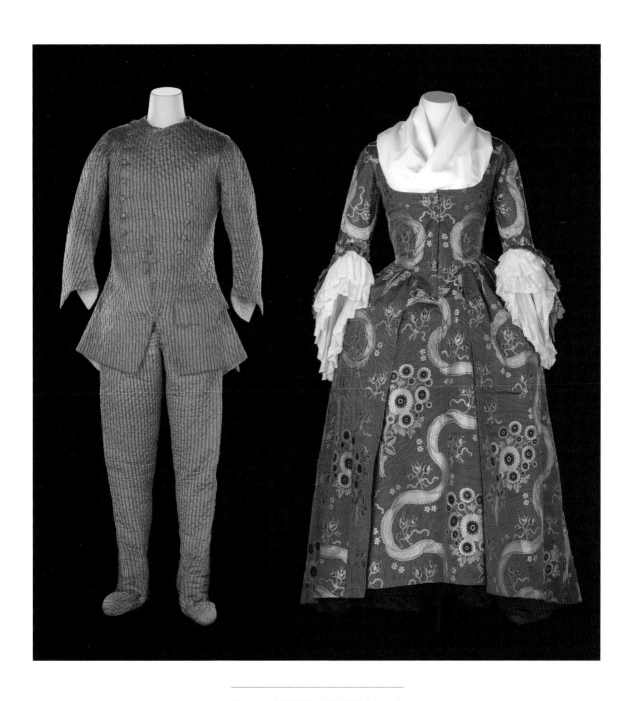

England, 1765 (suit); 1784 (dress)
Suit: Wool, silk, linen, cotton; 1600 mm
Dress: Silk brocade, lace; 1420 mm
ZBA4675–6, ZBA4678

The log of the *Betsey*

Nicholas Pocock

Nicholas Pocock (1740–1821) was born in Bristol, where his father was a merchant seaman. At 17, Nicholas joined him at sea but his father died two years later and he was then apprenticed to a prominent Bristol merchant. By 1766 Pocock had made several voyages to Charleston, South Carolina as captain of the *Lloyd*. At the age of 30, Pocock took command of the *Betsey* and was sent to a new destination, the Italian port of Leghorn (Livorno), a major Mediterranean trading centre.

The log of the *Betsey* is one of many in the Caird Library. A ship's log is an administrative document with daily entries noting course, distance, speed, weather conditions and events such as illness or punishments among the crew. But for Pocock, the log became more than a means of recording voyage details. Almost every day he painted a small watercolour of the *Betsey*, showing that what occupied him most was not record-keeping but his emerging talent as an artist. The quality of these illustrations is excellent, capturing movement, light and weather in a way that conveys far more than the statistical entries crowded around them.

The log records that the *Betsey* left Bristol on 28 February 1770 but got no further than Cork before being delayed by winter weather: 'Strong gales at ENE with snow and rain. Employed clearing the Hold. Continued till 17 March, when we unmoored ship, but the wind faltering and veering to the eastward, could not get out.' When at last the *Betsey* was able to sail a few days later, the log records a tragic accident: 'A sudden gust or whirlwind carried away our Foretop mast

and William Gillen, who was furling the Foretop gallant sail, was drowned.' The voyage was far from swift: it took nearly a month to reach Cadiz and 24 more days were spent at Gibraltar; more than three months after leaving Bristol, the *Betsey* arrived at Leghorn. A further 40 days were occupied taking on cargo before returning to Greenhithe some 50 days later. All told, the round voyage took nine months.

While navigating the Mediterranean, Pocock was also clearly developing his pictorial skills. Though he never painted people or shipboard activity, every image of the *Betsey* is almost alive: sometimes becalmed with sagging sails, at others heeling with the wind or riding heavy swells. Though Pocock left his life at sea to set up as an artist in 1778, a chance comment on his work by Joshua Reynolds advised him to 'carry his palette and pencils to the waterside' and develop his talent for marine art. He went on to do hundreds of oil paintings, watercolours and other drawings, becoming much in demand for his accurate and lifelike representations of naval actions. The log of the *Betsey* might be a record of a slow and tedious voyage to Italy, but it was also the drawing board of some of the best images we have of life at sea in the eighteenth century.

Written and drawn at sea, 1770
Manuscript and wash on paper, leather-bound; 320 × 220mm
LOG/M/3

Bellona, third rate, 74 guns

Thomas Burkett and William Thompson

It is possible that this model of the *Bellona*, a 74-gun third-rate ship of the line, was shown to George III by the Admiralty in order to raise his interest and secure funding for the programme to copper the hulls of the British fleet. The protection of underwater hulls from marine boring molluscs (shipworm), barnacles and weed growth, which adversely affected sailing quality, was an age-old problem. For the Royal Navy, this required warships to be regularly dry-docked for expensive maintenance. However, by the early 1760s, it was discovered that cladding hulls with copper plates largely solved these problems. Nevertheless, the projected expense of coppering the entire fleet was enormous.

Although there is no direct proof that this model was used to demonstrate the process to the king, Sir Charles Middleton, Comptroller of the Navy and the driving force behind the coppering project, later wrote: 'I was convinced in my own mind that we might with safety copper the bottoms of every ships in the fleet ... I proposed it privately to Lord Sandwich ... I afterwards accompanied his lordship to Buckingham House and explained the whole process in so satisfactory a manner that he [George III] conceived it at once and ordered it to be carried into execution.' He may also have had the model available by then, since he was certainly its owner at an early stage and the Museum eventually acquired it from his descendants in 1977. Fascinatingly, and only recently, examination of the interior using a flexible endoscope discovered an original note glued inside. This identifies the previously unknown makers as Thomas Burkett and William Thompson of Chatham Dockyard, and shows the model was built in 1759, at the same time as the ship. It is only likely to have been coppered in the 1770s, and turning it into a demonstration item for Middleton could have been the reason. The fact that its base also has handles, making it easy to carry, is further support for this, and it is certainly one of the earliest surviving models to show coppering. The king was also an early witness of this being done on a ship: on 8 May 1778, during a visit to Portsmouth, he was taken 'under the bottom of a frigate of 28-guns, to see the workmen sheathe her with copper, where His Majesty staid near half an hour'.

The model is set on a slipway ready for launching and made in the 'Georgian' style showing the actual colour scheme and elaborate carved decoration for a warship of this period.

Chatham, 1759–76
Scale: 1:38.4 (or ⁵⁄₁₆-inch to the foot)
Fruitwood, varnish, bone, cotton, copper, brass, mica, compo,
gravel, paint, ivory; 560 × 1600 × 370 mm
SLR0338

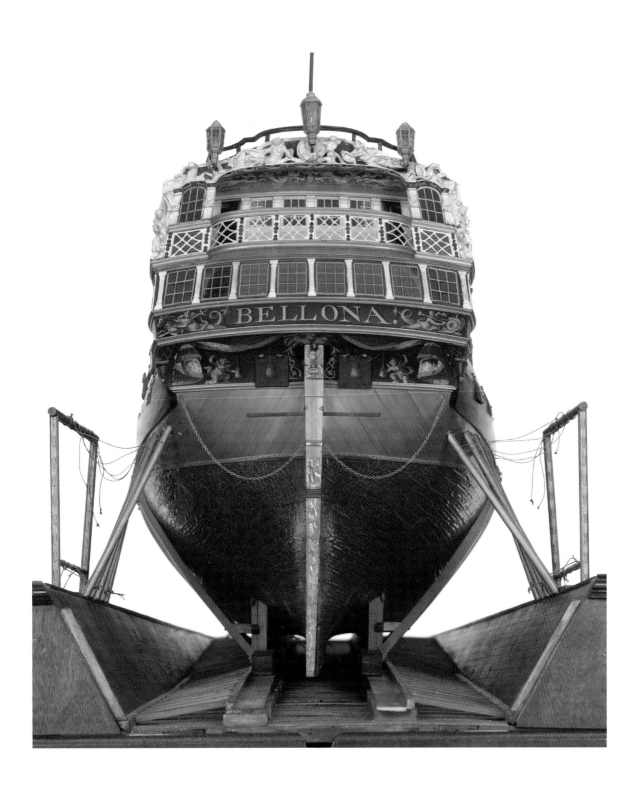

The Kongouro from New Holland

George Stubbs

'Kangaroo' and its pendant painting 'Dingo' were commissioned by the gentleman-scientist Joseph Banks following his participation in James Cook's first voyage to the Pacific (1768–71), which was also the first British voyage devoted exclusively to scientific discovery. They are the earliest painted representations of these animals in Western art.

Cook's *Endeavour* voyage, and the two that followed, ushered in a new era of maritime exploration that had a profound impact on the cultures, politics and societies of both explorers and explored. All three voyages produced significant scientific results. However, it was the dramatic revelations of new lands, species and peoples from the first that captured the imagination of both the general public and the scientific community. The scientific focus and outcomes were due in large part to Banks, whose personal entourage included two artists, Alexander Buchan and Sydney Parkinson. Both died during the voyage but Parkinson produced over 800 drawings of people, plants and animals.

Banks's decision to engage George Stubbs (1724–1806) on his return in 1771 is testimony to the artist's reputation as the foremost animal painter in Britain. Stubbs's equestrian portraits may be better known today but the artistic importance of his 'exotic' subjects cannot be overestimated. 'Kangaroo' and 'Dingo' are the only painted portraits by Stubbs of animals native to Australia, and the only ones not based on live (or dead) examples. Lacking either, he worked from written and verbal descriptions provided by

Banks himself and, in the case of the kangaroo, a small group of slight pencil sketches made by Parkinson and a stuffed (or inflated) pelt that Banks had brought back.

Banks's decision to employ such a celebrated animal painter, renowned for his scientific methods, intentionally helped give the discoveries of Cook's first voyage the kind of cultural significance only achievable through the public display and dissemination of great works of art. Capitalising on the topicality of the voyage and the novelty of his subjects, Stubbs exhibited both paintings at the Society of Artists in London in 1773. This brought immediate public attention to the two previously unknown animals. Later in 1773 an engraving after Stubbs's 'Kangaroo' was included in John Hawkesworth's best-selling account of recent Pacific voyages. From 1777, Banks housed his ever-expanding collections of specimens and associated artwork in 32 Soho Square, London. Here too he displayed the 'Kangaroo' and 'Dingo' and the portrait of Captain Cook by Nathaniel Dance (see page 96). This house essentially became a museum and research institute, where scientists and politicians from across Europe would meet.

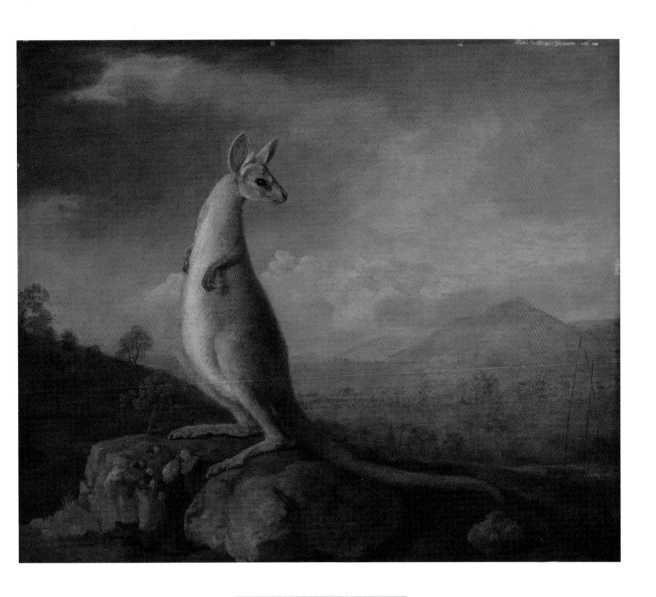

1772
Beeswax on mahogany panel, 605 × 715 mm

ZBA5754; acquired with the assistance of the Heritage Lottery Fund; The Eyal and Marilyn Ofer Foundation
(formerly known as the Eyal Ofer Family Foundation); The Monument Trust; Art Fund (with a contribution
from the Wolfson Foundation); The Crosthwaite Bequest; The Sackler Trust; Sir Harry Djanogly CBE;
The Hartnett Conservation Trust; Sheila Richardson and Anthony Nixon; The Leathersellers' Company;
Gapper Charitable Trust; Genevieve Muinzer and others.

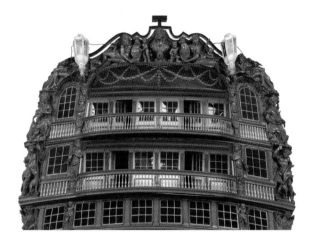

42

Royal George, first rate, 100 guns

Thomas Burroughs and Joseph Marshall

When the 4th Earl of Sandwich became First Lord of the Admiralty in 1771, one of his priorities was to get George III more interested in the Royal Navy. Sandwich organised visits to the dockyards and the fleet, and he also commissioned models for the exclusive use of the king and his eldest son.

In 1772 the Admiralty gave orders for 'a model to be forthwith made of a section of the *Royal George* lengthways': this is the resulting model, and it is probably the finest example of eighteenth-century model making. The model is fully planked on the starboard side, while the port side is without planking to show the internal layout and numerous fittings such as galley stoves, capstans and cabin furnishings.

Models such as this were prized not only for their beauty but also for their technical accuracy, which Sandwich knew they would appeal to the king's enquiring mind and love of craftsmanship. George III showed great interest in the arts and sciences, having already amassed a notable collection of paintings and scientific instruments. Sandwich wanted to direct some of this curiosity towards the Navy, whose dockyards were struggling to keep up with the increasing demand for ships. During a visit to review the fleet at Portsmouth in 1773, the king said he wished to

'form some idea of the wonderful mechanism that is concerned in forming the amazing machines that float on the sea'.

No expense was spared on this model. It is of the highest quality and attention to detail. The friezes along the bulwarks were painted by the artist Joseph Marshall and the carved decoration was by Thomas Burroughs, master carver to Deptford Dockyard. Not surprisingly, the model took five years to build and was finally presented to George III in July 1777.

Launched in 1756, the *Royal George* was Admiral Hawke's flagship at the Battle of Quiberon Bay in 1759. As a first rate, it was one of the largest ships in the Navy, carrying 100 guns on three decks. In 1782 the *Royal George* sank accidentally at Spithead while being repaired with the loss of around 900 lives, including women and children visiting seamen on board. Among those drowned was Rear-Admiral Kempenfelt, who became trapped in his cabin as the ship listed. The disaster prompted William Cowper's celebrated poem, 'Toll for the brave'. William IV presented the model to the Royal Hospital for Seamen at Greenwich in 1830.

Woolwich, 1777
Scale 1:48 (¼-inch to the foot)
Wood, bone, mother of pearl, brass, silver, mica, paint, varnish, gilt; 440 × 1400 × 340 mm
SLR0336; Greenwich Hospital Collection

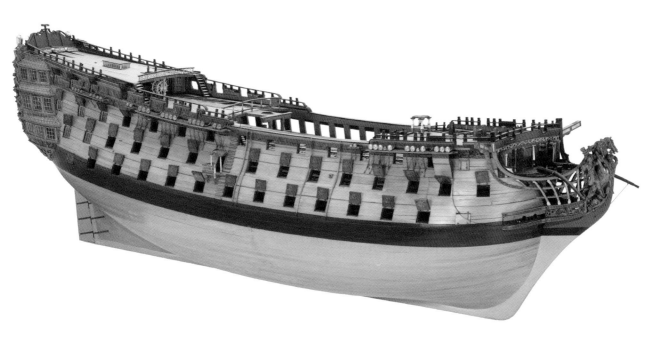

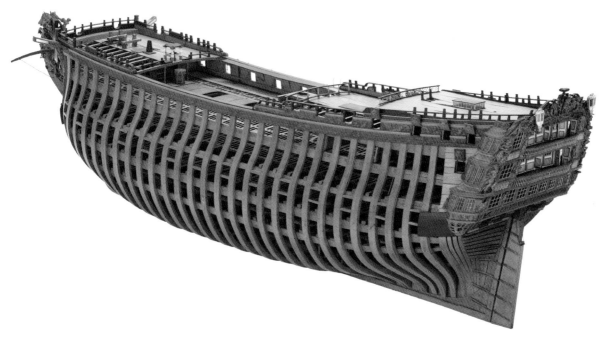

43

Album of watercolours

Gabriel Bray

Between 1774 and 1777, the *Pallas*, a 36-gun Royal Navy frigate, made two voyages to West Africa to protect Britain's slave-trading interests, inspect British forts in the region and survey the coast. On board was Lieutenant Gabriel Bray (1749–1823), who produced a series of watercolours depicting his experiences on the voyages from shore life at Portsmouth to shipboard activity and encounters with the people and landscapes of West Africa. The result is an intriguing and unique group of 75 sketches that were later assembled in an album, but apparently not by Bray himself.

Naval officers learned to draw as part of their training. Committing coastal profiles to paper was an important part of survey work and they were later printed on official charts as an aid to navigation. Bray's sketches, however, are the entirely personal visual 'memoranda' of a habitual amateur artist painting for pleasure. They display a keen observational eye, capturing moments of humdrum routine and individuals forgotten to history, like watermen and shopkeepers at Portsmouth Point, seamen fishing off the ship's guns and portraits of the crew at off-watch moments of leisure below deck. There are also self-portraits of Bray shaving and painting with his watercolours set before him (shown above). While his landscapes of West Africa are competent, if conventional, his portraits of local people show a fascination with cultures he encountered. For instance, he drew a series of African heads, showing different styles of braided hair and facial adornment along the coast.

Bray was born in Kent in 1749 and joined the Navy aged 15. He spent the next six years serving in a series of ships and passed his examination for lieutenant in 1770. Opportunities for promotion were rather limited in peacetime, but a chance occurred in 1773, when he was serving in the Royal Yacht *Augusta* during George III's first review of the fleet at Portsmouth. The budding artist sketched the scene and spent the night working it into a finished state. The next day he presented it to the king, which 'occasioned his Majesty on seeing it to promote him' to lieutenant. The ability to draw certainly had benefits beyond surveying.

1774–77

Paper, graphite ink and wash; various sizes

PAJ1976–2049; purchased with the assistance of the Society for Nautical Research Macpherson Fund, 1991

A View of Cape Stephens in Cook's Straits with Waterspout

William Hodges

At the age of 14, William Hodges (1744–97) was articled for seven years as apprentice and assistant to Richard Wilson, the leading British landscape painter of the day. Wilson's landscapes, in the classical grand style, had a profound influence on Hodges throughout his career. In 1772, he was appointed by the Admiralty as an official artist accompanying Captain James Cook's second voyage to the Pacific (1772–75), in search of *Terra Australis*, the fabled Great Southern Continent. His primary task during the voyage was to record the societies and places encountered. He made numerous drawings of coastlines, landscapes – typically in the form of coastal profiles and topographical sketches – as well as people, including portraits. He also produced some *plein-air* compositions in oils, mostly on a small scale. Hodges's famous portrait of Cook in naval captain's undress uniform, also in the Museum's collection, may have been begun while at sea. On his return, Hodges was employed by the Admiralty, both to work up his sketches for Cook's official account, first published in 1779, and to paint further pictures – a number on a grand scale – for display in Admiralty buildings in Whitehall. These tasks occupied him until late 1778. In addition, Hodges produced versions of compositions, such as 'Tahiti Revisited', that were exhibited at the Royal Academy and other contemporary art forums. In 1779, Hodges travelled to India under the patronage of Warren Hastings, the first Governor General, and with the full support of the East India Company.

Like those of India, the images that Hodges produced during and after Cook's second voyage would influence British perceptions of the people, culture and landscapes for many decades to come. It is important to appreciate, therefore, that his finished works of art deliberately strike a balance between accurate observation and an artistic objective learned from Richard Wilson and the example of seventeenth-century European masters, such as Claude Lorrain, Gaspard Dughet and Salvator Rosa. This was to imbue the art of landscape and marine painting (and by extension voyage and exploration) with the grandeur of the religious and mythological epic. His large, ambitious coastal scene of Cape Stephens, on the north-west entrance to Cook Strait, New Zealand, is the best example of this aim. Hodges melds his real-life experience of the rare and terrifying maritime phenomenon of a waterspout with a classically composed representation that also incorporated artistic conventions associated with 'the sublime'; that is, elements calculated to inspire awe and terror in the viewer. Here these include the dramatic contrasts of light and dark seen with the luminous whiteness of the waterspout juxtaposed above and below by the inky blackness of sky and sea, and the vulnerability suggested by Cook's ship, which is shown dwarfed and buffeted by the overwhelming scale and power of the natural world. The painting is one of a set of four of the same size created as a result of the voyage, all of which are now at Greenwich.

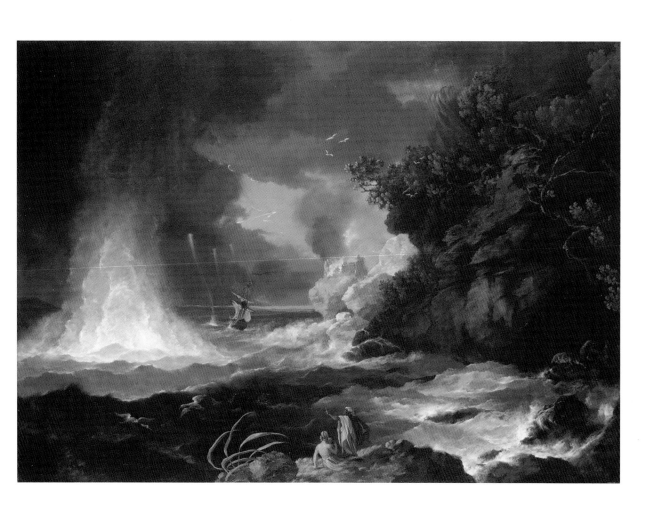

1776
Oil on canvas; 1359 × 1930 mm
BHC1906

Captain James Cook

Nathaniel Dance

In 1755, James Cook (1728–79) enlisted as an able seaman in the Royal Navy. He was 26 and had spent the previous nine years employed in the coal trade, plying up and down the east coast of England through the treacherous waters of the North Sea. This experience taught Cook much about seamanship and navigation, serving him well in his extraordinary career to come. He quickly rose to the rank of master and began to interest himself in hydrographical surveying, undertaking a survey of the St Lawrence River that proved important in the British capture of Quebec in 1759. In the early-1760s this led to a major survey of the coast of Newfoundland, which produced high-quality and accurate charts for the Admiralty. In 1767, Cook was appointed commander of an expedition to observe the transit of Venus from Tahiti. The following year, he set off in the *Endeavour* on the first of his three famous voyages to the Pacific. The transit was duly observed and Cook then made surveys of New Zealand and the previously unknown east coast of Australia. Banks and his team found flora and fauna new to European science, taking specimens and recording their discoveries. The expedition was a major success and the published voyage narrative became a best-seller, sealing Cook's reputation.

This portrait was commissioned by Joseph Banks and shows Captain Cook after the second voyage of 1772–75. This voyage also circumnavigated the globe, frequently at high southern latitudes, to dispel the myth of a great southern continent. Cook's resulting charts, one of which he proudly holds, successfully disproved the idea. Cook sat to the artist Nathaniel Dance (1735–1811) 'for a few hours before dinner' on 25 May 1776. It is not known whether there was another sitting but, in any case, Cook left London on his third Pacific voyage on 24 June that year, never to return. The portrait hung in the library of Banks's house in Soho Square, London, along with George Stubbs's paintings of a kangaroo and a dingo, both sighted by Cook on the first voyage. In 1829, following the death of Banks and his widow, the portrait was presented to Greenwich Hospital and displayed in the Painted Hall, where it was seen by Cook's widow Elizabeth.

On 14 February 1779, Cook was killed in a violent encounter with Hawaiian islanders. His legacy is complex. The scientific work he undertook and helped to facilitate while exploring the vast ocean transformed Western understandings of the world. But his encounters with indigenous people were not always friendly – often far from it – leaving powerful memories of loss and resentment. European involvement in the region after Cook's voyages did little to heal these wounds.

1776

Oil on canvas; 1270 × 1016 mm

BHC2628; Greenwich Hospital Collection

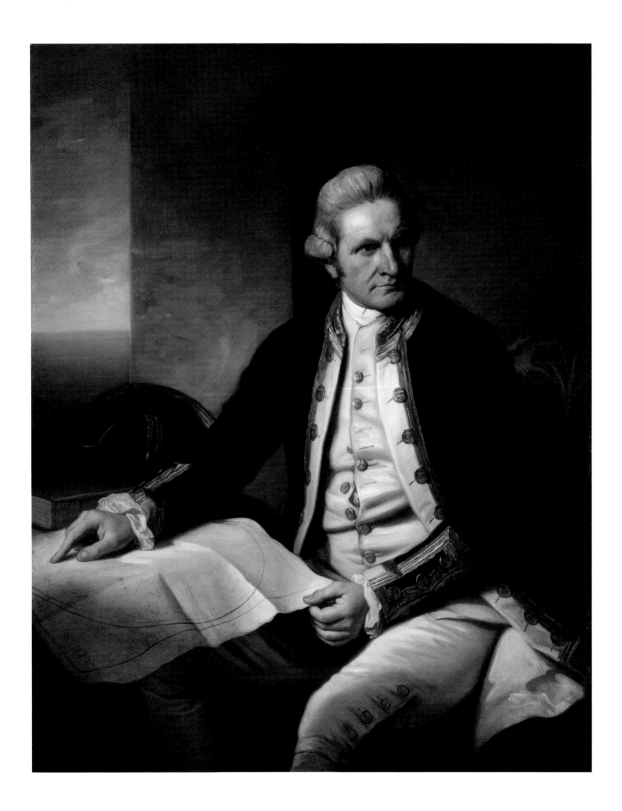

The Atlantic Neptune

J.F.W. Des Barres

Published in 1779, this chart of New York Harbour is one sheet of *The Atlantic Neptune*, a four-volume atlas that embodies British colonial and surveying ambitions in the eighteenth century. The story of *The Atlantic Neptune* goes back to the conclusion of the Seven Years War in 1763, when Britain's territories in North America greatly expanded. This extension of empire brought with it an impulse to survey, to enable better navigation along colonial coasts. The Swiss-born surveyor Joseph Frederick Wallet Des Barres (1721–1824) was tasked with managing a survey of Nova Scotia, and he gathered existing charts of North America at the same time.

Des Barres returned to London in 1774, bringing with him the most extensive collection of charts and surveys of British North America ever compiled, and set to work getting support from the Admiralty for the publication of his monumental atlas. As tensions between Britain and 13 of its American colonies mounted, the British desire to have reliable charts of the North American coastline increased. The Admiralty gave its financial support and the charts of *The Atlantic Neptune* were supplied to the Royal Navy immediately after printing.

This chart of New York Harbour was produced in the middle of the War of American Independence. From September 1776, following the Declaration of Independence, British troops were stationed in New York, which was used as a base for further operations in North America. After the alliance between France and the fledgling United States in 1778, New York became even more strategically important as a naval base for attacks on French and American vessels. That same year, Lieutenants John Knight and John Hunter found time between harassing enemy ships to measure the angles and the depths that were used to construct this chart. Four years after it was first published, the war ended and the British finally withdrew from New York.

With their detailed coastal profiles, which give a mariner's eye view of important features, and playful *trompe-l'oeil* arrangement, the charts of *The Atlantic Neptune* are also remarkable for their style. The engraving of the copper plates from which it was printed was so fine that in 1784, when the work was completed, a French journal declared it 'one of the most remarkable products of human history that has ever been given to the world through the arts of printing and engraving'. Commissioned before, and completed after the War of American Independence, *The Atlantic Neptune* is a document of Britain's changing relationship – as a colonial power (which it remained in Canada), an enemy force, a defeated foe and a trading partner – with the North American continent.

Des Barres was a remarkable character, whose final post was as Governor of Cape Breton and Prince Edward Island. He is reported to have marked his 100th birthday by dancing on the table and died just short of 103.

London, 1779
Paper; 815 × 605 mm
HNS146B; Caird Collection

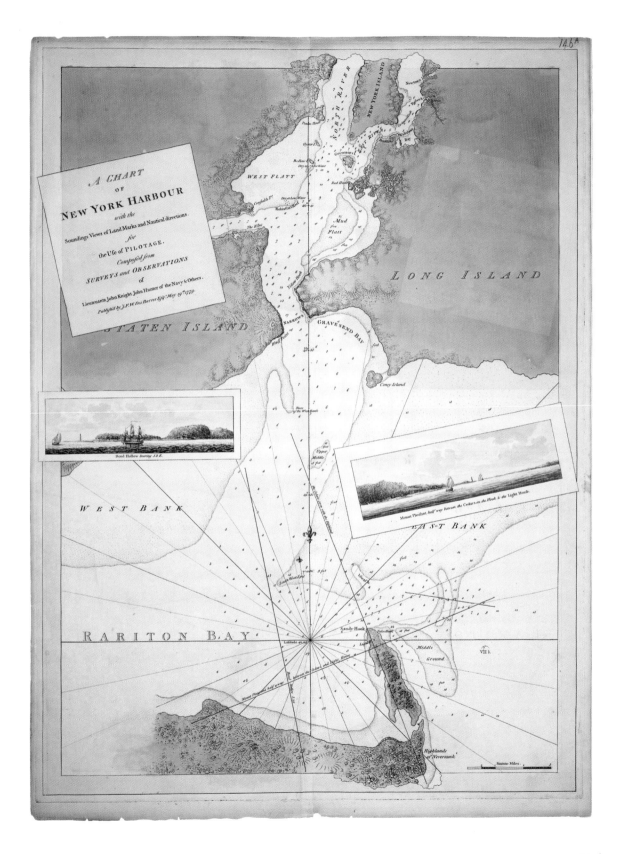

A CHART
OF
NEW YORK HARBOUR
with the
Soundings Views of Land Marks and Nautical directions.
for
the Use of PILOTAGE.
Composed from
SURVEYS and OBSERVATIONS
of
Lieutenants John Knight, John Hunter of the Navy & Others.
Published by J. F. W. Des Barres Esq.r May 19.th 1779.

NORTH RIVER

NEW YORK ISLAND

EAST RIVER

Newtown

LONG ISLAND

WEST FLATT

Mud Flatt

STATEN ISLAND

NARROWS

GRAVESEND BAY

Coney Island

Bond Hollow bearing S.b.E.

Mount Pleasant half way between the Cedars on the Hook & the Light House.

WEST BANK

EAST BANK

RARITON BAY

Sandy Hook

Middle Ground

Latitude 40.28.

Mount Pleasant half way between the Cedars and Light House.

Highlands of Neversink

Statute Miles

Domestic medicine: or, a treatise on the prevention and cure of diseases by regimen and simple medicines

William Buchan

The Museum's Caird Library and Archive is the most extensive maritime reference resource in the world. It contains over 100,000 books, around 8,000 of which are classified as 'rare'. These include all those published before 1850, which are scarce or whose provenance makes them unique. Among these is this copy of an eighteenth-century medical book by Scottish physician William Buchan (1729–1805). It ran to well over 100 editions in English, was translated into several European languages, and was the most popular medical book of its day. In it, Buchan sets out the rules for living a healthy lifestyle, and describes specific diseases and how to cure them. Scurvy, for example, is said to be 'occasioned by cold moist air, by the long use of salted or smoke-dried provisions, or by any kind of food that is hard of digestion'.

This otherwise unremarkable copy, which is bound in sail-cloth, found its way into the Caird Library because of its fascinating provenance. It was on board the *Bounty* during the famous mutiny led by Fletcher Christian on the morning of 28 April 1789. After this notorious event, the mutineers spent nine months searching for somewhere to settle. They returned to Tahiti, where some remained and were later captured: four died before reaching home, where all were tried and

three hanged. The rest sailed with Christian and some Tahitians to Pitcairn. It was nearly 20 years before they were discovered in February 1808. By then only one, John Adams, was still alive, with some of the Tahitian women and the children the mutineers had by them.

A hand-written note in the book, dated 23 December 1787, gives the *Bounty*'s location as Spithead: this was the day it finally sailed from there. The crossed-out signature of Thomas Huggan, the ship's surgeon, is on the title page. Huggan died on Tahiti before the mutiny, when the book and all his other medical kit was taken over by surgeon's mate Thomas Ledward, as acting-surgeon. He in turn lost it all in the mutiny and later drowned, after surviving the *Bounty* launch voyage, when the Dutch ship carrying him home vanished in the Indian Ocean.

The mutineers' descendants on Pitcairn sold or exchanged belongings with passing ships and this is how the book came to leave the island. A letter inside from Charles Blackett, dated 1884, gives its provenance and says he bought it on Pitcairn in 1837, when he was a midshipman. He also says that the 'book was in the possession of Fletcher Christian one of the mutineers until the time of his death' in 1793.

His Britannic Majesty's
Ship Bounty: Spithead,

23rd December 1787

T O

Sir JOHN PRINGLE, Bart.

PHYSICIAN TO HER MAJESTY.

S I R,

THE character which you juftly fuf-
tain in the literary world, your laud-
able and fuccefsful endeavours to extend
and improve the art of Medicine, the con-
fidence repofed in your fkill by the Public,
and the important ftation you hold in the
care of the Royal Family, all confpire to
point you out as the moft proper Patron
of a Performance which has for its object
the HEALTH of the inhabitants of Great
Britain.

A 2 THESE,

London: W. Strahan, T. Cadell, J. Balfour and W. Creech, 6th edn, 1779
Printed paper, leather binding, wrapped in sailcloth
PBD6069

Emma Hart (later Lady Hamilton)

George Romney

Emma Hart (1765–1815) met George Romney (1734–1802) in April 1782: she was 16 and a statuesque beauty; he was 47 and reaching the height of his powers as a leading portraitist. Over the next four years, Romney painted Emma in scores of portraits, responding to her allure and extraordinary ability to occupy a range of different allegorical, mythological and literary personas. As Romney's captivating muse, Emma became the artist's principal focus, sometimes to the cost of other commissions, but his portraits of her were the most vivid from the later part of his career. Although Emma's departure for Naples in 1786 hit Romney hard, he continued to paint her from sketches and from memory. The two were reunited, albeit briefly, when she travelled back to London in 1791 for her marriage to Sir William Hamilton, the British envoy in Naples. Returning to Italy as Lady Hamilton, she left Romney for the last time: although surrounded by Emma's likeness in his studio, he would never see her again. Often believed to be Emma as Ariadne, the daughter of King Minos of Crete in Greek mythology, it is now

thought that her pensive pose connotes absence. It is likely that Romney painted it from memory or using sketches rather than from life.

Emma's life in Naples changed in 1798, when she met (for the second time) Horatio Nelson in the aftermath of his famous victory at the Battle of the Nile. Despite both being married, they embarked on a rather public affair and their daughter, Horatia, was born in 1801. It is likely that the couple exchanged gold rings before Nelson's return to sea in 1805. (Nelson's ring is shown above; the other, which belonged to Emma, is in the collection of the National Museum of the Royal Navy in Portsmouth.) Nelson was wearing this ring at the Battle of Trafalgar when he was shot and fatally wounded. After his death, Emma's life began to unravel. Denied the government pension Nelson hoped she would receive, she fell into debt. Merton Place, the house they set up together, and much of its contents had to be sold, and she was even briefly in debtors' prison. In 1814, she fled to France to escape her creditors and died, poverty-stricken, in Calais the following January. She was 49.

1785–86
Oil on canvas; 1270 × 1016 mm
BHC2736; Caird Fund

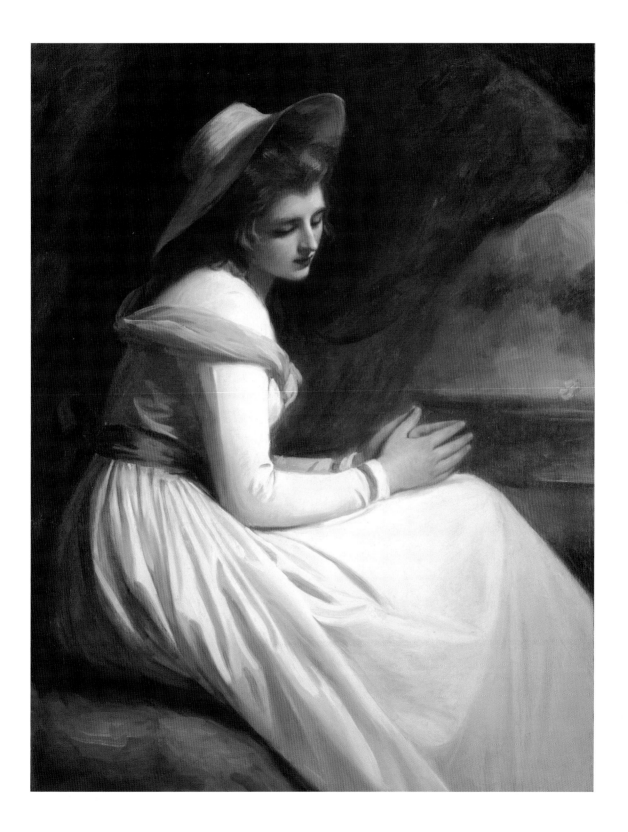

Relics from the mutiny on the *Bounty* belonging to William Bligh

In December 1787, the *Bounty* set sail for Tahiti under the command of Lieutenant William Bligh (1754–1817). His mission was to transport breadfruit plants from the Pacific to Britain's colonies in the Caribbean, where they were to be cultivated as food for the enslaved African population. The ship was small for the mission and the voyage out was long and difficult, which set a pattern of stress exacerbated by events after they reached Tahiti in October 1788. Ashore, the 45-man crew enjoyed the many attractions of this tropical paradise and it proved impossible to maintain naval discipline. After nearly five months on the island, *Bounty* began its voyage to the Caribbean on 4 April 1789. With overcrowding made worse by the hundreds of plants now on board and the men resenting the return to shipboard routine after the freedoms of island life, tensions simmered. On the morning of 28 April, they boiled over. The master's mate, Fletcher Christian, led a mutiny and seized control of the *Bounty* with his supporters. Bligh and 18 loyal men were set adrift in the ship's launch, a 23-foot (7-metre) open boat. What followed was one of the most remarkable feats of navigation in the history of seafaring.

Bligh and his men headed for the nearby island of Tofua (in the Tonga group). Here they found fresh supplies, but barely escaped attack by the islanders: one man, the quartermaster John Norton, was killed. Back out at sea, Bligh navigated, largely from memory, the 4,000 (land) miles across the Pacific to Timor in the Dutch East Indies to seek help and a ship back to Britain. The conditions on board were grim. With food and water in short supply, and no way of knowing how long their ordeal would last, Bligh had to distribute the meagre rations. A beaker's worth of water was issued three times a day together with $\frac{1}{25}$th of a pound of ship's biscuit, measured out using a bullet as a weight. Small amounts of salted pork, wine and rum were also consumed. Despite these privations, and with no shelter from sun, wind, rain and stormy seas, they all survived the six-week voyage. The coconut bowl is the one Bligh used for his 'miserable ration'.

On film, in particular, Bligh has often been portrayed as a brutal captain, justifying the revolt against him. In fact, he cared for his men's health, disliked corporal punishment and used it far less than many contemporaries. He had a volatile temper, however, and never understood the disorientating effect his sudden shifts from calm reason to abusive rage had on many of those under him, which eventually triggered mutiny in otherwise very unusual circumstances.

c.1789

Coconut shell, lead, horn; various sizes

ZBA2701–03; purchased with assistance from the Garfield Weston Foundation, the Friends of the National Maritime Museum, and the Valentine Charitable Trust, 2002.

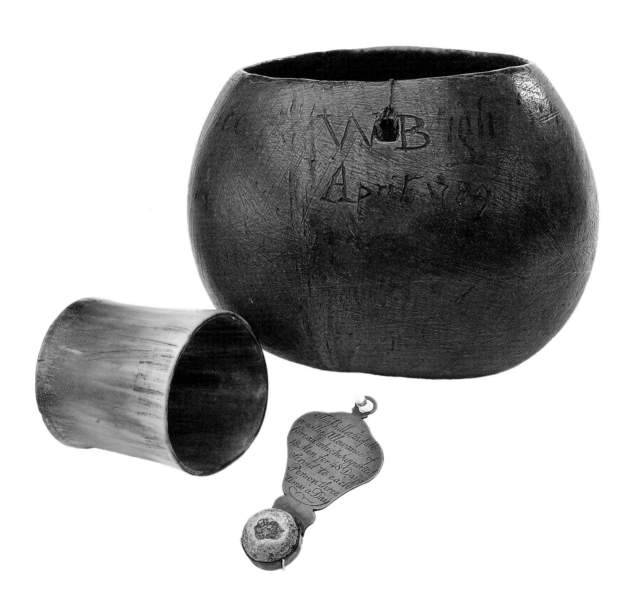

Log of the slave-ship *Sandown*, kept by Samuel Gamble

In April 1793, the merchant ship *Sandown* began a voyage from London to Upper Guinea on the West African coast to buy captive Africans, who were then transported in appalling conditions to Jamaica, where they were sold into slavery on local plantations. The ship's master, Samuel Gamble, left with a crew of 22 seamen and two boys as part of a convoy of over 170 vessels heading to the Caribbean, before heading south towards Africa with a smaller group of ships. The log details his voyage, and, unusually, features various illustrations. Despite the purpose of his mission, Gamble was particularly interested in local African communities and describes his encounters with them.

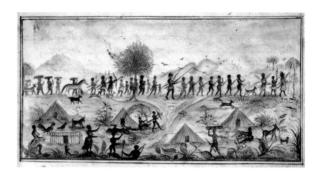

Gamble's destination was the Iles de Los and rivers along the nearby Guinea coast. On arrival, most of his men contracted yellow fever. Gamble had to wait nine months until March 1794 before he had an adequate crew to cross the Atlantic with the 234 captive Africans he had bought in exchange for goods like salt, tobacco and ironware. The log includes a drawing of captured Africans and he describes the cruelties involved as African traders marched their captives to the coast:

> The Slaves they make fast round the Neck a long stick which is secured round the others waist from one to another so that one Man can steer fifty and stop them at his pleasure. At Night their hands are tied behind their backs, which causes them to lay down with great difficulty.

The voyage to Jamaica was troubled and typical of the infamous 'middle passage'. Many of the Africans on board and some of the crew died from further outbreaks of yellow fever. There was also an unsuccessful uprising by the Africans, and leaking water kegs meant Gamble had to reduce the rations. The dwindling crew made it difficult to navigate the vessel. When he was forced to put into Barbados for supplies, 16 men left the ship. With a remaining crew of only six, the *Sandown* struggled on to Jamaica and a scene of chaos: an epidemic of yellow fever had left the harbour filled with ships, all waiting to sell Africans to plantation owners. Gamble described 3,000 being held in ships in the harbour, awaiting sale, in conditions that must have been appalling. He also reveals the scale of trade by reporting that 60,000 slaves had been sold in the last 12 months. The log of the *Sandown* is a rare survival chronicling first-hand the shocking inhumanity of transatlantic slavery and the immense misery and suffering it caused for the sake of economic gain.

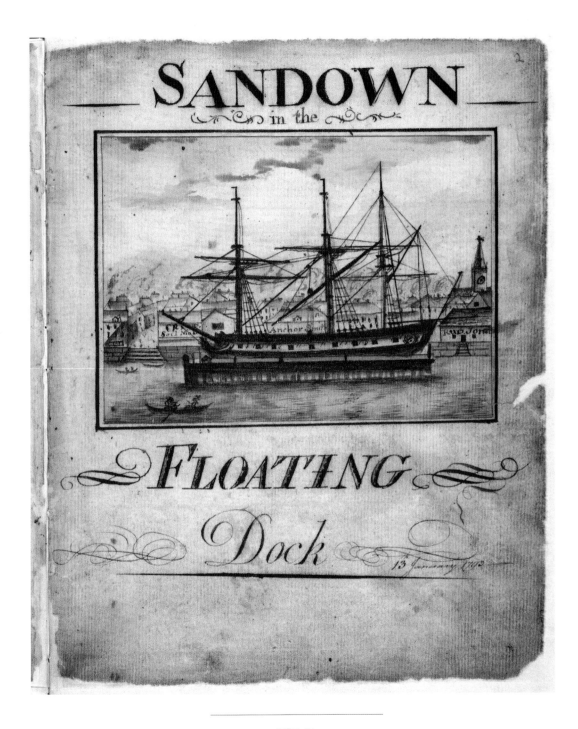

SANDOWN

in the

FLOATING

Dock

13 January 1793

1793–94
Manuscript and watercolour on paper
LOG/M/21

The Selenographia

John Russell

The maker of this lunar globe, John Russell (1745–1806), is most famous as a fashionable portrait artist. He was a member of the Royal Academy and, by 1790, Painter to George III and the Prince of Wales. The subject of his enduring fascination, however, was the Moon: he made pastel drawings and detailed sketches of it; he corresponded with prominent astronomers about it; and he bought high-end telescopes to make his observations. The Moon, Russell asserted, needed 'much attention to be well understood'. Although not the first lunar globe, the Selenographia was the first to incorporate the specifics of lunar motion by means of the brass apparatus that surrounds the sphere. The geared mechanisms, coupled with graduated scales, allowed the globe to be used to demonstrate libration – the slight wobble that means that, if observed over a long period, 59 per cent of the lunar surface is visible from Earth.

Making the Selenographia was a painstaking process. Partial maps of the Moon, made over a period of 18 years, were put together and linked by a series of triangles. The triangles were then transferred to a papered sphere, along with the detail of lunar features. This sphere was used as the model from which Russell engraved copper plates to produce 'gores' (the paper segments used to cover a globe). These would be pasted to specially prepared spheres, which were then set within their brass fittings. Since he was connected to some of the most prominent instrument-makers and cartographers in London at the time, Russell had access to people with the necessary skills and craftsmanship to enable the construction of so complex an object.

Russell described how his instrument would be a useful model to aid the understanding of libration, and how one could use it to measure the distances between different lunar features. He even suggested how the Selenographia could stand in for the Moon itself, being a pleasing object to observe through a telescope (the recommended distance of 140 feet itself indicates the sort of audience that Russell envisaged – wealthy enough to have sufficient space). The Selenographia is testament not only to Russell's dedication to our nearest celestial neighbour, but also to the world of polite science in which he moved, where astronomy and social accomplishment often went hand in hand.

London, 1797
Paper, papier-mâché, brass; 300 mm diameter
GLB0140; Caird Fund

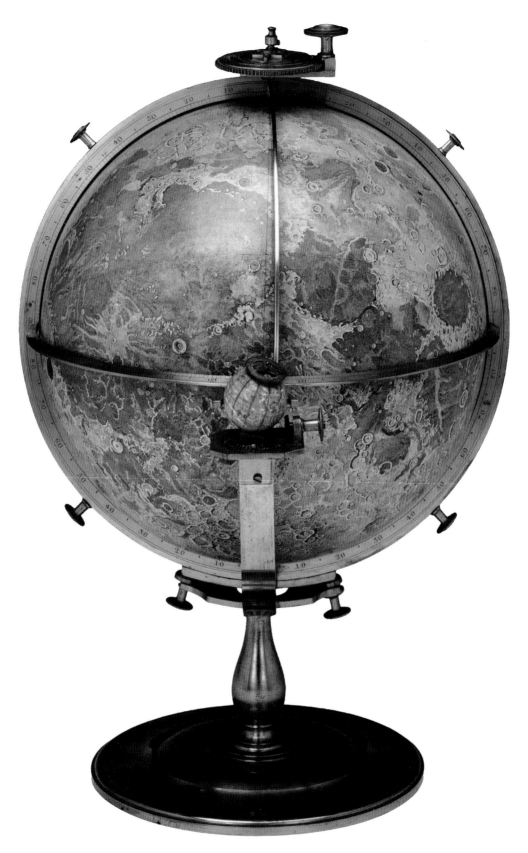

Nelson's first letter written using his left hand

On 24 July 1797, while attempting to come ashore in a launch during a failed British attempt to capture the Spanish port of Santa Cruz de Tenerife in the Canary Islands, Horatio Nelson (1758–1805) was shot in the right arm, just above the elbow, and badly wounded. Lieutenant Josiah Nisbet, his stepson, used two silk neckerchiefs to staunch the flow of blood from the severed artery, while they returned as quickly as possible to Nelson's flagship, the *Theseus*. Once on board, the surgeon Thomas Eshelby amputated the arm immediately in a quick and clean operation. The limb was thrown overboard. Nelson was given nightly doses of opium to alleviate the pain. Almost at once, he began to write with his left hand. This letter to Admiral Lord St Vincent, the commander of the Mediterranean Fleet, begins: 'I am become a burthen to my friends and useless to my Country' and goes on to request 'a frigate to convey the remains of my carcase to England'. In a postscript he begs St Vincent's forgiveness: 'You will excuse my scrawl considering it is my first attempt.' (In fact, because he had to write more slowly to form words using his left hand, they are often easier to read than letters dashed off with his right hand.) But Nelson was clearly greatly troubled both by the physical trauma of his injury and by the psychological impact of the broader tactical disaster at Tenerife. Indeed, the loss of his arm was a constant reminder of this failure.

Nelson returned to Britain to recuperate and was nursed by his wife Frances at lodgings in Bath. But the arm was slow to heal, with a nerve caught by a ligature, and he sought the opinion of surgeons in London. By late November, the ligature finally came away, decreasing his suffering, and the wound began to improve. Nelson thereafter employed various aids to compensate for the loss of his arm, including a combined knife and fork. The following spring, he returned to the fleet in the Mediterranean and was soon in action. These operations culminated in a singular victory against the French at the Battle of the Nile on 1 August 1798, which cemented Nelson's reputation as the most brilliant and audacious naval commander of the age. Even greater achievements would follow, but having thought himself 'useless' in July 1797, he had proved decidedly useful a year later.

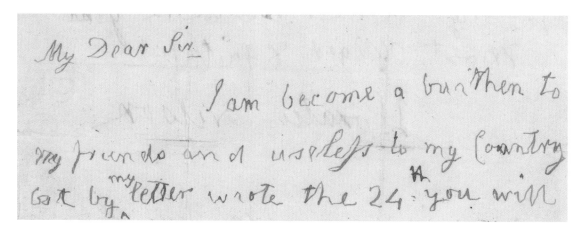

y will be able to give me a frigate to convey the remains of my carcase to England, God Bless You My Dear Sir & Believe Me your Most Obliged & faithful

Horatio Nelson

You will excuse My Scrawl considering it is my first Attempt —

Sir John Jervis K B.th

27 July 1797
Ink on paper
PAR/251/1

Earl St Vincent's presentation small-sword

James Morisset and Robert Makepeace

On the morning of 14 February 1797, a British fleet commanded by Admiral Sir John Jervis (1735–1823) prepared to do battle off Cape St Vincent in southern Portugal against a Spanish fleet of unknown size. On the quarterdeck of Jervis's flagship, the *Victory*, Captains Calder and Hallowell counted the Spanish ships as they emerged from fog. At first there were eight, then 20, then 25 and then 27 – nearly twice as many as the British. At this point Jervis barked, 'Enough, sir, no more of that; the die is cast, and if there are fifty sail I will go through them.' The British fleet formed up into a single line of battle and advanced on the rather unprepared Spanish. The action is notable as an early example of the 'Nelson touch'. Horatio Nelson was in command of the *Captain* (74 guns). Instead of obeying Jervis's direct orders to follow the *Victory* into battle, he came out of the line to engage a detaching group of enemy ships. What followed was the stuff of Nelson legend. Generating a terrific rate of fire, the *Captain* took the fight to the Spanish warships and Nelson boarded and seized two of them – the *San Nicholás* (80 guns) and *San José* (112 guns). Britain held the day with no ships lost and far fewer casualties.

Nelson was made a knight of the Bath and Jervis was created Earl St Vincent. This high-quality presentation small-sword was awarded to Jervis by the City of London. The enamelled hilt is particularly fine. On one side of the pommel is the coat of arms of the City of London, with Jervis's on the other. The blue-enamelled grip is decorated with oval portraits of the *Victory* surrounded by cut gemstones. The guard features scenes of the battle and the knuckle guard is inlaid with trophies of arms. Jervis was also granted the freedom of the City of London, which came with a gold box valued at 100 guineas (£105). The wealth of London and the wider nation relied on the freedom of the seas and the protection offered by the Royal Navy to British seaborne trade. Victories at sea were, therefore, to be celebrated, and as well as titles and honours, Jervis was awarded the very substantial pension of £3,000 a year by parliament. But there was more to come. The Spanish ships captured by the British, including the two seized by Nelson and his crew, meant the payment of prize money: as the commander of the fleet, Jervis was entitled to the largest share. The battle proved a lucrative encounter.

London, 1797

Steel, gold, enamel and other materials; 813 × 21 mm (blade)

WPN1439

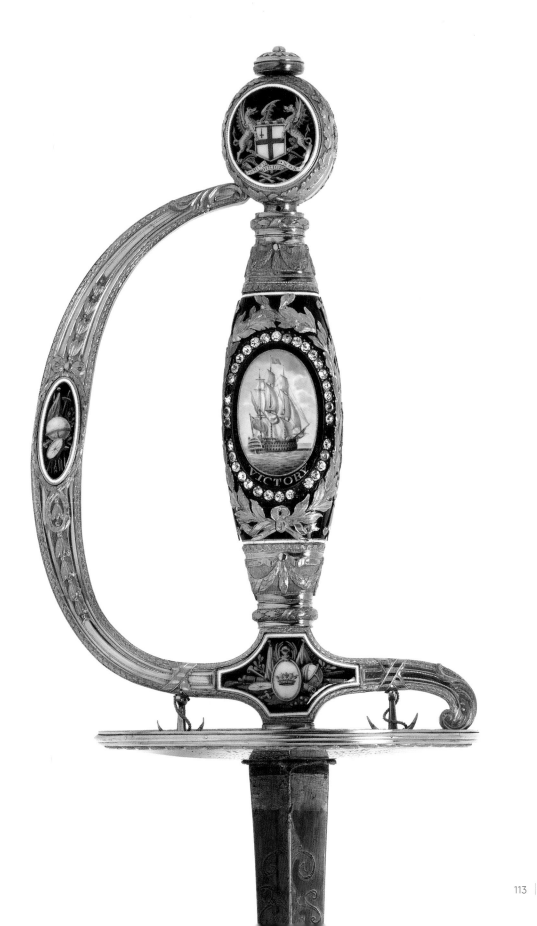

Rear-Admiral Sir Horatio Nelson

Lemuel Francis Abbott

This is arguably the most famous portrait of Nelson. It shows him in a rear-admiral's undress uniform coat and hat, and was commissioned in 1799 by John McArthur, Nelson's biographer, to illustrate a short memoir in the *Naval Chronicle*. Abbott (c.1760–1802) did not paint the portrait from life, as Nelson was abroad at the time, but he used an earlier oil study from a 1797 sitting at Greenwich Hospital, where Nelson was staying as guest of an old friend while recuperating from the loss of his right arm. He is thought to have produced about 40 versions from the same study, but this is the only one showing the admiral in a hat. However, Abbott had to guess at the form of the *chelengk* – the jewelled decoration on Nelson's hat that was a gift from the Sultan of Turkey following his victory at the Battle of the Nile in 1798 – and exaggerated its size.

The commissioning of this portrait is evidence of Nelson's growing fame and the need for new images to satisfy public demand. After his death, paintings were produced retrospectively, recording incidents from across his naval career to illustrate numerous biographies of the fallen hero and give shape to his 'exemplary' life. These naturally emphasise Nelson's role in events, placing him centre stage and, together with the Victorian tendency to write highly idealised lives of the admiral, helped to create a powerful Nelson myth. His place in the national psyche was truly cemented with the laying out of Trafalgar Square and the construction of William Railton's Dartmoor granite memorial column between 1840 and 1843. It is surmounted by Edward Hodges Baily's monumental statue of Nelson, whose stern features, hewn from resilient Craigleith sandstone, gaze down Whitehall.

As a national naval hero, Nelson has no rival. He is the subject of well over a hundred 'lives', from propagandist hagiographies to meticulously researched scholarly examinations. At times of national crisis and danger, Nelson's words, deeds and examples are drawn upon by politicians, commentators and cartoonists. He has been portrayed in successful feature films and has inspired novelists, advertising executives and artists alike. Nelson was famous in his own lifetime and he remains famous today. Despite changing times, tastes and fashions, the public appetite for all things Nelsonian has yet to fade: perhaps it never will.

1799
Oil on canvas; 762 × 635 mm
BHC2889; Greenwich Hospital Collection

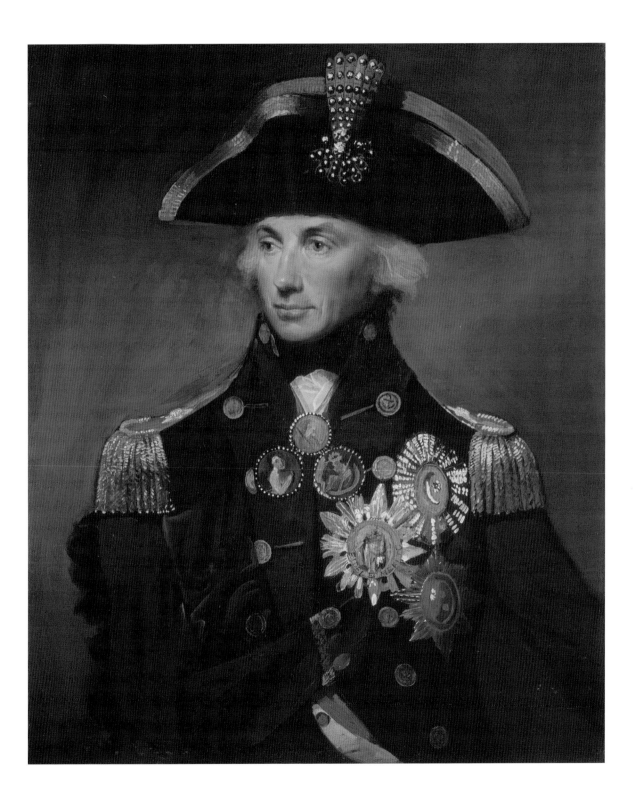

Nelson's undress uniform coat, worn at Trafalgar

Nelson wore this coat, his undress uniform for everyday wear, at the Battle of Trafalgar, 21 October 1805. As his flagship, the *Victory*, sailed into battle, Nelson and his crew were embroiled in some of the heaviest fighting that day, exchanging deadly broadsides with the French ship *Redoutable*. The two ships were locked together in a bitter struggle. French marksmen, high in the rigging, fired down on *Victory*'s deck. At quarter past one, Nelson was shot in the left shoulder, and the bullet passed through his lung, severing his spine. Paralysed, he collapsed on the deck and, knowing the injury to be fatal, gasped to his flag captain, 'Hardy, I believe they have done it at last'. He was carried below deck to the surgeon, William Beatty, who did his best to make Nelson comfortable but told him honestly, 'My Lord, unhappily for our country nothing can be done for you'. Nelson stayed alive long enough to hear the guns fall silent and learn that the British had secured a famous victory. His last words were to Hardy: 'Do be kind to poor Lady Hamilton' and 'Thank God, I have done my duty.' He died at half past four.

Lady Hamilton was, of course, Emma Hamilton, his beloved mistress and mother of his daughter, Horatia. Nelson's blood-stained coat and pigtail (shown above) were eventually passed to her. Emma held on to these most poignant of relics for as long as she could, but eventually her mounting debts compelled her to sell the Trafalgar coat to Alderman Joshua Smith. In 1845, Prince Albert purchased the coat for £150 and presented it to Greenwich Hospital. It has been on almost permanent display in Greenwich ever since.

On the left breast of the coat are the embroidered stars of Nelson's four orders of chivalry: the Order of the Bath, the Order of Crescent (sewn on upside-down), the Order of St Ferdinand and of Merit (from Naples), and the German Order of St Joachim. The bullet hole is clearly visible on the shoulder above. The lead musket ball carried with it some of the gold braid from Nelson's epaulette. This remains embedded in the bullet itself, which is now in the Royal Collection at Windsor Castle.

United Kingdom, before 1805; 1793–1812 pattern
Wool, silk and other materials; 1160 × 560 × 530 mm
UNI0024; Greenwich Hospital Collection

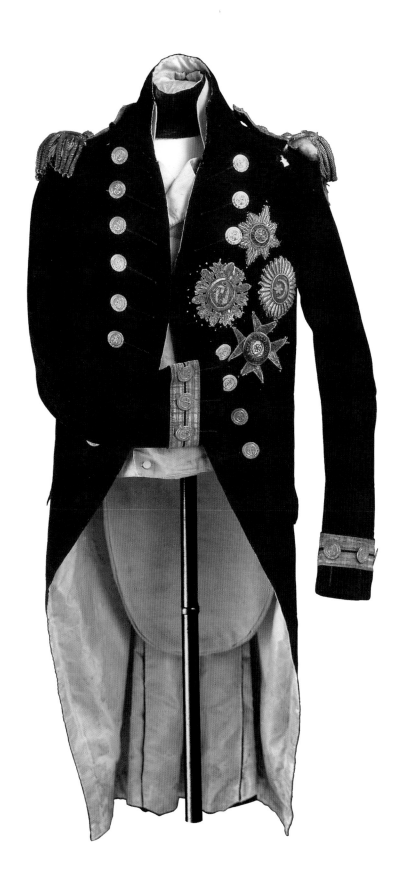

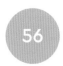

The Algiers centrepiece

Paul Storr

This large table centrepiece was presented to Admiral Edward Pellew, 1st Viscount Exmouth, by the officers who served under him at the Bombardment of Algiers, 27 August 1816. Pellew led a combined British and Dutch naval force against this North African city state to secure the release of more than a thousand Europeans held prisoner by the Dey of Algiers. The city was subjected to a blistering nine-hour bombardment before the Dey came to terms. The ferocity of the fighting meant Pellew's fleet sustained considerable losses, with 141 dead and 742 wounded. The object is loaded with imagery of the action. The central structure is a representation of the Lighthouse Fort, a key component of Algiers's seaward defences with batteries of 44 guns and masonry walls five-feet thick. Around the base, figures of British seamen are shown releasing captive Europeans, while others overwhelm Algerian corsairs. There are relief panels with further scenes of the bombardment and a fulsome dedication to Pellew. The admiral also received

the thanks of Parliament: the City of London presented him with an enamelled and diamond-studded sword, and he was made a viscount. Honours were also bestowed by Spain, Naples, Sardinia and the Netherlands. Pellew ended his active naval career as the port admiral at Plymouth before retiring in 1821.

The officers who gave Pellew the centrepiece chose possibly the greatest British silversmith of the age. At this time, Paul Storr (1770–1844) was coming towards the end of his relationship with the important firm of Rundell, Bridge & Rundell, which, as principal royal goldsmiths and jewellers, produced wares of the highest quality for George III and George IV. In 1819, he broke with the firm in order to gain greater artistic freedom over the direction of his work and established a flourishing business. There are other examples of his work in the Museum's collections, including a large silver cup and cover, known as the 'Turkey Cup', which was presented to Nelson following the Battle of the Nile, but none compare to this centrepiece.

London, 1817–18
Silver-gilt, 927 × 698 × 698 mm
PLT0047

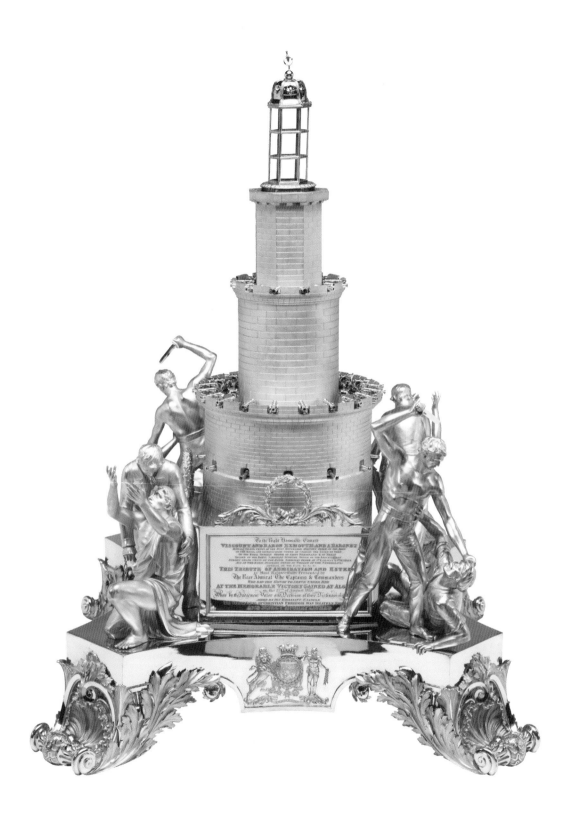

Métis shot pouch from the Canadian Arctic

This embroidered shot pouch was probably made by a Métis woman at the Red River settlement in what is now Manitoba, Canada. Métis communities consisted of people of mixed descent, the result of relationships between European fur traders and First Nations women. Bags like this were often used by men involved in the fur trade in the region. They held ammunition, tobacco and pipes, or fire-making equipment.

The bag is exquisitely made from bleached caribou skin, lined with cotton fabric, and embroidered with dyed porcupine quills. Such embroidery was often influenced by European decorative arts, which were brought to the area by the nuns who settled there, with floral elements copied from china, textiles and wallpaper. The very fine quillwork on this bag, however, may also have incorporated indigenous meanings. The strawberry motif on one side, for example, links to First Nations cosmologies, as strawberries are the fruit that line the road to the land of the dead. The two

embroidered sides of the bag are different: one may have been for public display, and the other, having more personal meanings, may have been designed to be kept private. The woven beadwork panel is thought to show the Cathedral of St Boniface in Winnipeg, and is in colours often used by the Northern Cree – although blue is also a significant colour for Métis communities. The triangular tin tabs are an unusual shape for this kind of bag and may have come from snuff cans.

The bag, a rare example, belonged to the British naval officer Admiral Sir George Back (1796–1878), but its precise date of manufacture and collection are unknown. Back took part in three overland journeys to explore the north coast of America in 1819–22, 1825–27 and 1833–35. He travelled north via the network of rivers and lakes on the Canadian Shield, stopping at Hudson Bay Company trading posts. The bag was bequeathed to Greenwich Hospital by Mrs Eliza Back, his nephew's widow, in 1900.

Canada, probably made between 1819 and 1834
Caribou skin, linen, bird quill, porcupine quill, glass beads; 345 × 210 mm
AAA2644; Greenwich Hospital Collection

The Battle of Trafalgar, 21 October 1805

Joseph Mallord William Turner

By the mid-eighteenth century, naval battle painting was an established and distinct branch of marine art in Britain. And yet, despite the extended period of conflict represented by the French Revolutionary and Napoleonic Wars (1793–1815), it was to feature very little in Turner's work. In contrast, his engagement with the Battle of Trafalgar and its consequences, and the Royal Navy more generally, was wide-ranging and profound. It was a subject he returned to repeatedly in exhibited paintings and watercolours and in designs for print projects. Above all, his interest in the subject is signposted by three major paintings that span more than 30 years: *The Battle of Trafalgar, as Seen from the Mizen Starboard Shrouds of Victory* (1806–08, Tate), *The Battle of Trafalgar* (1822–24, pictured) and *The Fighting Temeraire* (1839, National Gallery).

In 1822 George IV commissioned J.M.W. Turner (1775–1851) to paint *The Battle of Trafalgar*. It was to be displayed alongside an earlier work by Philip James de Loutherbourg, *The Glorious First of June* (1795, also now at Greenwich) in St James's Palace. Measuring 12 feet (3.7 metres) across, it proved to be his largest work and arguably his most complex and ambitious on the theme of war. In preparation for this painting, Turner embarked on an unusual amount of practical research. In addition to the sketches he had made of *Victory* in December 1805, he borrowed a plan of the ship from the Admiralty and asked the marine artist John Christian Schetky to make further sketches of it at Portsmouth.

The finished painting is monumental in scale, panoramic in scope and extraordinarily detailed. It also attempts to encapsulate the significance of this major and bloody British victory by combining a number of incidents from different times during the battle. The falling mast, perhaps an allusion to the dying Nelson, bears his white vice-admiral's flag, while code flags spelling 'd-u-t-y' – both the last word of his famous signal to the British fleet at the beginning of the battle ('England expects that every man will do his duty'), and the last word Nelson reportedly said ('Thank God I have done my duty') – are flying from the mainmast. On the right is the French *Redoutable*, surrendered and shown sinking. Beyond *Victory* on the left are the Spanish *Santísima Trinidad* and the French *Bucentaure*, flagship of Admiral Villeneuve. *Temeraire* is on the far right, all but concealed by battle smoke. In the foreground, British seamen try to save fellow and enemy crew from the bloodied sea, which is strewn with wreckage. Fragments of Nelson's motto, *Palmam qui meruit ferat* ('Let him who has earned it bear the palm') can be seen below the water's surface. Given the centrality of the Navy to the fortunes of the nation, Turner includes a highly symbolic detail at the centre of the composition: a British sailor holding up the Union flag. In 1829, the two battle paintings by Turner and De Loutherbourg were presented by George IV to the recently founded 'National Gallery of Naval Art' at Greenwich Hospital.

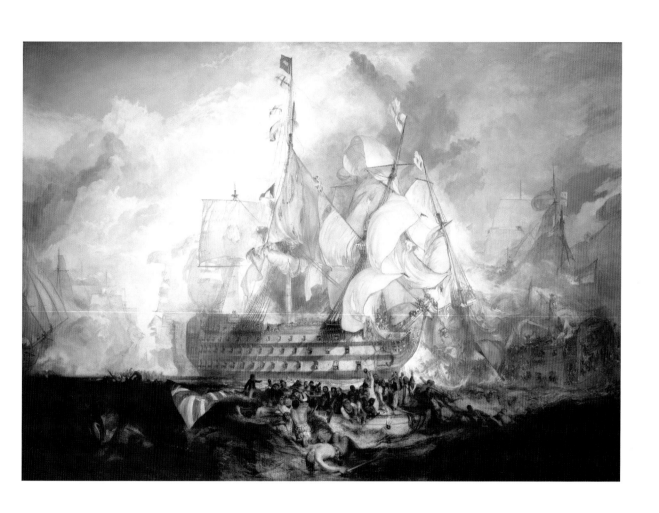

1822–24

Oil on canvas; 2615 × 3685 mm

BHC0565; Greenwich Hospital Collection

Figurehead from the Royal Yacht *Royal Charlotte*

This beautifully carved and highly finished figurehead is arguably the finest in the Museum's collection. It is a retrospective half-length portrayal of the young Queen Charlotte (1744–1818), the wife of George III. The *Royal Charlotte* was one in a long line of royal yachts. The first was the *Mary*, presented by the city of Amsterdam to Charles II upon his return from exile at the restoration of the monarchy in 1660. Undoubtedly the most noticeable feature of these vessels was the richly painted and carved decoration on the hulls, marking the royal family's high status when at sea, though the yachts were also used for other official purposes.

Figureheads of this size and complexity were normally made of several large blocks of timber held together by iron bolts and, in some cases, smaller wooden treenails or dowels. This large wooden mass was then fashioned by the Master Carver, after which it was mounted on the bow of the ship and gilded.

The young Queen Charlotte is portrayed wearing a crown, holding an orb in her left hand and a sceptre in the right. On either side she is supported from behind by attendant cherubs. The Hanoverian coat of arms and the Union flag, both within foliate carved shields, complete the decorative scheme.

The *Royal Charlotte* of 1824, the second yacht of this name, was designed by the Surveyor of the Navy, Sir Robert Seppings. His design included an engine and paddle wheels, but these were not included when the yacht was built at Woolwich Dockyard. After fitting out at Deptford Dockyard, the yacht was finally commissioned in May 1826 and given over for the use of the Lord Lieutenant of Ireland. It remained in service only until 1832, before being broken up in Pembroke Dockyard. The yacht's rather uneventful career may explain the good condition of the figurehead. Indeed, prior to the yacht's service in Ireland, an officer serving on board the Royal Yacht *William and Mary* had spent nine months on station in Dublin and wrote that 'apart from attending to his excellency, as part of his suite, I have literally nothing to do in the world'.

A Victorian display label in the collection describes the figurehead as 'a very good likeness of Her late Majesty'.

Woolwich, 1824
Gilded wood; 2159 × 1118 × 1295 mm
FHD0097

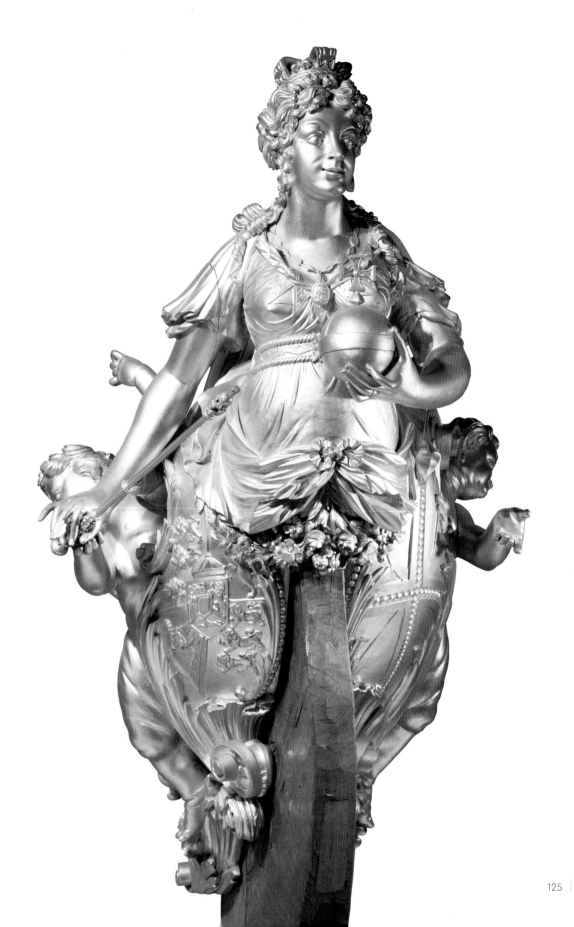

Commander James Clark Ross

John Robert Wildman

James Clark Ross (1800–62) was a major polar explorer, especially of the Arctic. He entered the Royal Navy in 1812, aged 12. His first Arctic expedition, with his uncle John Ross, was in 1818. Between 1819 and 1827, he took part in another four expeditions under the command of William Parry. These made a series of geographical and scientific discoveries as they pushed further north, eventually coming to within 500 miles of the pole. Ross was promoted commander in 1827 and yet again returned to the Arctic with his uncle in 1829–33, over-wintering four times in the frozen darkness. This mission was sponsored by the gin magnate Felix Booth, after whom the Boothia Peninsula was named. A major achievement of the expedition was locating the magnetic North Pole. On 1 June 1831, Ross raised a Union flag on the spot; the jack-staff on which he hoisted it is also in the Museum's collection (shown above).

This portrait was painted to celebrate his successes. It shows Ross in commander's uniform with a bearskin draped over his shoulder – a clear reference to the overriding need to keep warm in the harsh conditions of the far north. In the background an icy landscape stretches out into the distance, with the Pole Star shining brightly above. The scientific instrument in front of Ross is his magnetic dip circle, used to pinpoint the magnetic North Pole. The whole composition emphasises man's scientific conquest of the natural wilderness.

Despite his many missions and achievements, Ross's polar career was far from over. He ventured to Antarctica in 1839–43, undertaking more magnetic surveys and other scientific work, and discovering a series of major geographical features, including Mount Erebus and the Ross Sea, which was named after him. In 1843, he married his wife Ann, and promised her that he would not return to the polar regions. It was for this reason that he declined command of the 1845 North-West Passage expedition, which was eventually given to Sir John Franklin. However, when no news was received from the doomed Franklin or his men, Ann permitted Ross to undertake a search mission: he came back in 1849, having found nothing.

Franklin's widow, Lady Jane, knew Ross well and was grateful for his efforts. She once described him as 'the handsomest man in the Navy'. The artist, John Wildman (1788–1843), appears to have captured something of that sentiment in this romanticised portrait of a naval officer as a heroic polar explorer and man of science.

1834
Oil on canvas, 1442 × 1120 mm
BHC2981; Caird Fund

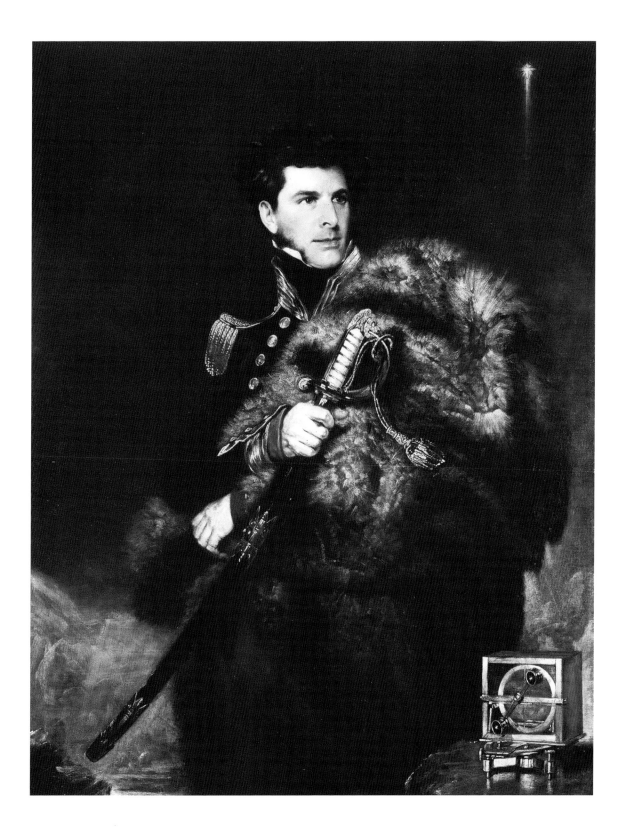

The Queen's Trophy

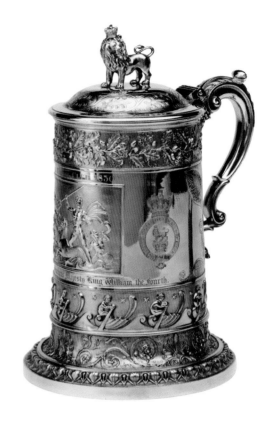

This was the first Queen's Trophy of Queen Victoria's reign. It was won by Joseph Weld in his 193-ton cutter-rigged yacht *Alarm* at a Royal Yacht Squadron (RYS) race held off Cowes on 17 August 1838 to honour the birthday of Victoria's mother, the Duchess of Kent. The trophy is in the form of a silver-gilt shield. The central boss shows Britannia in a sea chariot drawn by hippocampi (mythical beasts with the forequarters of a horse and a fish's tail) being offered a victor's wreath and palm frond by two female attendants. The yachting scene surrounding the boss includes a depiction of the *Alarm*. Beneath are the royal coat of arms and an inscribed shell cartouche: 'ROYAL YACHT SQUADRON, 1838. THE GIFT OF Her Most Gracious Majesty Queen Victoria'.

The award of the Queen's Trophy was hardly the *Alarm*'s first success. On 21 August 1830, for example, it won the inaugural King's Cup (shown above). This substantial silver-gilt tankard was a gift from William IV to the Royal Yacht Club (the precursor of the RYS). It is decorated with a band of oak leaves below the lip and a frieze of putti rowing stylised shells above the flared foot. Flanked by royal armorials, a rectangular panel in low relief contains an image of Neptune in his chariot. The hinged, domed lid is topped with a finial in the form of a crowned lion and a portrait medallion of William IV is mounted inside, completing the decorative scheme.

Weld and the *Alarm* failed, however, to win what was to become the first of the 'America's Cup' races. The schooner yacht *America*, backed by the New

York Yacht Club, entered a RYS race around the Isle of Wight on 23 August 1851. The prize was a £100 silver cup donated by the Marquis of Anglesey. The American yacht had already achieved a reputation for swift sailing and the competition was eagerly anticipated. *America* won the race by eight minutes, hence 'America's Cup'. The *Alarm* went to the assistance of another yacht, the *Arrow*, which ran aground off Ventnor. Having failed to complete the race, Weld decided to adapt the *Alarm*, extending the yacht in line with the *America*'s design. When the two yachts met again ten years later, the *Alarm* passed the finishing buoy some 37 minutes ahead of the *America*.

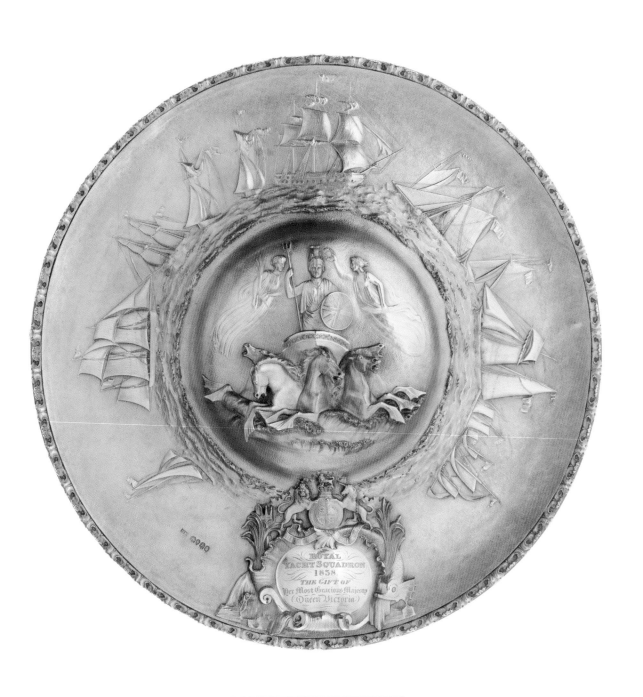

Benjamin Preston for Rundell, Bridge & Co., London, 1837–38

Silver-gilt; 60 × 440 mm

PLT0257

Child's sailor suit made for Albert Edward, Prince of Wales

While sailing on the Royal Yacht around the Channel Islands, Queen Victoria decided to surprise her son Albert Edward (1841–1910), the four-year-old Prince of Wales (then called Bertie and later to become Edward VII). She had the crew make up a child's sailor suit, recording that the outfit had been 'beautifully made by the man who makes [uniforms] for our men'. Bertie appeared in the attire of a very junior yachtsman on 2 September 1846 to the delight of the crew and his father, Prince Albert. Albert then commissioned one of Queen Victoria's favourite artists, Franz Xaver Winterhalter, to paint the Prince of Wales in his sailor suit as a Christmas gift for Victoria. When the portrait was exhibited at St James's Palace in 1847, it was seen by more than 100,000 people. Its display and subsequent engravings helped to popularise sailor suits for boys and girls, a trend that continued well into the twentieth century. The outfits became emblematic of respectability, duty and loyalty, which were deemed perfect qualities for Victorian and Edwardian children. For Victoria and Albert, however, the young Prince of Wales fell somewhat short of these ideals and his rather wayward behaviour was, variously, a source of

disappointment, anxiety and embarrassment.

Nevertheless, the prince did grow up to be an enthusiastic sailor. While the gift of this sailor suit may not have directly sparked this interest, time spent on the Royal Yacht certainly developed his affinity with the sea. In 1851, he witnessed the excitement of the first 'America's Cup' race around the Isle of Wight. He became commodore of the Royal Yacht Squadron at Cowes in 1863. Following this he purchased a racing yacht, the *Dagmar*. This was the first of eight yachts, culminating in the famous and highly successful *Britannia* of 1893. The *Britannia* was fit for a future king. It had four sleeping cabins, a substantial salon, a bathroom large enough for a full-size bath, and more modest accommodation for the rest of the crew. While owned by the Prince of Wales, the yacht won 122 of its 219 races. However, racing became less pleasurable when Kaiser Wilhelm II, who was highly competitive, began to challenge his uncle in the larger yacht, *Meteor II*. The Prince of Wales lamented that the Cowes regatta 'used to be a pleasant relaxation for me; since the Kaiser takes command it is a vexation'. He put *Britannia* up for sale in 1897 and bowed out of yacht racing.

Made on board the Royal Yacht *Victoria and Albert*, 1846
Linen and cotton; 470 × 423 × 160 mm
UNI0293–94

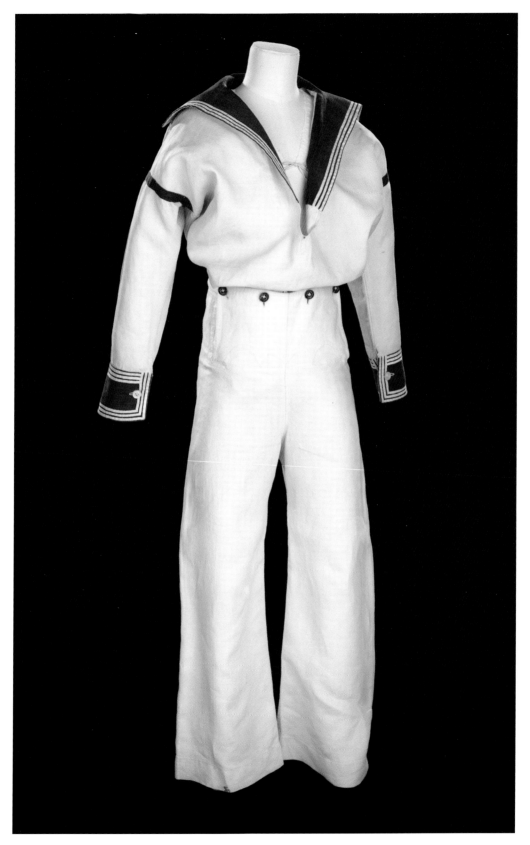

The last record of Sir John Franklin's 1845 British North-West Passage Expedition

The 1845 British North-West Passage expedition, commanded by Captain Sir John Franklin (1786–1847), carried a large stock of this printed form. Completed copies were intended to be left to record the expedition's progress and the finder was asked to forward them onto the British Admiralty. This is why the request is written in six languages.

In late May 1845, Franklin's expedition set off in a spirit of optimism from Greenhithe, on the Thames, in two specially converted ships, HMS *Erebus* and *Terror*. The aim was to map the final part of a sea passage across northern Canada and undertake scientific research linked to an international geomagnetic project. The expedition ships were last spoken to on 25 and 26 July 1845 by two whalers, the *Enterprise* and *Prince of Wales*, while waiting at the entrance to Lancaster Sound for the ice to break up. After that, they were never seen again by Western eyes until discovery of the sunken wrecks of *Erebus* and *Terror* in 2014 and 2016 respectively.

Despite 19 land- and sea-based official Admiralty and private search expeditions from 1847 to 1855, few traces and no written records of Franklin's party were found. In 1856, Jane, Lady Franklin determined to make another attempt to unravel its fate and, she hoped, written records proving that it had found the North-West Passage. To do so she privately engaged the steam yacht *Fox*, under the command of Francis Leopold McClintock, who left for the Arctic in 1857.

This record sheet was found by Lieutenant Hobson in 1859, in a stone cairn on the west coast of King William Island, during his 74-day overland sledging expedition from the *Fox*. His official report stated: 'The cairn was of course the first object of our search. The small cylinder was soon discovered among some loose stones... It contained a brief statement of the movements of the lost expedition.'

It is a unique and vital record of the fateful decision made by Captain Crozier and Captain Fitzjames to abandon *Erebus* and *Terror* in April 1848, and head south to mainland Canada. It states the expedition's successes until May 1847 with the optimistic comment (underlined) 'All Well'. By contrast, in a second hand dated April 1848, it briefly tells of the death of Sir John Franklin, eight other officers and 15 men, and a plan to reach the Back River. As a document it raises more questions than it answers. What had killed so many men by this date? Why did they travel south when rescue was likely to come from the north? As a last record it is an emotive item that contrasts optimism and desperation in one of the most inhospitable landscapes on the planet.

1845–48
Manuscript and print on paper; 323 × 198 mm
HSR/C/9/1

H. M. S. *ships Erebus and Terror*
{ Wintered in the Ice in
28 of May 184 7 } Lat. 70° 5' N Long. 98° 23' W

Having wintered in 1846—7 at Beechey Island
in Lat 74° 43' 28" N. Long 91° 39' 15" W after having
ascended Wellington Channel to Lat 77° and returned
by the West side of Cornwallis Island.

Sir John Franklin commanding the Expedition.

Commander.

All well

WHOEVER finds this paper is requested to forward it to the Secretary of
the Admiralty, London, *with a note of the time and place at which it was
found*: or, if more convenient, to deliver it for that purpose to the British
Consul at the nearest Port.

QUICONQUE trouvera ce papier est prié d'y marquer le tems et lieu ou
il l'aura trouvé, et de le faire parvenir au plutot au Secretaire de l'Amirauté
Britannique à Londres.

CUALQUIERA que hallare este Papel, se le suplica de enviarlo al Secretario
del Almirantazgo, en Londrés, con una nota del tiempo y del lugar en
donde se halló.

EEN ieder die dit Papier mogt vinden, wordt hiermede verzogt, om het
zelve, ten spoedigste, te willen zenden aan den Heer Minister van de
Marine der Nederlanden in 's Gravenhage, of wel aan den Secretaris der
Britsche Admiraliteit, te London, en daar by te voegen eene Nota,
inhoudende de tyd en de plaats alwaar dit Papier is gevonden geworden.

FINDEREN af dette Papiir ombedes, naar Leilighed gives, at sende
samme til Admiralitets Secretairen i London, eller nærmeste Embedsmand
i Danmark, Norge, eller Sverrig. Tiden og Stœdit hvor dette er fundet
önskes venskabeligt paategnet.

WER diesen Zettel findet, wird hier-durch ersucht denselben an den
Secretair des Admiralitets in London einsenden, mit gefälliger angabe
an welchen ort und zu welcher zeit er gefundet werden ist.

Party consisting ... officers and 6 men
left the Ships on Monday 24th May 1847

Quintant

Janet Taylor

Although this showy navigational instrument was identified as a 'sextant for measuring angular distances between heavenly bodies' when it was displayed at the Great Exhibition of 1851, it is more accurately a quintant, since it can be used to measure angles up to 142° (with the scale engraved to 160°). Both sextants and quintants – each named after the sector of a circle formed by their frames (a sixth and a fifth respectively) – are used to measure angles, which can be between celestial bodies for navigation, or between terrestrial targets for surveying.

The jury at the Great Exhibition rightly remarked that this silver instrument seemed to be 'intended for show rather than use' but did not see fit to award its maker any prize. The costly but impractical materials exaggerate its ornate decorative treatment: the frame holds the Prince of Wales's crest and motto, 'Ich Dien' (I serve), and incorporates a British ensign and Royal Standard, with thistles, roses, shamrocks and daffodils to symbolise Scotland, England, Ireland and Wales. The instrument's rosewood box is just as fine, lined with blue velvet and bearing the Prince of Wales's crest in silver.

The instrument's maker, Janet Taylor (1804– 70), was equally notable within the commercial and maritime community of nineteenth-century London. Born in County Durham, she learned navigation from her father, who was master of Wolsingham Free Grammar School. Clearly a talented mathematician, she began publishing on navigation in the 1830s and was rewarded by the Admiralty, Trinity House and the East India Company for a simplified method for lunar-distance calculations to find longitude. From 1835, she ran a prominent nautical school and navigation warehouse, selling charts and instruments near the Tower of London. She took the lead in the business, although it was officially listed in the name of her husband, George. Mrs Taylor also had a canny eye for ostentatious self-promotion: as well as using the Great Exhibition to show off her firm's skills, she later presented this quintant to the young Albert Edward, Prince of Wales (later Edward VII). It was among various gifts to the Museum from his daughter-in-law, Queen Mary, in 1936.

London, c.1850
Silver, gold, ivory, glass; 152 × 170 × 85 mm
NAV1135

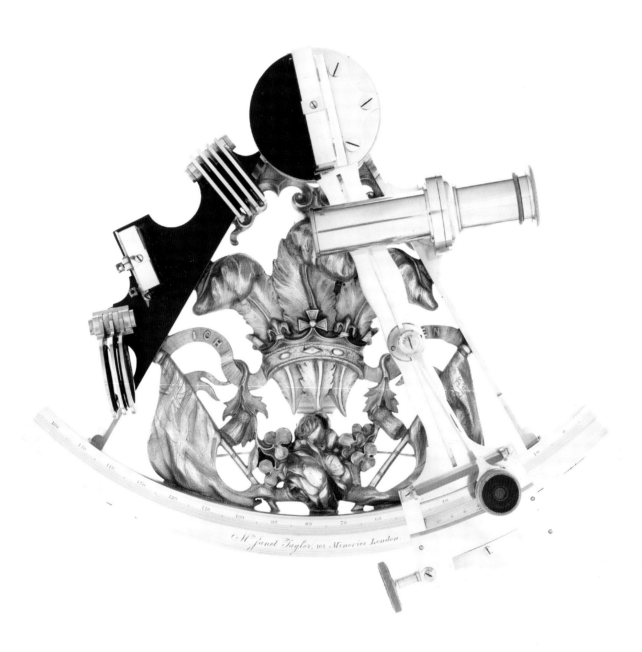

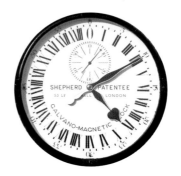

Electric motor clock

Charles Shepherd

Following a visit in 1851 to the Great Exhibition in Hyde Park, London, the seventh Astronomer Royal George Biddell Airy contracted chronometer-maker Charles Shepherd (1830–1905) to make an electric clock system for the Royal Observatory. Shepherd's mechanism transformed the practice of keeping time at the Observatory and, for the first time, allowed the electrical transmission of Greenwich Mean Time (GMT).

The motor clock is an electrically maintained pendulum that is housed in the trunk of the carved mahogany case. The dial above the clock chamber is known as the 'primary slave'. This and other 'slave dials' were driven by electrical pulses generated by the pendulum and the primary slave operated a series of mechanical switches that dispatched time signals at prearranged hours. This switching system worked in the same way as the alarm mechanism in a typical mechanical bedside alarm clock. It was, of course, substantially more refined to deliver the signals with superlative precision.

Before its installation, the Observatory broadcast accurate visual one o'clock signals on a daily basis using the Time Ball, installed in 1833, so that mariners could check the rate of their chronometers while on the Thames or otherwise in sight in the London docks. Using the electric clock system, Airy improved the accuracy of the Time Ball by automating its drop and thereby eliminating

human error. With this new technology, he was also able to extend the service for seafarers. He connected the motor clock by telegraph to the newly built time ball in Deal, Kent. Deal overlooks the Downs, then a major shipping anchorage and rendezvous point at the eastern end of the English Channel, and electrical control from Greenwich provided an accurate time signal for ships there without the need for a local observatory.

The motor clock served not only the Royal Navy and merchant fleets but also benefited scientific and civil communities alike. Airy sent time signals by telegraph so that they could be compared with the receiver's local time and precisely determine their longitude in relation to Greenwich. In October 1866 a signal was sent via submarine cable to the Harvard College Observatory for this purpose. The motor clock also drove the Shepherd Gate Clock (shown above), which provided the first continuous public display of GMT. Legend has it that its installation on the outer wall was intended to put a stop to visitors in Greenwich Park disturbing Observatory staff by asking for the correct time.

This clock also provided time for the Post Office, railways, public time signals and to many subscribers, who paid to receive time signals for use in their shops and factories. The Shepherd motor clock was, in effect, the beating heart of GMT that punctuated life in Victorian Britain.

London, 1852
Mahogany, brass, steel, mercury, silver; 1900 × 590 × 260 mm
ZAA0531

Victoria Cross award to Captain Sir William Peel, RN

Hancocks & Co.

William Peel (1824–58), the third son of the Tory Prime Minister Sir Robert Peel, was a Victorian naval hero *par excellence*. He joined the Royal Navy in 1838 aged 13, saw action off Syria in 1840 and was promoted lieutenant four years later. Not yet 20, he was sent to the Pacific and undertook an intelligence mission, reporting on territory in Oregon, which was disputed between Britain and the United States. With his secret dispatches, he returned overland from San Blas to Vera Cruz in Mexico before sailing to Britain. In January 1849, he was promoted captain. Peel then spent time travelling in the Middle East and North Africa, journeying up the Nile beyond Khartoum. He later published an account of his exploits in *A Ride through the Nubian Desert* (1852).

Naval service in the Mediterranean was followed by action in the Black Sea during the Crimean War (1854–56). Peel distinguished himself time and again with acts of astonishing bravery. On 18 October 1854, at the siege of Sebastopol, a Russian shell landed in Peel's gun battery among cases of gunpowder, its fuse fizzing. With cool determination and quick purpose, he picked it up and threw it over the parapet, where the shell exploded immediately. Peel's actions had saved him and the lives of his men. For this and other acts of bravery, including repeatedly raising a tattered Union flag (shown above) in defiance of Russian guns, Peel was highly commended. After the war, with the institution of the Victoria Cross, he was one of its first recipients.

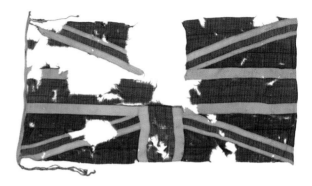

Peel was in command of the steam frigate HMS *Shannon* at the outbreak of the Second China War in 1856. In June 1857, while en route to Hong Kong, he heard news of a serious rebellion in India, the so-called Indian Mutiny. On his return from China, he formed a 450-strong naval brigade at Calcutta from the *Shannon*'s company. Armed with the ship's guns, which were mounted on to makeshift carriages, Peel's brigade was a formidable fighting force and in January 1858 his services were further recognised when he was appointed KCB and an aide-de-camp to Queen Victoria. On 9 March, however, during the intense fighting of the relief of Lucknow, Peel was shot in the thigh and badly wounded; the deeply embedded bullet had to be dug out of the other side of his leg. Weakened, he succumbed to smallpox at Cawnpore and died there on 27 April. He was 33. Brave to a fault, there can be little doubt that had he lived, Peel would have become a significant figure.

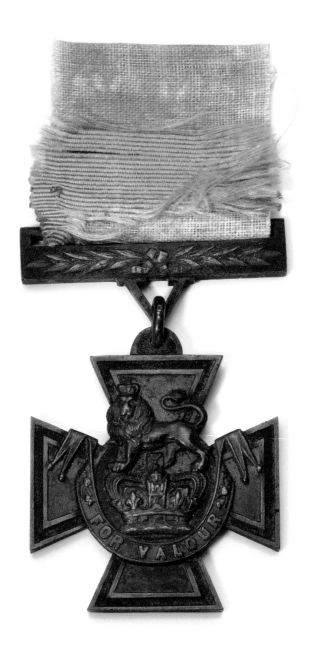

London, 1857
Bronze and ribbon
MED1252; Greenwich Hospital Collection

Inboard profile plan of HMS *Warrior*

This compact and highly detailed plan shows the interior of the ironclad HMS *Warrior* (1860) as originally completed and fitted for service in 1861. It is part of a set of 50 drawings that relate to this ship, although some also make reference to its sister, the *Black Prince*. In addition to the key structural features of internal framing and decks, the drawing also shows the ship's propulsion machinery and a range of other details that would not normally be included in plans of earlier vessels.

Launched on 29 December 1860 and completed less than a year later, HMS *Warrior* was the first of Britain's seagoing iron-built warships. The publicity that attended the appearance of this powerful ship, particularly with reference to Anglo-French rivalry at the time, has tended to obscure the fact that it was more the product of steady advances in warship

design than a reaction to the sudden appearance of the French ironclad *La Gloire*. Never destined to be employed in combat, the *Warrior* still proved itself a success and was a harbinger of the enormous technological changes that were to sweep through the Royal Navy over the following decades. Superior in general terms to all other warships afloat in 1861, it was overshadowed within five years of completion by the newer and even more formidable HMS *Achilles*. Nevertheless, *Warrior* lasted nearly 20 years before its active service came to an end in 1880. The ship is now preserved at Portsmouth.

The significance of this plan lies not just in the specific vessel to which it relates, but also in its place in the wider story of the decline of wooden warships and their replacement by iron and steel ones. The advent of the iron-framed and iron-armoured *Warrior*-class design marked

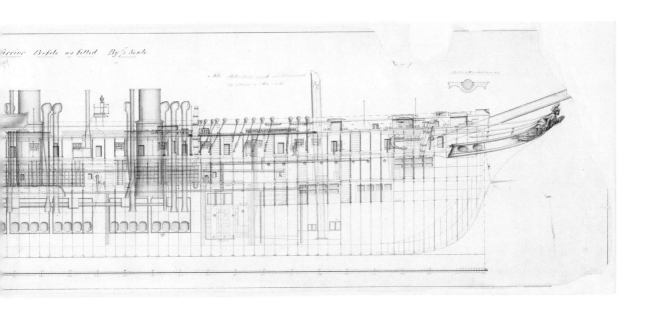

irrior Profile as fitted By ½ Scale.

a significant change in the style and content of the Admiralty's ship plans. Construction using the expensive new materials demanded a higher degree of precision. It was now far more difficult to effect changes during construction than it had been with the sailing Navy's wooden warships. Equally significant, the new generation of ships presented unprecedented challenges in terms of stability and weight calculations, and this necessitated a corresponding increase in the detail.

The plans of *Warrior*, in the Admiralty Collection held by the National Maritime Museum, cover the technical story of this fascinating warship

from its original inception in the late 1850s, to the alterations carried out while with the fleet, its conversion to a depot ship in 1902, and its final relegation to use as an oil pipeline pier in 1945. The Admiralty plans as a whole form one of the most significant collections in the world and, in terms of numbers, are the largest single group within the Museum's holdings of this type of material. They also have the most extensive coverage in terms of date, starting in the first decade of the eighteenth century, providing a virtually unbroken technical record of the Royal Navy's ships until the mid-1960s.

Woolwich Dockyard, 28 December 1861
Paper, ink, wash; 303 × 1468 mm
NPC5112

The Parting Cheer

Henry Nelson O'Neil

Between the end of the Napoleonic Wars in 1815 and the outbreak of the First World War in 1914, more than 20 million people emigrated from the British Isles, seeking a new life overseas. Emigration was part of every family's story and it became a recurring theme in art and literature. In *David Copperfield*, Charles Dickens captures the poignant scene of separation when the eponymous hero bids farewell to Emily and her uncle, Mr Peggotty, as they depart for Australia:

> As the sails rose to the wind, and the ship began to move, there broke from all the three boats three resounding cheers, which those on board took up, and echoed back, and which were echoed and re-echoed. My heart burst out when I heard the sound, and beheld the waving of hats and handkerchiefs – and then I saw her! Then I saw her, at her uncle's side, and trembling on his shoulder. He pointed to us with an eager hand; and she saw us, and waved her last good-bye to me.

In his large narrative painting, *The Parting Cheer*, Henry Nelson O'Neil (1817–80) shows in his characteristic clarity and detail the moment on the quayside as the emigrant ship slips its moorings and, towed by a steam tug, heads out to sea. For its Victorian audience, the painting could be read through its use of recognisable characters, like the street-trading child carrying a basket of oranges and the grieving widow. Contrasts of clothing and the range of emotional responses add further layers of interpretation. In the left foreground, a working-class woman with two children looks towards the ship with a sense of sorrowful resignation. She may, perhaps, be the wife of a sailor, about to be deprived of his company and support once more. The widow, by contrast, is clearly wealthier and is comforted by her daughter, fashionably dressed in a purple shawl and a straw hat tied with a vivid yellow ribbon.

When O'Neil exhibited the painting at the Royal Academy in 1861, it was, on the whole, relatively well received by critics and the public. In its review of Saturday 4 May 1861, however, *The Times* was less than impressed by emotions it presented: 'The agony is of the most demonstrative kind – too loud and rampant to be as impressive as such suffering might be made. More suppression is desiderated by the mind as well as the eye.' But the *Saturday Review* was of a different opinion: 'Never, perhaps, do Englishmen so thoroughly throw off their reserve as on the occasion of such a parting, and we doubt whether the varied forms of demonstrative grief here expressed are at all exaggerated.' The latter review may be nearer the mark. After all, when emigrants left their friends and families behind in the nineteenth century, many were saying farewell for good.

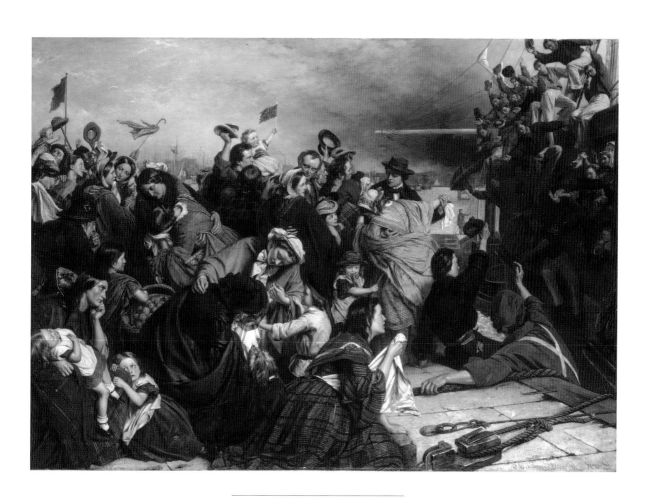

1861
Oil on canvas; 1320 × 1860 mm
ZBA4022; purchased with assistance from the Heritage Lottery Fund,
the Art Fund and the Friends of the National Maritime Museum.

Cutty Sark

The *Cutty Sark* is a ship like no other. It has travelled the globe, weathered storms, wars and fire and, today, is the world's sole surviving tea clipper, as well as the largest object in the Museum's collections. Built in Dumbarton and launched in 1869, the *Cutty Sark* was intended for the China tea trade. In a shrewd move, shipowner John Willis commissioned newcomers in the field to build him the fastest ship afloat. The ship cost him just £16,150, but the builders, William Dundas Scott-Moncrieff and Hercules Linton, were bankrupted in the process.

With premiums paid for the first of the season's fresh tea back to London, the *Cutty Sark* needed to be fast. Of pioneering American design, clipper ships emphasised pace over cargo space. Streamlined hulls, sharp bows and raking masts enabled them to surge through the seas 'at a clip'. The *Cutty Sark* employed these elements as well as a composite construction of a wooden hull attached to a wrought-iron frame. This made it strong enough to withstand the arduous passage to China and light enough to safeguard as much cargo as possible.

Although the *Cutty Sark* made eight voyages to China and carried over nine million pounds of tea, it never quite realised its thoroughbred potential. The Suez Canal, opened just five days before the *Cutty Sark*'s launch, ensured this would never happen. The canal created a 'short-cut' to China, reducing the journey by 3,000 miles, but the windless Red Sea and expensive tolls meant it was not an option for sailing ships. Steamships began to dominate.

Consequently, the *Cutty Sark* entered the Australian wool trade. Australia, the world's premier wool producer, was too distant for steamers reliant upon coaling stations, but the route back suited the *Cutty Sark* perfectly. Running eastward in the

Southern Ocean round Cape Horn, before the strongest winds in the world, its broke records and forged an enviable reputation.

With no family to pass his fleet onto, the ageing Willis sold the *Cutty Sark* to a Portuguese firm in 1895. Renamed *Ferreira*, it spent 27 years as a general cargo carrier until a stop at Falmouth brought it to Captain Wilfred Dowman's attention. He bought and restored the ship, returned its original name and opened it as a training vessel and visitor attraction in 1924. After his death it continued as a training ship for the Incorporated Thames Nautical College at Greenhithe, but following the Second World War, it fell into perilous disrepair. The dedicated work of the Cutty Sark Preservation Society secured a site in Greenwich where a dry dock was built to preserve it. The *Cutty Sark* opened as a museum ship and memorial to the Merchant Navy in 1957.

In 2006 a new project began to save its original fabric. When fire broke out in 2007, less than five per cent of original material was lost. In 2019, the *Cutty Sark* celebrates its 150th anniversary, having been built to last for just 30 years.

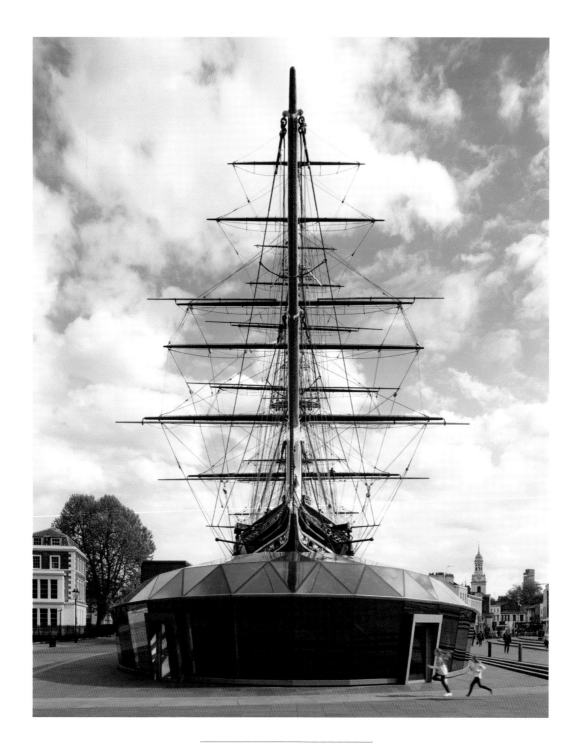

Built by Scott & Linton, Dumbarton; launched on 22 November 1869
Composite ship (wood and iron); depth 22½ feet (7 metres); hull length 212½ feet (65 metres);
width (beam) 36 feet (11 metres); gross tonnage 963 tons
ZBA7518

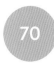

City of London freedom casket

Ernesto Rinzi

Freedom caskets contain a scroll granting the recipient the freedom of a city. This elaborate example was presented to the seventh Astronomer Royal, Sir George Biddell Airy, by the City of London in 1875. The hinged lid of the gold casket is surmounted by the City's coat of arms, bearing the Latin motto *Domine Dirige Nos* ('God guide us'). The box was designed by the noted Italian jeweller Ernesto Rinzi (1836–1909) and is highly ornamented, with enamel panels at the front and each end representing the Universe. Star motifs proliferate and models of globes and telescopes pointing towards the heavens add to the decorative scheme. The back panel is inscribed with a lengthy dedication:

> A Common Council holden in the Chamber
> of the Guildhall of the City of London
> on Thursday the 29th Day of April 1875,
> resolved unanimously that the Freedom
> of this City in a gold box be presented
> to Sir George Biddell Airy K.C.B. D.C.L.
> L.L.D. &c. &c. Astronomer Royal. AS A
> RECOGNITION OF HIS INDEFATIGABLE
> LABOURS IN ASTRONOMY and of his
> eminent services in the advancement
> of practical science, whereby he has
> so materially benefited the cause of
> COMMERCE & CIVILIZATION.

The inscription ends, rather confusingly, 'STONE Mayor MONCKTON'. David Henry Stone was the Lord Mayor of London at the time of the presentation and Sir John Braddick Monckton was the Town Clerk of London.

Airy began his long career as Astronomer Royal in 1835, following the retirement of John Pond, and remained in post until 1881. Prior to his appointment, he was Lucasian Professor of Mathematics and Plumian Professor of Astronomy at the University of Cambridge. At Greenwich, Airy threw himself into the work of the Observatory with considerable energy, extending the range of its activities and investing in new and more up-to-date equipment. Astronomical photography was introduced and, importantly, he began to use the electric telegraph to broadcast Greenwich time across Britain. The government also called upon Airy as a more general scientific adviser, consulting him on everything from railway gauges and the launch of the *Great Eastern* to Charles Babbage's difference engine (a 'proto-computer') and the repair of Big Ben. He was finally knighted in 1872, having turned down the honour on three previous occasions, pleading 'poverty' on the first instance in 1835 and a reluctance to pay the required £30 when offered for the third time in 1863. Airy's significant achievements helped make Greenwich both the location of the Prime Meridian, Longitude 0°, and the centre of world time.

London, c.1875

Gold, enamel, wood, 160 × 95 × 178 mm

PLT0002; Airy Collection

Davy Jones's Locker

William Lionel Wyllie

When this unusual painting was exhibited at the Royal Academy, a critic from *The Times* wrote on 3 May 1890:

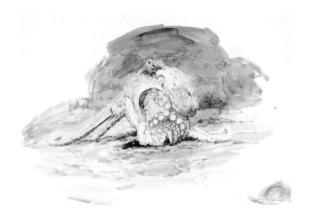

> Mr Wyllie has for once left the surface of the sea in his fantastic picture called 'Davy Jones's Locker' … a picture which he has boldly and literally gone to the bottom to paint. We believe that we are accurate in saying that the observations for this curious work were taken from a glazed diving-bell, and that the seaweed, the stones, the anemones strewn about 'the deep's untrampled floor' were painted from nature by this most enterprising artist. What will the modern learner not do in the pursuit of truth? Mr Wyllie has been for a Challenger expedition on his own account, and none can say that he has not found his reward in the strange assemblage of forms and colours represented in his most original picture.

The critic compares Wyllie's underwater composition with the 1873–76 expedition of HMS *Challenger*, which circumnavigated the globe in pursuit of greater understanding of the deep ocean. In reality, the artist had improvised a makeshift diving helmet from a biscuit tin to make underwater observations while on holiday with his family in the Firth of Clyde, while the closely observed octopus was drawn from life in the less-than-intrepid surroundings of Brighton aquarium (see sketch shown above). Nevertheless, as Wyllie's wife Marion wrote, the scene is one of 'beautiful, green, transparent water, the loom of a wreck in the background, while a big rusty anchor, bones and jewels sprinkle the bottom'. It is quite unlike any other painting in the Museum's collection.

William Lionel Wyllie (1851–1931) was a prolific artist, principally of maritime scenes. Having won the Turner Gold Medal at the Royal Academy School in 1869, aged only 18, he began his career in the early 1870s, drawing magazine illustrations for *The Graphic*. Wyllie became highly skilled and accomplished in both watercolour and etching. He produced many studies of the working Thames, emphasising the grittiness of its industry and commerce. When he moved to Portsmouth in 1907, the ships of the Royal Navy became an important focus of his work. Latterly, he was active in the campaign to save Nelson's flagship, HMS *Victory*. At Portsmouth Dockyard in 1930, George V unveiled Wyllie's vast panorama of the Battle of Trafalgar, which is 42 feet long and 12 feet high.

Following Wyllie's death, just short of 80 in 1931, his entire studio collection of working sketches (including some finished watercolours) was purchased for the Museum by its benefactor, and Wyllie's friend, Sir James Caird. With other Wyllie material added later, it is a major single-artist holding of over 7,000 items.

1890

Oil on canvas, 1025 × 1360 mm

ZBA5055; purchased with the assistance of the Society for Nautical Research Macpherson Fund.

The Great Equatorial Telescope

One of the largest of its type in the world, this telescope marked the beginning of a new chapter in the work of the Royal Observatory. Since its inception in 1675, the primary focus of the Observatory had been the collection of star-position data for the purposes of navigation and timekeeping. This started to change during the nineteenth century, when emerging new technologies enabled astronomers at Greenwich and elsewhere to widen the scope of their work. In particular, larger and better telescopes were being built across Europe and the United States, both privately and state-funded. Not to be outdone, the eighth Astronomer Royal William Christie petitioned the Admiralty to fund the construction of a suitably large instrument for the Observatory, to keep pace with its international rivals. With the funds approved, Christie commissioned a new telescope from the Grubb Telescope Company in Dublin and the instrument was finally installed in 1893.

Attached to an existing mount, previously used to support another telescope, the new Great Equatorial Telescope allowed astronomers at Greenwich to collect starlight in a new way, enabling them to examine the nature of the stars themselves. The axis of the mount was aligned with the North Star, Polaris, while the telescope tube itself was set to move parallel to the Earth's equator, hence the instrument's name. Astronomers could now swing the telescope across the sky in an arc-like movement that mimicked the apparent motion of the stars, making it ideal for astrophotography. Similarly, by adding a clockwork drive to keep the telescope synchronised with the stars, astronomers had the facility to take long-exposure photographs of distant star clouds known as nebulae, resolving detailed features that had previously been invisible to the naked eye. The telescope was also used to measure the changing separation between double stars as they slowly orbited around each other. Astronomers were able to use this data to 'weigh' the stars and calculate their mass.

After several decades of productive study, the telescope came under threat from events beyond the Observatory. With the outbreak of war in September 1939, the tenth Astronomer Royal Harold Spencer Jones decided to dismantle the telescope and remove its precious 28-inch diameter lens to a place of safety. His prescient decision was justified when the Great Equatorial dome was reduced to cinders after a nearby hit from a V1 flying bomb on 15 July 1944. Concerned about the deteriorating observing conditions at Greenwich, the astronomers were reluctant to reinstate the telescope after the war, preferring to leave it dismantled until 1957 when it was reinstated at the Observatory's new home at Herstmonceux in Sussex, away from the smoke and light pollution of London. After several more years of service, the telescope was finally returned to Greenwich in 1971 and it continues to be used for public observations with our 'Evening with the Stars' programme, held during autumn and winter months.

Dublin, 1893 (mount made in Ipswich, 1859)
Cast iron, steel, glass; telescope tube: 8.2 metres, 1.4 tons
AST0932

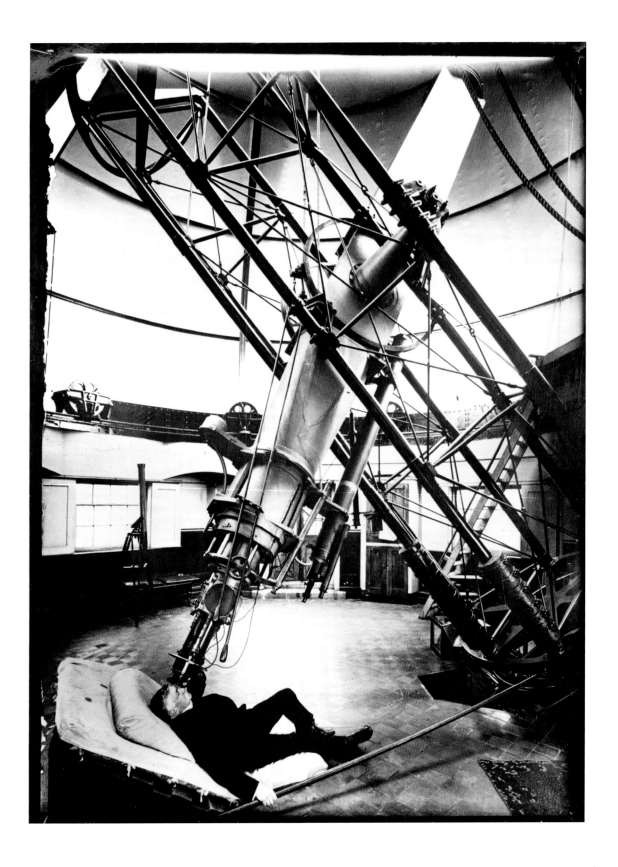

Flag of Nana Olomu

Itsekiri people, Nigeria

This is the personal flag of Nana Olomu (or Olumu, 1852–1916), an Itsekiri chief and merchant working on the Benin River in the Niger Delta. The Itsekiri used their position to act as middlemen, controlling the trade in palm oil between the producers, the land-locked Urhobo, and European clients at the coast. The trade made Nana wealthy and influential and he was able to exert a great deal of political power, commercial clout and military might. In 1884, Nana succeeded his father Olomu as 'Governor of the Benin River'. Relations with Britain began to worsen as a consequence of the late-nineteenth-century 'scramble for Africa', which saw most of the continent carved up by European powers. To drive down costs, British traders were keen to deal directly with the Urhobo rather than rely on Itsekiri intermediaries. Matters came to a head in 1894 when the British laid siege to Nana's capital, Ebrohimi. Stiff Itsekiri resistance compelled Britain to send a larger force and the Royal Navy ships, HMS *Alecto*, *Phoebe*, *Philomel* and *Widgeon* were dispatched up river. Nana was captured, tried and exiled to the Gold Coast, present-day Ghana. His possessions were then sold to defray the costs of the punitive expedition. Eventually the region came under British control as the new colony of Nigeria. He was allowed to return to home in 1906, settling in the small river town of Koko.

The plain, machine-sewn flag was probably manufactured in Britain and then decorated by Itsekiri artisans. Flags of this type were used on river canoes. This example was captured during the expedition of 1894. When a delegation of Ugbajo Itsekiri UK (an Itsekiri socio-cultural organisation in Britain) saw Nana's flag, Rex Clarke, a member of the group, captured the mood by saying, 'It is like a family visiting a fallen soldier and we are here to give him warmth and recognition'. Mrs Veron Oritselumewo Guate, a great grand-daughter of Nana, continued: 'He was a victim of British imperialism who, in defence of his people and protection of his trading empire, fought but was defeated by the British government; a tragic event which today makes him one of the brave pre-colonial nationalists in the history of Africa.' It is one of a small number of African flags in the Museum's collections that relate to the often bloody events of the scramble for Africa and the extraordinary efforts made by Africans to maintain their political and economic independence in the face of European intervention.

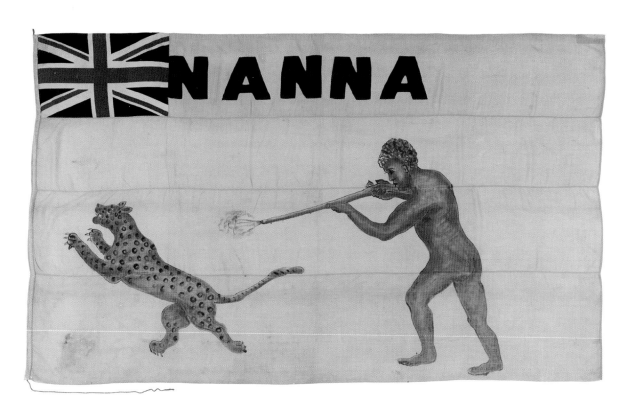

Nigeria, c.1894
Wool and linen; 2388 × 4191 mm
AAA0555

Dolphin binnacle from the royal yachts

A binnacle is a casing that supports and protects a ship's compass. This example, decorated with dolphins, painted white and gilded, was originally one of a pair carved from solid mahogany for the yacht *Royal George* (1817) and reflects the lavish taste of the notoriously extravagant Prince Regent, later George IV. Fittings from previous yachts were reused on successive vessels during the Victorian period. Ultimately, this binnacle was employed on the *Victoria and Albert III*. This new vessel, launched at Pembroke Dockyard in 1899, was the result of many years of lobbying by Queen Victoria for a new royal yacht to replace the outmoded, paddle-driven *Victoria and Albert II*, which she felt no longer reflected Britain's status as the world's leading maritime power. Moreover, other monarchs had larger and more modern yachts and Victoria, who revelled in her title as Empress of India, was determined not to be outshone by any crowned head of Europe. The launch itself was very nearly a disaster. During the construction, considerable extra weight had been added to the yacht and as it entered the water it almost capsized, causing a great deal of damage.

Despite its inauspicious start, the yacht was successful and much loved, being widely used by the royal family, especially Edward VII. By the time of the First World War, the yacht had made more than 60 voyages, two-thirds of them to foreign ports. It was last used in 1939 before becoming an accommodation ship for the duration of the Second World War. The costs of refurbishing the yacht could not be justified in the austerity of the post-war period and it was considered more sensible to build an entirely new vessel – the Royal Yacht *Britannia*, launched in 1953. When *Victoria and Albert III* was broken up in 1954, this binnacle was allocated to the National Maritime Museum but the tradition of reusing earlier yacht fixtures was also maintained, since its pair had already been installed on the veranda deck of *Britannia*.

The magnetic compass in the binnacle was made by the firm of Kevin and James White to patent no. 7376, taken out by Sir William Thomson, later Lord Kelvin. The specification included corrector magnets and iron spheres to counteract 'compass deviation'. This was the unforeseen effect of local magnetic attraction caused by the iron used in ship construction. Without this correction, it was impossible to set an accurate course. Thomson perfected the necessary techniques.

Binnacle: Deptford, c.1817; Compass: Glasgow, 1899
Painted and gilded wood; brass, glass, steel; 1510 × 1000 × 670 mm (overall)
NAV0352

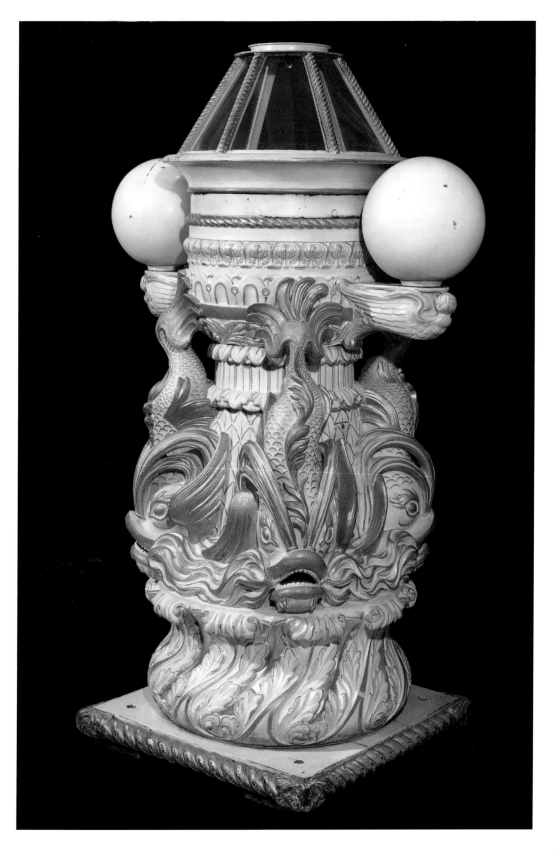

The Francis Frith & Co. Collection

These photographic prints are from negatives in the Museum's Francis Frith & Co. Collection, which mainly comprises topographical views of coastal regions around the British Isles. As can be seen from the quality of the images, they are the work of highly skilled photographers, especially given the practicalities of working with glass-plate negatives.

Francis Frith (1822–98) founded his company in 1859 with the aim of producing high-quality postcards. Although their remit was very broad in terms of subject matter, Frith & Co. soon established a reputation for beautiful topographical pictures. Within a few years they had become the world's largest publisher of commercial photographic images.

Despite their early successes, however, the company went into liquidation in 1971. Well over a thousand of their glass negatives were purchased by the National Maritime Museum, focusing on coastal and riverine subjects. Even now, the Frith images are arguably the best topographical collection in the Museum's care. The pictures cover ports, harbours, resorts, beaches, lakes, canals, rivers and a variety of human activity associated with these locations. The period covered is from around 1880 to 1940. While the collection is heavily weighted towards places, various maritime craft from fishing boats to liners and static training ships also feature, as do their crews.

The top image was produced in 1901 and shows a picturesque view of the quiet Cornish town of Looe. The picture was taken from the shore end of Banjo Pier, looking towards the houses on Hannafore Road, West Looe. A number of rowing boats can be seen in the foreground and it is a testament to the sharpness of the image that the names *Maud*, *Edna & May*, *Ethel*, *Britannia*, *Charley* and *Doris* can be made out on the hulls in the original negative. To the right, three girls are sitting on the quayside watching a fisherman tend his boat.

The image below provides quite a bustling contrast and shows a view of Brighton around 1902. This picture was taken looking eastwards along the King's Road and beach towards the Palace Pier. A number of working boats can be seen, evidently repurposed as pleasure craft for the holiday season, with hauling-out capstans visible at intervals along the shore. A large number of holidaymakers populate this image, and to the right, just passing the pier, is the excursion steamer *Brighton Queen* (1897).

United Kingdom, c.1901–02
Prints from glass, silver halide and gelatine negatives; 151 × 215 mm
G3000, G3030

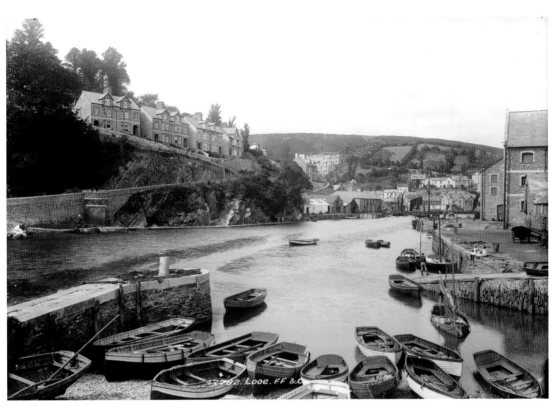

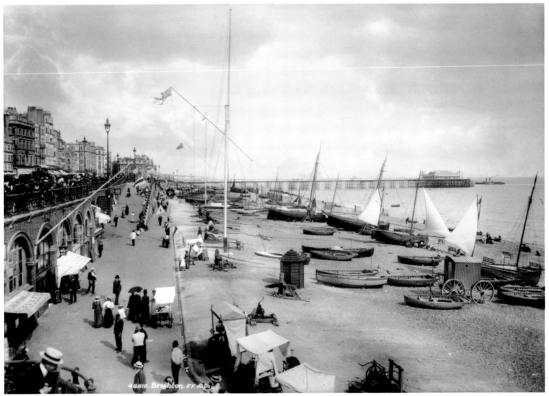

Exhibition model of the Japanese protected cruiser *Niitaka*

Yokosuka Naval Yard, Japan

This Japanese naval builder's model of the cruiser *Niitaka* is of a quality comparable to the very best British shipbuilders' models from the early twentieth century. The level of fine detail is impressive. Even the smallest fittings are beautifully crafted and plated either in gold or silver – a feature broadly thought to attract potential clients at trade fairs. The bridge in particular is an incredible piece of work, complete with shutter telegraph, awning frame, chart table, binnacle and sash windows.

The model, complete with its ornate black lacquered or 'Japanned' case with gold embellishments, was one of a set of six brought over by the Japanese Government for the Japan–British Exhibition held in Shepherd's Bush, London from 14 May to 29 October 1910. This very high-profile event was designed to improve trade relations between the two countries. After the exhibition closed, the models were presented to the Royal Naval Museum in the Royal Naval College, Greenwich, of which the 1913 catalogue records the gift 'as a token of their sincere gratitude for the kindness and courtesy which Japanese Constructors and Engineers have experienced at the hands of the authorities of the Royal Naval College on the occasion of their studies there'. Admiral Togo – the hero of the Imperial Japanese Navy – had trained there as a naval officer and had returned to attend the Royal Naval Coronation Fleet Review held in 1911.

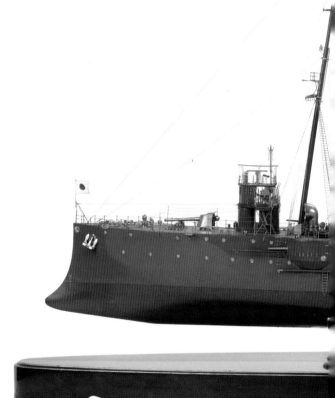

The *Niitaka* was a small third-class protected cruiser, similar to the British *Sirius*-class of 1891 but more heavily armed. Built at Yokosuka, it was 312 feet in length, 44 feet in beam and had a displacement of 3,420 tons. Its armament, which was of German design, included six 6-inch guns and ten 12-pounders. A triple-expansion engine driving twin screws provided a service speed of 20 knots.

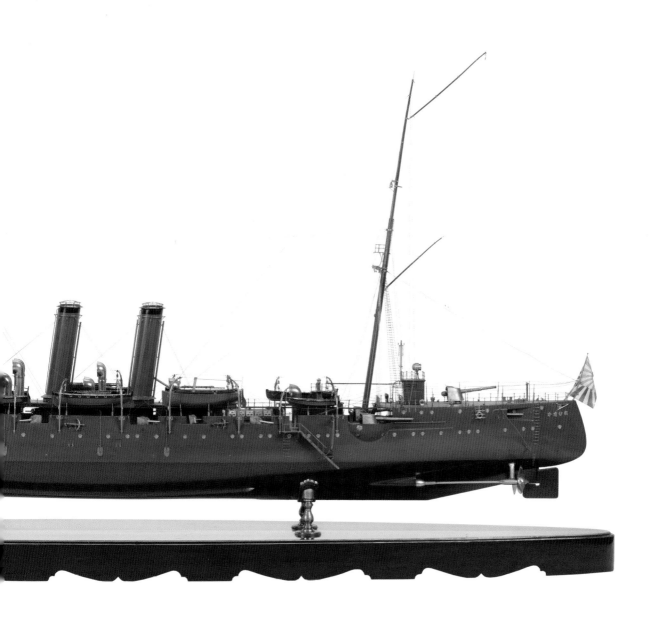

The *Niitaka* was one of the first Japanese warships to be of Japanese design and was well regarded. It took a prominent part in the fighting in the Russo-Japanese war (1904–05), first in the attack on the Russian fleet at Port Arthur and later, under Togo, in the decisive Battle of Tsushima Strait. The *Niitaka* remained in service until wrecked by a typhoon in 1922.

Japan, c.1902
Scale: 1:48 (¼-inch to the foot)
Wood, metal, gold, silver, cordage, paint, textile, glass; 744 × 2852 × 936 mm
SLR1334

Musical toy pig

Sold before the First World War as a musical toy that cost ten shillings (50p), this pig contains a clockwork mechanism and soundboard. When new, it played a tune by winding the tail. The pig was owned by Edith Rosenbaum, who had it with her when she boarded a transatlantic liner at Cherbourg bound for New York: her chosen ship was the *Titanic*.

Edith was born into a wealthy Cincinnati family in 1879. In 1908 she moved to Paris, beginning a career in fashion and journalism. The pig was a gift from her mother following a serious car crash in 1911, which killed Edith's fiancé Ludwig Loewe, a German arms merchant, and left her concussed. With pigs widely regarded as a symbol of good luck, Edith vowed to carry it with her wherever she went. It was, therefore, in her first-class state room – A.11 – on the *Titanic* when it struck an iceberg on 14 April 1912. As the evacuation of the ship began, she sat in the lounge watching the scene of commotion unfold. She asked her steward, Robert Fletcher, to fetch the toy for her, which he did, bringing it on to the deck wrapped in a blanket. Many years later, Edith recalled that she had not intended to leave the ship but the pig was taken from her and thrown down into lifeboat 11: she followed. The overcrowded boat was lowered into the Atlantic and Edith used the pig and its tune to calm the many children huddled in the cold, inky darkness. Edith Rosenbaum was among 710 survivors of the disaster; more than 1,500 drowned.

Edith remained in the fashion industry until the late 1930s and travelled widely, eventually settling in London. In the 1950s, there was a great revival of interest in the *Titanic* story and Edith was in demand to recall her remarkable experiences. An American film starring Clifton Webb and Barbara Stanwyck was released in 1953. Two years later Walter Lord published his best-selling history, *A Night to Remember*, which William MacQuitty produced as the 1958 British film of the same name with Kenneth More in the lead role. Edith was a historical adviser for the film. On her death in 1975, aged 95, she bequeathed the pig to Walter Lord, who had immortalised her *Titanic* story in print and ensured its translation onto the silver screen, when she was played (uncredited) by Theresa Thorne in the 1958 adaptation. When Lord died in 2002, it came to the Museum as part of the Lord-Macquitty Collection, together with the floral evening slippers (shown above) Edith wore in boat number 11 on that fateful 'night to remember' 90 years before.

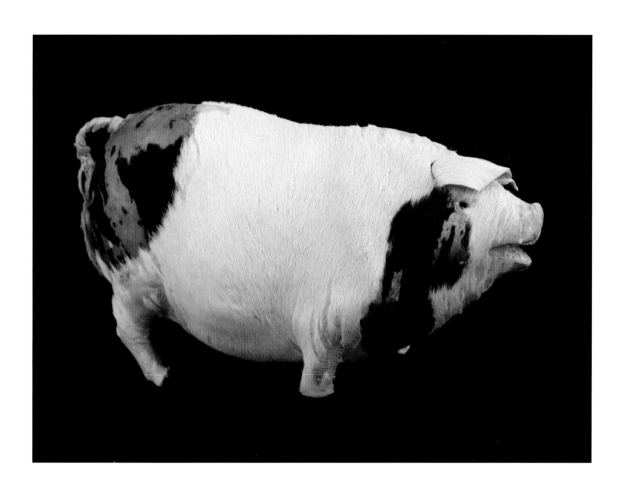

c.1911
Papier-mâché, animal skin, metal; 60 × 80 × 250 mm
ZBA2989; Lord-MacQuitty Collection

Mars globe

Emmy Ingeborg Brun

This globe was made by Emmy Ingeborg Brun (1872–1929), a Danish amateur astronomer and socialist. A manuscript globe, hand-painted and hand-lettered, it is one of a small number that she made and presented to prominent astronomers and scientific societies. The globe depicts Mars but the planet is rendered unfamiliar, being blue and covered in crisscrossed lines. Made in the early twentieth century, Brun's globes were part of a debate about the existence of canals on the surface of Mars. Prominent astronomers from the mid-nineteenth century on – most famously Camille Flammarion (to whom Brun gave one of her globes) and Giovanni Schiaparelli – had suggested the existence of purposefully constructed canals on the planet.

Brun's globes were specifically modelled on maps of this 'canal network' made by American astronomer Percival Lowell, and published in his books *Mars and its Canals* (1906) and *Mars as the Abode of Life* (1908). These books suggested Mars as a blue-green and ochre planet, luxuriant in vegetation, covered with canals that converged at oases. Lowell argued that the canals proved the existence of intelligent and peaceful life on Mars. He reasoned that Martian civilisation must be intelligent because the lines and nodes of canals and oases were some sort of solution to a planet short of water, and it had to be peaceful because

the spread of this network across the planet implied global cooperation.

Though housebound at the time she made these globes, Brun's engagement with both astronomy and politics is clear. Her perspective on the Martian canals is shown by the inscriptions on the base of the globe. These indicate a pointedly Christian understanding of Lowell's work: a slogan of the Labour movement – 'Free Land. Free Trade. Free Men' – describes the Martian community, and a line from the Lord's Prayer – 'Thy will be done on Earth as it is in Heaven' – calls for such a community in the human world. This globe, like most, revolves on its stand; it also stands for social revolution.

Alas for Brun and the 'canal school' of Martian astronomers, improved telescopes later showed that they had been misled by the human eye's ability to form patterns from the unclear but random marks seen through older instruments. Although the theory of 'channels' and the Martian civilisation they presupposed persisted long enough to inspire early science-fiction writers, they themselves turned out to be fiction, too.

Denmark, 1909
Papier-mâché, brass; diameter: 180 mm
ZBA5460

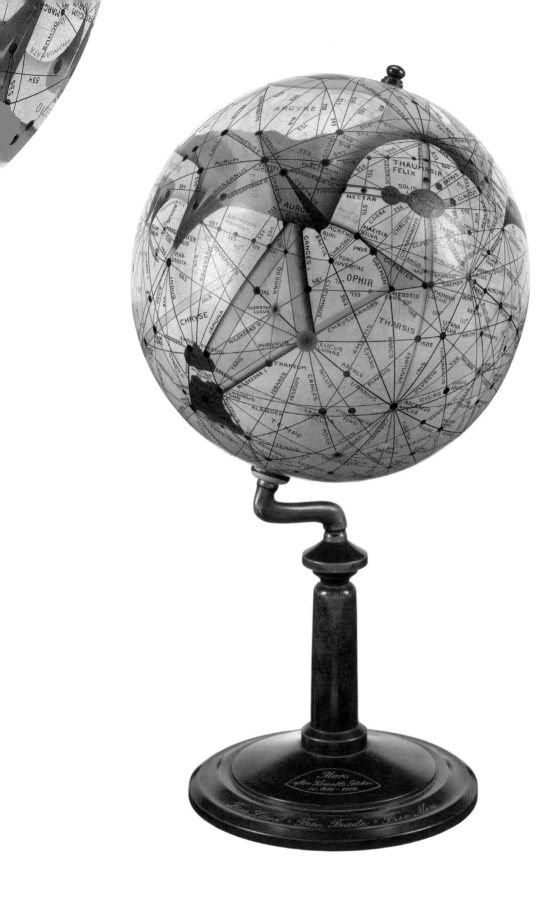

Searching for Hallé's Comet at Greenwich Observatory

William Heath Robinson

This cartoon was reproduced in the illustrated weekly journal *The Sketch* on 17 November 1909 in response to the return of Halley's Comet after its approximately 76-year orbit around the Sun. Produced by the cartoonist and illustrator William Heath Robinson (1872–1944), the fictional scene shows a group of boffins desperately trying to observe the comet, which smiles down mischievously on them. In his characteristic style, Heath Robinson has created a ludicrous telescope with a ship's wheel and mantel clock to emphasise the Greenwich location. Famed for his humorous drawings of mechanical inventions, Heath Robinson was later chosen in 1933 as the illustrator for Norman Hunter's scatter-brained character 'Professor Branestawm', and the artist's name became a by-word for ridiculously impossible inventions, usually made from household items.

The return of Halley's Comet in September 1909 was eagerly anticipated by astronomers. Not seen since 1835, this was the first opportunity for scientists to study this celestial snowball using the new technologies of photography and spectroscopy. As the comet continued to hurtle towards the Sun it was eventually captured on camera by staff at the Lowell Observatory in Flagstaff, Arizona on 13 May 1910. A few days later, the Earth passed directly through the comet's gas tail, providing astronomers with the opportunity to use spectroscopic techniques to analyse the comet's light and determine its chemical composition. The results revealed the presence of the poisonous compound cyanogen in the outer envelope of gas around the comet's rocky nucleus. This toxic gas had previously been detected in Comet Morehouse a few years earlier and some doomsayers had predicted that the Earth would be poisoned by the return of Halley's Comet. Astronomers at Greenwich and other observatories sought to reassure anxious members of the public that the Earth's atmosphere would protect them from such gases, but some were not convinced and were duped into buying gas masks and anti-comet pills.

Such hysteria surrounding the return of Halley's Comet was nothing new. First recorded by Chinese astronomers in 240 BC, the comet has long been regarded as a portent of doom, heralding ominous events such as the murder of the Roman Emperor Macrinus in 218 AD, or appearing above the ill-fated English army of 1066 in the Bayeux tapestry. Until the late seventeenth century, it was generally assumed that comets only passed once through the Solar System but this perception changed after English astronomer Edmond Halley (1656–1742) realised that the observations of specific bright comets throughout history were in fact repeat appearances of a single comet. Using Newton's recently developed mathematical theory of gravitation, Halley successfully predicted the comet's return in 1758 and it was duly named in his honour.

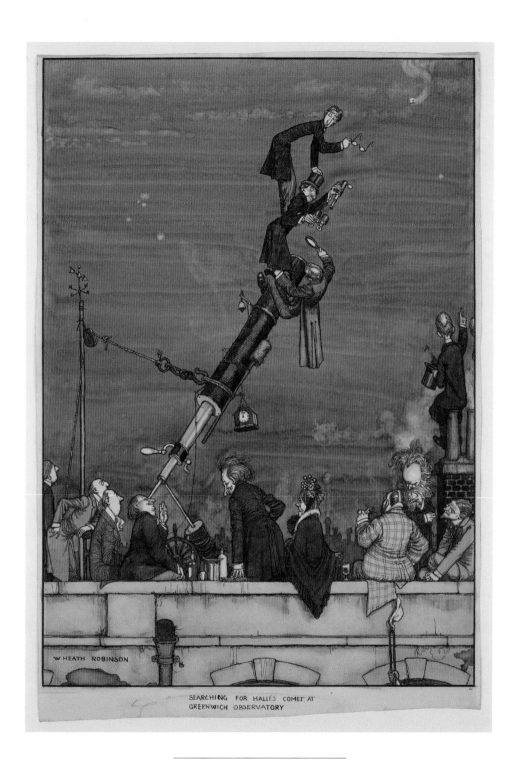

1909
Pen ink, monochrome watercolour, paper; 420 × 290 mm
ZBA5194

Scott of the Antarctic's sledge flag

Kathleen Scott

This Antarctic silk sledge flag, once owned by Captain Robert Falcon Scott, is designed as a medieval standard. It was made by his wife Kathleen (1878–1947), who became a noted sculptor. The flag has the cross of St George near the hoist, and the remainder is divided horizontally white over blue. The centre is embroidered with Scott's family crest of a stag's head and the motto: 'Ready Aye Ready' in brown, overlapping the join between the two stripes. The edge of the pennant is worked in twisted cream and blue cord.

Scott's flew this flag on his sledge on his last Antarctic expedition (1910–12), which had the joint aims of furthering the scientific work he had started in 1901 and of reaching the South Pole. The flag was also flown at the South Pole on 18 January 1912 when the Polar party finally reached it, a month after the Norwegian expedition led by Roald Amundsen. In fact, as the group photograph taken by 'Birdie' Bowers shows, five flags were flown by the Polar party: along with Scott's, there was the Union flag presented by Queen Alexandra, Dr Edward Wilson's sledge flag made by his wife Oriana, Bowers's self-made sledge flag, and a flag made by Teddy Evans's wife Hilda to be flown at the Pole. However, as Commander Evans was not selected for the Polar party, Bowers had promised to fly it on his behalf.

When Scott's party failed to return to the expedition hut in March 1912, the remaining men had to wait until the next Antarctic spring before setting out to find them. On 12 November, the tent containing the frozen bodies of three of the missing men was discovered about 11 miles south of One Ton Depot. As Cherry-Garrard wrote in his journal, 'To say it has been a ghastly day cannot express it – it is too bad for words.' The tent was dug out of the snow and they removed a large number of items, including this sledge flag, the diaries and journals, photographic negatives, a meteorological log, letters, spare clothing and, from the sledge outside, 30 pounds of geological specimens.

Scott's overshoes were also retrieved (shown left). The overshoes were made of sealskin with canvas sides and wooden heels sewn on with wire set in a groove. Their battered and split state indicates the extreme conditions the party endured when returning from the Pole. Ice abrasion has almost worn the fur away from the soles and uppers, as Scott and his team slowly attempted to reach the hut. The bamboo poles were then taken away and the tent became a shroud for Scott,

Wilson and Bowers. A large snow cairn was built over it with a cross made from skis on top. The rescue party held a brief memorial service before trying to find the body of Captain Oates a few miles further south, after they learned from Scott's diary how he had walked out to die in a blizzard rather than continue to slow his companions down because of his weakened and frostbitten state. His body was never discovered.

United Kingdom, 1910
Silk; 330 × 840 mm
ZBA1609; acquired with assistance from the Heritage Lottery Fund.

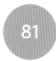

Gibson's of Scilly Shipwreck Collection

Gibson's of Scilly; Herbert or Alexander Gibson

This dramatic photograph (above) from the Gibson's of Scilly Collection is one in a series recording the breaking up of the three-masted steel barque *Cromdale* (1891) on the rocks off the Lizard, Cornwall in May 1913. The *Cromdale* ran aground in thick fog with a cargo of nitrates after 124 days inbound from Taltal, Chile to Falmouth. Its master, Captain Arthur, had fixed his position after speaking to a passing steamer but became concerned when neither the Lizard nor the Anthony lighthouses came into view. At 21.50, the helmsman spotted breakers in the gloom ahead, and before he could alter course the ship was aground on the rocks below Bass Point. The *Cromdale* settled rapidly by the stern and had to be abandoned in less than ten minutes. The next day, once the fog had lifted, the crew salvaged some of their personal items and the ship's instruments. A week later, a heavy south-south-westerly gale broke the ship up, as depicted in this photograph.

The Gibson photographic collection is the working 'archive' generated by the family firm, started by John Gibson in the 1860s. The full original collection covered a wide range of subject matter relating to Cornwall and the Isles of Scilly, including shipwrecks, Scilly gig racing, topographical views and life in Cornwall. In 2013, the Museum bought the shipwreck-related negatives, totalling some 1,700 images. The majority of these shipwreck photographs were created by John's two sons, Alexander and Herbert Gibson. They travelled extensively around the Cornish coast and the Isles of Scilly to record ships that were wrecked, grounded or salvaged there.

On occasion the brothers were at the scene of dramatic rescues. This crewman from the *City of Cardiff* (below) is suspended in a breeches buoy midway between the ship and the shore. When the *City of Cardiff* ran aground in a freshening southerly gale near Penzance in March 1912, the local volunteer Sennan Rocket Brigade arrived to help rescue the crew. Lines were fired by rocket from the shore to the ship, allowing those on board to be winched to safety. In this case the first across were the wives of the captain and chief officer, followed by the chief engineer with the chief officer's two-year-old son.

The result of the photographic skill and interest of five generations of the Gibson family is a collection that reflects the variety of shipping passing Cornwall from the 1870s to the 1990s, from small fishing vessels and rowing boats to large sailing vessels, steamships, passenger liners and warships. It includes the quirky, such as rescued cows being towed ashore to graze on unpopulated islands, and the poignant, such as the stacks of coffins in a mass grave, resulting from the loss of the *Mohegan* on the Manacles reef in 1898, when 106 people died.

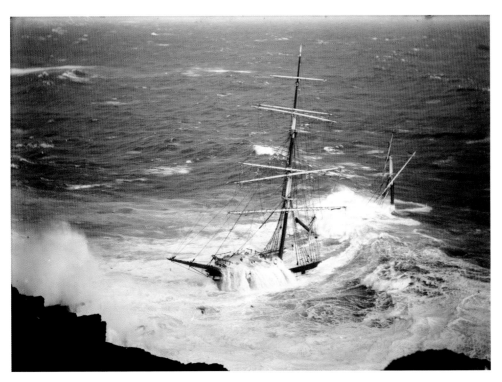

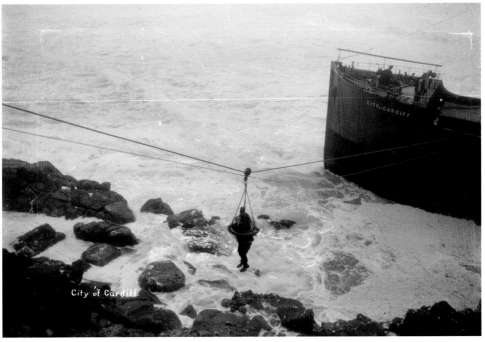

Lizard, Cornwall, late May 1913 (above); Near Penzance, March 1912 (below)
Prints from a glass plate negative; 6 × 8 in. (152 × 203 mm)
P50714 and P50704

82

'Ponko' the penguin

Ponko is a promotional stuffed toy based on photographic studies of Adelie penguins in the Antarctic by Herbert Ponting, named after his nickname. Ponting signed on as the official photographer for Captain Robert Falcon Scott's British Antarctic Expedition in the *Terra Nova*, 1910–12, becoming the first professional photographer to go to the Antarctic. As a joking aside, Taylor (one of the expedition geologists) invented the verb 'to pont', which meant 'to pose, until nearly frozen, in all sorts of uncomfortable positions' for a photograph.

Scott planned to continue the scientific work of his 1901–04 *Discovery* voyage but this time also to be the first to reach the South Pole. While Scott and four others died on the return journey from the Pole, the successes of the expedition are reflected in its significant scientific output and in the beautiful photographs composed by Ponting.

While Ponting (shown above on Ponko's label) was only there for the first 14 months, between late 1910 to early 1912, he exposed over 1,700 photographic plates and significant amounts of cine-film footage. This was to be formed into a visual narrative for a lecture series when Scott returned. Ponting assisted the scientists with studying the birds and animals of the Antarctic, especially the penguins. This interest in penguins is reflected in his photographs and in sections of the film that he produced afterwards to

commemorate the expedition and the deaths of Scott and his companions.

For the Museum, the Ponko toy tells two stories. First, it illustrates the commercialisation of polar exploration, as it seems to be one of the earliest pieces of merchandise to be sold in conjunction with a film. The film, Ponting's *Great White Silence* (which was later altered and extended), covered the story of Scott's last expedition and the research work it did in Antarctica, as well as recording the preparations and send-off for the push to the South Pole. The second story is the appeal this toy has for children: while Ponko never went to the Antarctic, he represents a familiar sight for them and opens the polar story for a new generation.

A larger version of Ponko features in a studio portrait photograph of Ponting and only one other example is known to exist.

United Kingdom, after 1913
Straw, wool, mohair; 420 × 210 × 275 mm
ZBA1691

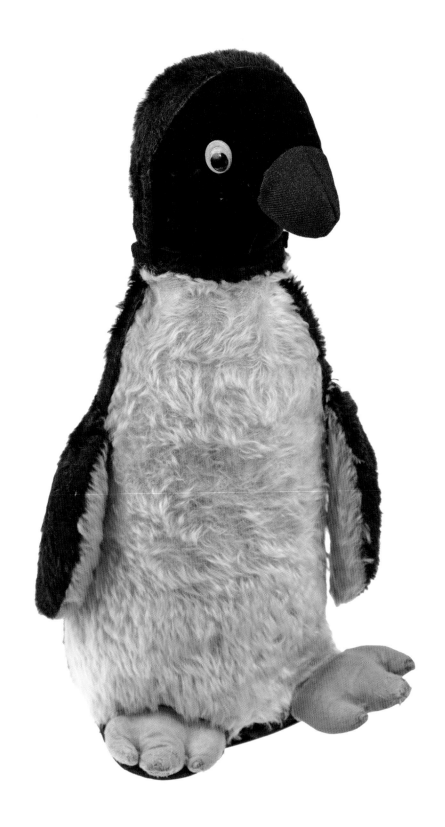

Dr Leonard Hussey's banjo

Arthur Octavius Windsor

This zither banjo, inlaid with mother of pearl, belonged to Dr Leonard D.A. Hussey (1894–1964), the meteorologist on Sir Ernest Shackleton's Imperial Trans-Antarctic Expedition of 1914–17. The banjo played an important role in the psychological welfare of the crew on board the expedition's ship *Endurance* and in the many months after it sank, when the chances of survival were extremely remote.

Shackleton's Antarctic expedition sought to cross the continent via the South Pole from the Weddell Sea to the Ross Sea. It was a two-pronged approach, with a party advancing from the Ross Sea laying supply depots for Shackleton, who was leaving from the Weddell Sea. However, the ice in the Weddell Sea was very bad in 1914, trapping and eventually crushing the *Endurance*. While the ship was stuck, the crew had to wait patiently for the ice to carry them northward again. The banjo was a source of light entertainment, as Shackleton recalled in his book *South* (1919):

> During the afternoon three Adelie penguins approached the ship across the floe while Hussey was discoursing sweet music on the banjo. The solemn-looking little birds appeared to appreciate 'It's a Long Way to Tipperary', but they fled in horror when Hussey treated them to a little of the music that comes from Scotland.

When the *Endurance* sank, the crew could only take a small number of personal items with them. However, Shackleton insisted on saving the banjo as 'vital mental tonic'. Once the crew had arrived on Elephant Island, it became even more important. After Shackleton and five others had departed in the *James Caird*, one of *Endurance*'s boats, to seek help from South Georgia, the banjo was frequently used to keep those left behind entertained and creatively occupied. Shackleton wrote afterwards:

> [It] did much to keep the men cheerful. Nearly every Saturday night such a concert was held, when each one sang a song about some other member of the party. If that other one objected to some of the remarks, a worse one was written for the next week.

The banjo has been signed by expedition members and others as follows: 'E.H. Shackleton, Frank Wild, Ruby Page le Brawn, Frank A. Worsley, L. Rickenson, George E. Marston, L.D.A. Hussey, A.H. Macklin, Frank Hurley, A.J. Kerr, F.W. Edwards, J.M. Wordie, T.O. Lees, C. Green, A. Cheetham, R.W. James, L. Greenstreet, Robert S. Clark, Harry McNeish'.

Birmingham, before 1913
Metal, mother of pearl, animal skin, wood; 110 × 950 × 335 mm
AAB0225; gift of Dr L.D.A. Hussey

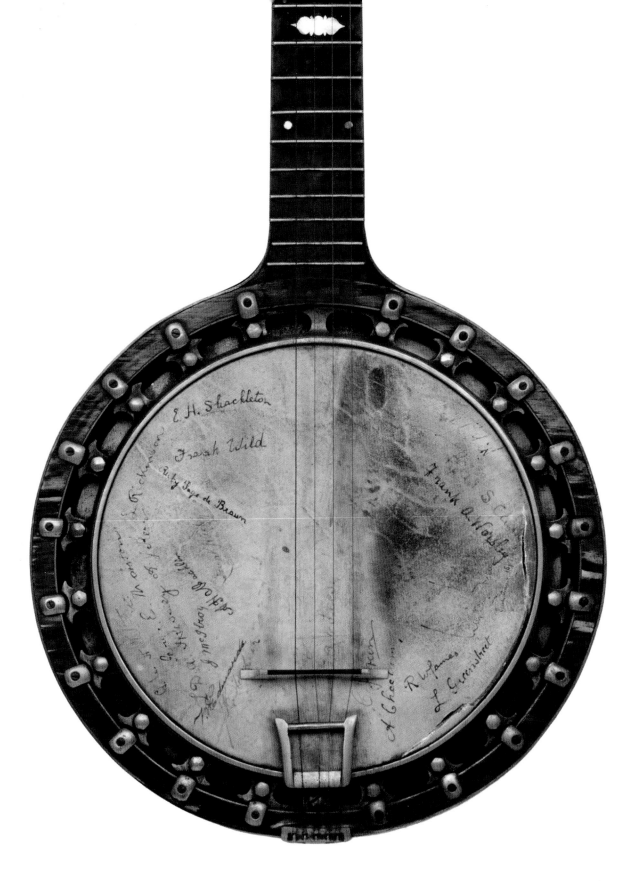

Liquid boat compass used in the *James Caird* rescue voyage

Kelvin & James White Ltd

This liquid lifeboat compass, complete with internal holder for a second reserve candle and shutter to cover the compass glass, was taken on Sir Ernest Shackleton's Imperial Trans-Antarctic Expedition in 1914. It is an unremarkable object with an extraordinary story to tell. After 11 months trapped in the moving ice of the Weddell Sea, the exploration ship *Endurance* was crushed. Useful items were salvaged from the wreck, both to help the crew survive on the ice as they waited for it to drift northwards and for when it eventually forced them to take to the three ship's boats and try and sail to safety. This compass was among them.

On arriving at Elephant Island in April 1916 the *James Caird* (the best of the boats) was modified for the 800-mile voyage to reach the whaling station on South Georgia. Shackleton (pictured above) selected Frank Worsley, Tom Crean, Henry McNeish, Timothy McCarthy and John Vincent to accompany him. The journey across the roughest seas on the planet lived up to expectations. Worsley described how the 22-foot boat 'pitched, rolled and jerked heavily, shipping seas all over as usual'. Life on board was horrific. The men were constantly wet; they slept for short periods in rotting, malodorous reindeer sleeping bags; they had to chip ice off the deck to prevent the boat capsizing; and could only cook by wedging the Primus stove between the feet of two off-watch crew.

The compass played a vital role. It helped to correct the steering after a night of sailing almost blind in the dark. Despite having candle holders, they only had an inch of candle and another six-inch candle to be used in emergencies, principally when approaching the coast. The inch of candle was lit for a few minutes and 'sheltered by our hands, its flickering light enabled the helmsman to correct the course ... no need to blow it out, the wind did that'. Without land to orientate the helmsman, the compass, in conjunction with the small flag at the top of the mast, allowed them to steer using the wind direction.

Worsley rose to the navigational challenges thrown at him on the voyage. He successfully piloted the *James Caird* to South Georgia having sighted the sun to fix his position only four times (and two of them mere glimpses) in the 16 days they were at sea. In the nightmare conditions, and over such a great distance, it would have been very easy for the smallest error in navigation to have caused them to miss the 104-mile-long island. On landing in South Georgia, Shackleton, Worsley and Crean crossed the mountainous and unmapped island in 36 hours to reach the whaling base on its north coast and began the process of recovering the remaining crew of the *Endurance* from Elephant Island. By the end of August 1916 Shackleton had achieved this and set about rescuing the final expedition members on the Ross Sea side of Antarctica. Despite everything, no men were lost.

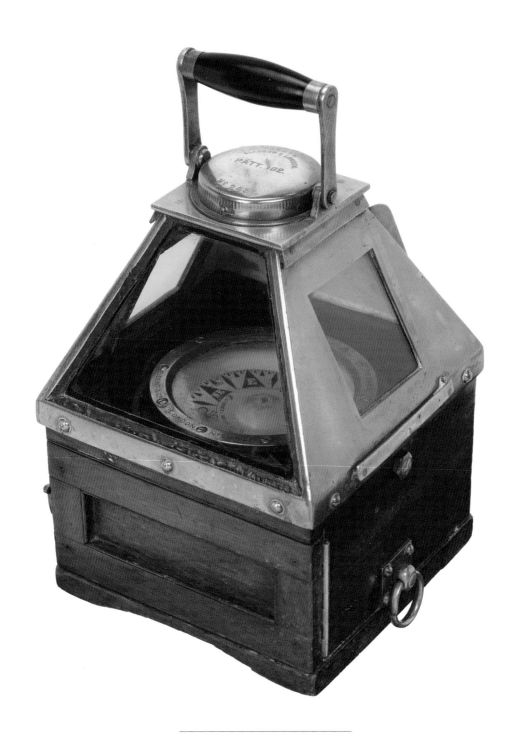

London or Glasgow, about 1914

Glass, alcohol, mica, wood, brass; 370 × 220 × 220 mm

ZBA1610

The Earl Howe Collection

Commander Viscount Curzon, later 5th Earl Howe

This group photograph of the Gunroom Glee Club concert party, in costume on board the battleship HMS *Queen Elizabeth* (1913), was taken in early 1916. The 19 midshipmen dressed up for this example of shipboard amateur dramatics show the lighter side of life in what was otherwise a dull and yet demandingly stressful existence.

This image is part of a larger collection of 389 negatives created by Commander Viscount Curzon (1884–1964) during his wartime service in HMS *Queen Elizabeth*. Curzon was assigned to the ship from 7 December 1914 until 17 September 1918. In addition to his regular duties he also served as one of the Fleet Photographic Officers, a new role in the First World War.

While his primary task was official photography, Curzon captured hundreds of 'unofficial' pictures of shipboard life in a variety of different circumstances. It is these images that comprise the bulk of his collection. As a group they represent a unique and important social narrative of life on one of the Grand Fleet's large warships.

Although weighted somewhat towards images of the officers, the collection's coverage is multifaceted. Formal group photographs abound and provide important historical documents. They mainly comprise groups of officers by rank but also include the *Queen Elizabeth*'s rowing and football teams. They also extend to the winners of serious shipboard competitions, such as the best shooting and loading teams among the gun crews.

Curzon photographed formal visits to the fleet, including separate ones by George V and the Bishop of London. On another occasion, despite a rather limited view of proceedings, he managed to photograph the award of the French *Médaille Militaire* to Chief Petty Officer Barry – a relatively junior member of the ship's crew.

Counterbalancing the more formal images, there are a significant number that were taken on impulse. Moreover, since their subjects were not always aware they were being photographed, these provide a very intimate portrait of 'day-to-day' activity. These pictures range from the horrific battle damage to HMS *Warspite* days after the Battle of Jutland in May 1916, to the curious and faintly amusing: for instance, crewmembers jammed into every conceivable space on the shelter deck to watch a boxing match refereed by the chaplain. There is also the intimate and heart-warming image of a young Orkney boy proudly showing off a large model of HMS *Iron Duke*, which he built from scraps of driftwood.

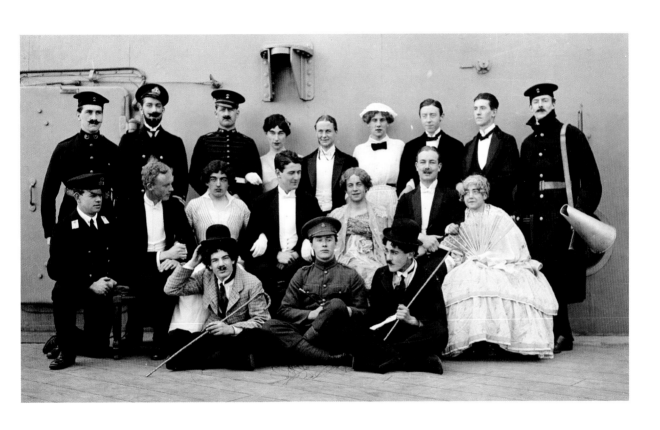

Scapa Flow, Orkney Islands, c.1916
Print from a silver halide negative on nitrate film; 110 × 160 mm
N16515 (detail)

Dame Katharine Furse's badge and star of the Order of the British Empire, 1st class

Garrard & Co.

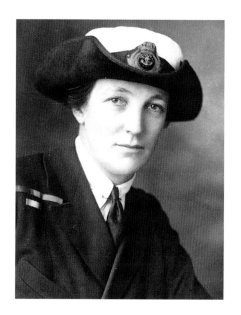

In 1917, Katharine Furse (1875–1952, pictured right) was one of five women appointed Dame Grand Cross in the newly created Order of the British Empire. She was awarded this honour in recognition of her work during the First World War in organising the Red Cross Voluntary Aid Detachments, which nursed wounded soldiers at home and abroad. But in November 1917 she resigned, unhappy at her lack of authority to institute change and make improvements. Keen to retain the services of a highly effective administrator, the government made her the director of a new organisation, the Women's Royal Naval Service (WRNS), with the equivalent rank of rear-admiral. By the time the service was disbanded in 1919, there were 7,000 Wrens (as its members became known) undertaking a variety of shore duties. Furse had introduced a distinctive uniform and demonstrated a role for women, however limited, in the Royal Navy. The service was revived during the Second World War, reaching a peak of 74,000 Wrens in 1944. A smaller peacetime corps

was retained and, until 1976, Wren officers were trained at the Royal Naval College in Greenwich. In 1990, 20 Wrens were selected for service at sea in the frigate HMS *Brilliant*. The success of this experiment led to the final disbanding of the WRNS and the full integration of its 4,535 Wrens into the Royal Navy and sea service.

Dame Katharine indulged her sporting pursuits between the wars, skiing in Switzerland with skill and determination. She also dedicated herself to the Girl Guides, becoming head of the Sea Guides and spending ten years as Director of the World Association of Girl Guides and Girl Scouts.

London, 1917
Silver, silver-gilt, enamel, silk; badge: 70 mm, star: 80 × 67 mm
MED1969.1–2

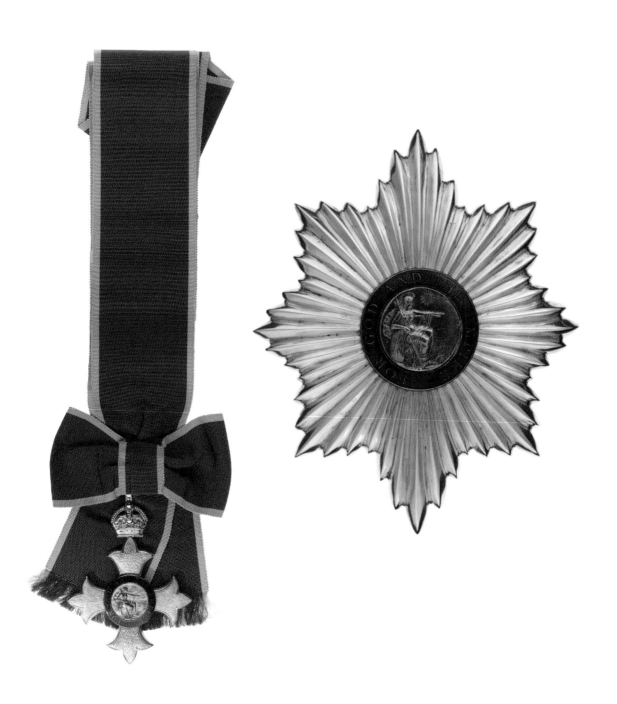

A Convoy, 1918

John Everett

Throughout the First World War, the Royal Navy and merchant shipping were increasingly under threat from German U-boats. The merchant fleet maintained indispensable lines of supply and communications, sustaining the British home and fighting fronts in equal measure. *A Convoy, 1918* by the prolific artist John Everett (1876–1949) shows a convoy of cargo ships, one flying the American flag, painted with 'dazzle' patterns. Dazzle was the brainchild of the marine and commercial artist Norman Wilkinson, and was intended primarily to deceive enemy submarines about the size, outline and course of a ship, making impossible to assess speed and distance.

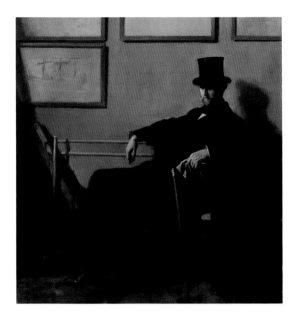

Wilkinson's concept relied on a series of strong, contrasting geometric patterns painted on the sides and upper works of a ship, creating false bow lines and breaking up its natural silhouette. In his proposal, sent to the Admiralty Board of Inventions and Research, he explained that 'the idea is not to render the ship in any degree invisible, as this is virtually impossible, but to largely distort the external shape by means of violent colour contrasts'. With the backing of the Ministry of Shipping, a 'Dazzle Section' was set up in the Royal Academy Schools rooms in the basement of Burlington House, Piccadilly. Because men were required for active service, most of the art students and artists engaged in painting the ship models with dazzle designs were women.

Unauthorised open-air drawing and sketching in sensitive areas, such as ports and naval bases, was forbidden under the wartime Defence of the Realm Act. The Ministry of Information, charged with national publicity and propaganda, approached Everett and gave him permission to paint scenes in the London docks. He spent the ensuing weeks outside capturing the dazzle patterns on the ships, often within unconventional compositions that further accentuate their abstract quality. *A Convoy, 1918* was possibly done to demonstrate how the asymmetry of dazzle tricked the eye, particularly the way in which the crazily slanting lines no longer offered a clear horizon.

John Everett (shown above in a portrait by William Orpen) was a fascinating figure who voyaged the world by sail and steam for the purpose of painting the sea and ships. He had the benefit of inherited private income and, since he did not need to sell much of his output, he bequeathed most of it (over 1,500 paintings and drawings) to the National Maritime Museum.

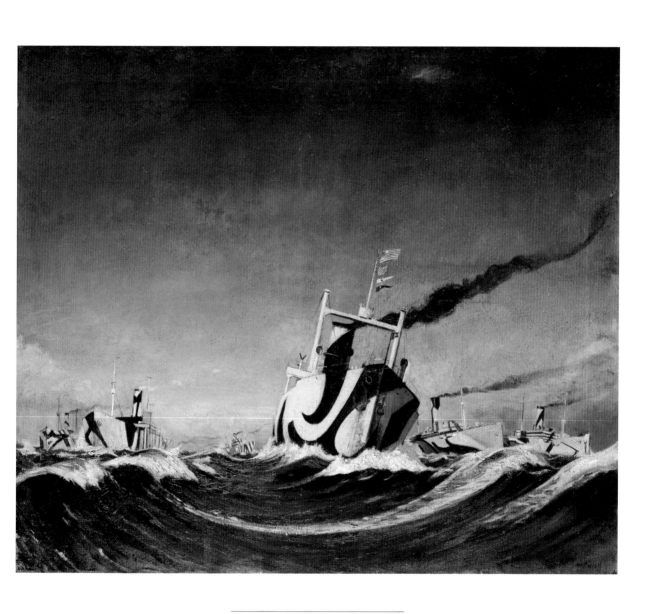

1918
Oil on canvas; 796 mm x 952 mm
BHC1387; bequeathed by the artist 1949.

Punchbowl commemorating the surrender of the High Seas Fleet, 1918

Painted by James Edwin Dean for Minton

This rare porcelain punchbowl commemorates the surrender of the German High Seas Fleet to Vice-Admiral Beatty, Commander-in-Chief of the British Grand Fleet in the Firth of Forth in November 1918. Under the terms of the Armistice, the German fleet was interned at Scapa Flow in Orkney. The surrender was codenamed 'Operation ZZ' and represented the final stage of the German capitulation, taking place ten days after the guns had fallen silent along the Western Front. The German Navy was escorted north by a massive British fleet of nearly 200 ships: together they formed the greatest assembly of warships in naval history. A correspondent for *The Times*, reporting from HMS *Queen Elizabeth*, wrote:

> The annals of naval warfare hold no parallel to the memorable event which it has been my privilege to witness today. It was the passing of a whole fleet, and it marked the final and ignoble abandonment of a vainglorious challenge to the naval supremacy of Britain.

Internment at Scapa Flow was a demoralising affair for the crews of the German ships, made worse by poor food, little opportunity for recreation and ineffective communication with loved ones in Germany. The issue of what to do with the fleet was the subject of considerable debate among the Allies but any thought of 'cherry-picking' the best of Germany's naval might was ended on 21 June 1919. At 11.20 that morning, Admiral Ludwig von Reuter ordered the scuttling of the German fleet and one by one the ships sank to the sea-bed, denying the enemy any spoils of victory.

The bowl has a gilded rim and foot, and a gilt band of twisted rope separates the lower, deep-blue ground from the painted upper border. This scene by the chief painter at Minton, James Edwin Dean (1863–1935), has a view of the fleet with an airship overhead. An inscription, also surrounded by a gilded rope border, reads: 'Admiral Sir David Beatty's Signal. "The German Flag is to be hauled down at sunset to-day and is not to be hoisted again without permission" 21st November, 1918.' The underside of the bowl bears the maker's mark and also the name and address of the retailer, John Ford & Co., 39 Princes Street, Edinburgh. Presumably this firm, selling high-end glass and chinaware, either purchased the bowl for a specific client or thought the event was of local interest and hoped they would find a buyer. The Museum acquired it in 1976.

Stoke-on-Trent, 1918
Porcelain; 125 × 245 mm
AAA5185

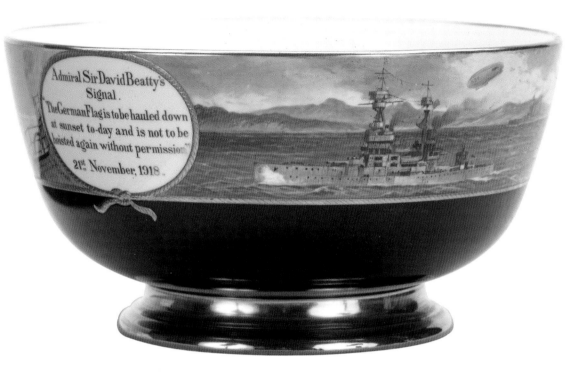

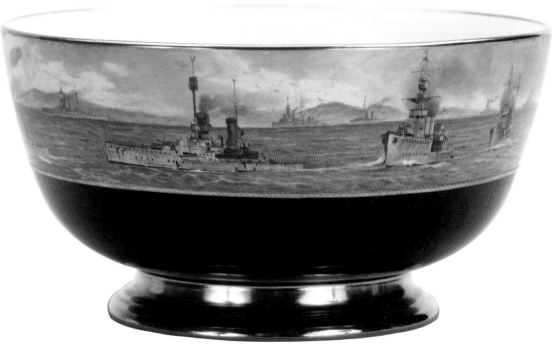

Glass positive of the 1919 total solar eclipse

Taken just six months after the end of the First World War, this photograph (a glass-plate positive) changed our perception of the Universe. A few years earlier, physicist Albert Einstein published his radical theory of general relativity, in which he argued that the gravitational field surrounding the stars distorted time and space around them. He proposed that a total solar eclipse would offer the best opportunity to view this distortion and confirm his theory. With the next eclipse predicted to occur on 29 May 1919, astronomers around the world began to plan how best to observe this event. By February of that year, two teams from the Royal Observatory set sail to establish observing stations on the island of Principe, off the west coast of Africa, and in Sobral, northern Brazil. Both lay within the narrow geographical band in which the solar eclipse of 1919 appeared total, as the Moon's orbit took it directly between Earth and the Sun.

Einstein's theory predicted that an eclipse would make the bending of starlight observable as it is distorted by the Sun's gravitational field on its journey to Earth, an effect that would normally be invisible owing to solar glare. The challenge for astronomers was to take precision photographs on glass plates before, during and after the eclipse to see if they could capture and measure star positions that would change by a fraction of a millimetre across the series. To help minimise errors, they used a series of mirrors mounted on clockwork drives that tracked the Sun's apparent movement across the sky, keeping its disc firmly in the field of view.

Thankfully, the weather in Sobral was beautiful on eclipse day and 27 photographic plates were taken, including the one shown here, which features an eruption of gas from the solar surface known as a prominence. The astronomers cabled back to Greenwich: 'Eclipse splendid.' Across the Atlantic in Principe, thunderstorms partly obscured the Sun and groups of mischievous monkeys clambered across the site and threatened to ruin the meticulous calibration of the instruments. Nevertheless the overall results of the British eclipse expedition appeared to confirm Einstein's predictions and the event is regarded as an important moment in the acceptance of his theories. For one of the Principe astronomers, A.S. Eddington, the expedition was more than just a scientific success. As a conscientious objector during the First World War, he escaped military service thanks to the intervention of the Ninth Astronomer Royal, Frank Dyson, who argued that his mathematical talents were ideal to prepare for this challenging experiment. Vindicated by his persuasive results, Eddington wrote to Einstein in December 1919 saying, 'It is the best possible thing that could have happened for scientific relations between England and Germany.' This glass plate thus serves as a powerful reminder of a significant moment both in science and in international cooperation.

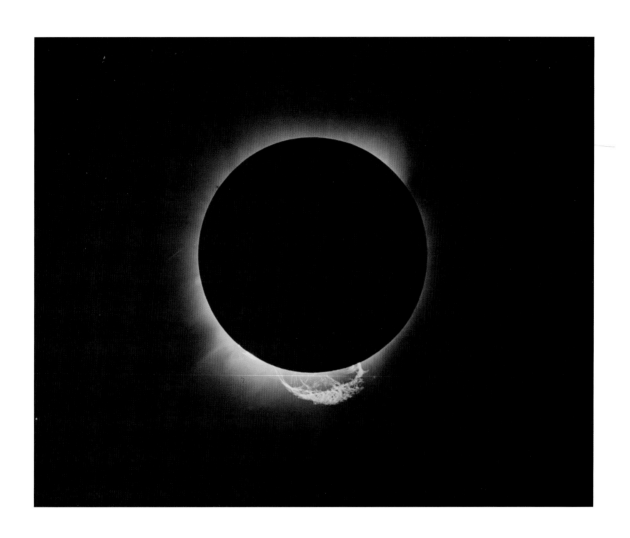

Sobral, Brazil, 1919
Glass-plate positive; 255 × 300 mm
AST1093 (detail)

The Richard Perkins Collection

This atmospheric photograph depicts the Royal Navy battle-cruiser HMS *Hood* (1918) under way at speed in the North Sea during her steaming and gunnery trials between 5 and 29 March 1920. It has been produced from a copy negative in the Richard Perkins Collection but unfortunately, the original photographer is not known.

Richard Perkins was born 16 June 1904 in Honolulu, Hawaii, the eldest son of zoologist Robert C.L. Perkins and his wife Zoë. By 1911 he was resident in Paignton. He remained in Devon for the rest of his life, dying at home in Bovey Tracey, Devon, on 21 March 1985.

Perkins had a lifelong interest in the ships of the Royal Navy and about 1925 he started to photograph warships, mainly at Portsmouth and Devonport. In 1930 he was a founding member of the Naval Photograph Club – an association of collectors of warship images from the beginning of photography, both British and foreign, that is still in existence. In the early 1930s Perkins bought negatives from commercial photographers, whose businesses were closing, including Amos at Dover, Coates from Harwich, Seward of Weymouth, Adamson & Robertson on the Clyde, and four companies in Portsmouth (Cozens, Hopkins, Owers, and West).

The start of the Second World War in 1939 forced Perkins to cease his outdoor activities. He then owned about 3,000 large glass-plate negatives and started making smaller copy negatives of most of these. He also extended the range of his collection by making copy negatives of older photographic prints, including many from the albums of Dr Oscar Parkes. Perkins's collection, as now held by the Museum, comprises 12,200 negatives. While it mainly covers ships from the 1860s to 1939 and is rightly regarded as the pre-eminent resource of Royal Navy warship photographs over that period, it also extends to 1946 owing to further negatives he acquired for that period from Lieutenant-Commanders Derisley Trimmingham and P.W. Ratcliffe, and from Captain T.D. Manning.

Perkins also produced eight volumes of highly accurate and detailed profile drawings showing all Royal Navy ships from the *Warrior* (1860) up to those in commission in 1939. These drawings detail changes of appearance from modifications made throughout each vessel's career, and these are such a valuable resource for identifying ships at particular dates that the Museum has now published them as a set of printed volumes.

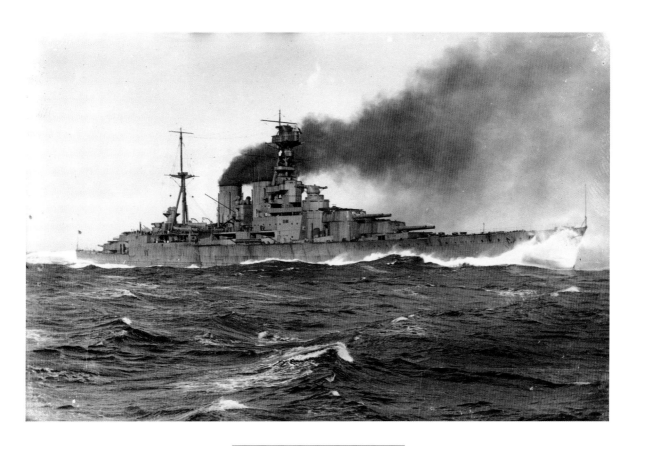

North Sea, 5 to 29 March 1920
Print from a glass and silver halide negative; 89 × 134 mm
N722

Miss Britain III

Hubert Scott-Paine

Miss Britain III of 1933 was a revolutionary speedboat designed, built and driven by Hubert Scott-Paine (1891–1954), a noted pioneer of flying boats and fast naval attack craft. He owned the Southampton-based British Powerboat Company, which specialised in mass production of small, fast hydroplanes, dinghies, motor cruisers and launches. He developed sea launches, aircraft tenders and motor torpedo-boats during the 1930s. The last, along with motor gun-boats, became the foundations of Britain's coastal defence force in the Second World War. *The Times*'s obituary of Scott-Paine specifically credited *Miss Britain III* as a developmental forerunner of them, and for the RAF's sea-rescue launches.

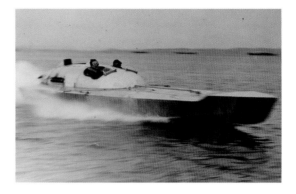

Miss Britain III was designed and built in secret as a challenger to Garfield Wood's *Miss America X*, which then held the Harmsworth Trophy for international powerboat racing. The contrast between the two contestants made the event famous: it was watched by over 250,000 people.

Miss America X was 12 metres (38 feet) long with four engines totalling 7,800 horsepower. In contrast, *Miss Britain III* was only 7.4 metres (24 feet) long and fitted with a single 1,375 hp engine. The wooden and aluminium hull frame was covered with alcad, a highly polished pure aluminium, which reduced drag and resisted corrosion in salt water. Scott-Paine also relied on the hydroplane stepped-hull shape and a specially designed single propeller to maximise speed potential. Even the duralumin countersunk hull screws were aligned with the water flow.

Although the public cannot see inside the speedboat, Scott-Paine's two St Christopher medallions are attached to the dashboard, reflecting his faith but also his recognition of the dangers of pushing the boundaries of hull design and speed limits. In fact, when *Miss Britain III* shed a propeller blade during trials, the blade shot through the light hull just behind the pilot's seat. Scott-Paine had a similarly lucky escape after returning from the Harmsworth Trophy when a broken fuel feed ignited and caused an engine fire.

Unfortunately, *Miss Britain III* was narrowly beaten in the Harmsworth Trophy. However, in that same year she was the first single-engined boat to pass the 100 mph (161 km/h) mark on salt water in the Solent. In 1934 Scott-Paine won both the Prince of Piedmont's Cup and the Count Volpi Cup, setting a world record with a speed of 110 mph (177 km/h).

In 1951 Hubert Scott-Paine presented *Miss Britain III* to the National Maritime Museum, where it is displayed with its restored engine – a Napier 'Lion' series VII B.

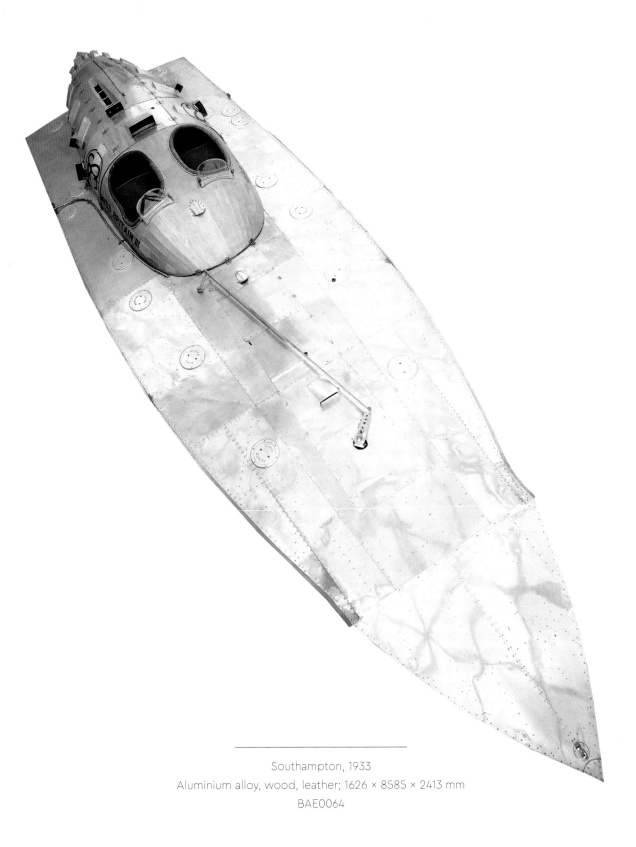

Southampton, 1933
Aluminium alloy, wood, leather; 1626 × 8585 × 2413 mm
BAE0064

The Waterline Collection

Marine Photo Service, later Waterline

These images are part of the Waterline Collection, which comprises 16,505 negatives focusing on the 'golden age' of ocean-liner cruise travel from the 1930s up to the very early 1970s. This brilliantly composed black-and-white image (right) shows the imposing port side of the new liner *Stratheden* (1938) moored alongside the Riva degli Schiavoni in Venice, one of the ports of call on her maiden voyage. The careful composition of the image is reflected in the inclusion of the recognisable bridge and the building to the right, which lead the viewer's eye towards the ship, whose lines and superstructure are not obstructed.

The colour picture (opposite) was taken on board the *Empress of Canada* (1960) and shows two contestants playfully battling for dominance in the greasy-pole competition in the mid-1960s. This was a very popular event and spectator sport, often proving quite competitive, with many ships running 'leader boards' to determine an overall winner.

The contrast between the still formality of the older image and the much more relaxed *Empress of Canada* picture could not be greater. It serves to illustrate not just the range of images in the collection, but also the different tone captured by the photographers, reflecting the changed atmosphere of post-war cruising.

Prior to that conflict, the pictures show shipboard society still bound by the rigid social conventions of the era, most notably in the manner in which the subjects are 'correctly' dressed, even for leisure activities. Many of the people in these pictures are either 'posed', or have consciously reacted to the presence of the camera. The character of the images from the 1950s onwards is very different, showing a much greater degree of casualness and spontaneity, although even this was often carefully staged.

Like some of the other 'gems' in the Museum's care, the Waterline Collection is fortunate to have survived. It was the creation of the Marine Photo Service, which came into being in the 1920s as a specialist firm that catered to passengers on Union Castle liners. As the first company to offer such a service, they enjoyed immediate success and soon numbered Cunard White Star and Peninsular & Orient (P&O) among their clientele. The company went from strength to strength until the severe recession of the early 1980s, which led to its being finally wound up by 1994. A large portion of their negatives endured inappropriate housing in a shed. Two years later a significant percentage was purchased by the National Maritime Museum.

Aboard *Empress of Canada*, exact location uncertain, 1960s (above)
Print from a cellulose acetate negative; 61 × 62 mm
P85862CN

The passenger liner *Stratheden*, Venice, 1938–39 (opposite)
Print from a cellulose-nitrate negative; 117 × 168 mm
P85031

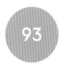

93

Withdrawal from Dunkirk, June 1940

Richard Eurich

This is one of a group of 11 oil paintings by the official war artist Richard Eurich (1903–92) allocated to the National Maritime Museum after the Second World War by the War Artists Advisory Committee (WAAC). It depicts the mass evacuation from Dunkirk of the British Expeditionary Force and Allied forces between 20 May and 4 June 1940. In all, 366,162 men escaped in naval vessels and, famously, in a mass of small boats from the north coast of France to England.

During the Second World War, the WAAC commissioned artists to cover general naval and maritime experiences, including areas of support operations and life on the home front. Under the chairmanship of its founder, Sir Kenneth Clark, the Committee also raised British public morale by showing the work in a series of exhibitions in the National Gallery, of which Clark was Director. Recognising the Dunkirk episode as an epic subject, and with many of the 'little ships' bringing exhausted troops into Southampton where he lived, Eurich secured the commission (for £50) from WAAC in July 1940.

The painting is panoramic in effect, as if viewed through a wide-angle lens or from the perspective of a low-flying aircraft. The artist's spacious composition, minute detail and use of colour all capture the dramatic events as they unfold. The work is not that of an eyewitness but was completed over three weeks using a combination of notes, first-hand accounts, sketches made the previous summer (just before the war broke out) and photographs.

Eurich's menacing cloud of smoke rising from Dunkirk's port, as backdrop to a deeply receding panorama of evacuation from the beaches, was featured in the *Illustrated London News* (7 September 1940). *Withdrawal from Dunkirk, June 1940* was a sensation with the public and the image was used as the Navy's Christmas card for 1940. In 1941, for the 'Britain at War' exhibition at the Museum of Modern Art, New York, it was both the dust-cover image and the frontispiece of the catalogue.

Eurich saw himself as an heir to Willem van de Velde the Younger and J.M.W. Turner, whose traditions he thought 'should be carried on to enrich and record our heritage'. He was also much influenced by the naïve paintings of Christopher Wood, who painted fishing communities on the coast of Brittany. In treating war subjects in home ports and incidents at sea, Eurich was perhaps the most significant modern marine painter to cover the 1939–45 conflict. His *Withdrawal from Dunkirk, June 1940* is one of the best-known examples. He created a companion piece – *Dunkirk Beaches, May 1940* – now in the National Gallery of Canada.

1940
Oil on canvas; 762 × 1016 mm
BHC0672

Diver (print from the 'Submarines' series)

Eric Ravilious

In February 1940, Eric Ravilious (1903–42), painter, graphic artist and designer, was assigned to the Royal Navy by the War Artists' Advisory Committee (WAAC) and given the rank of captain. Initially, he spent time at barracks in Chatham, Sheerness, Grimsby and Scapa Flow. This print, worked up from an earlier sketch (also in the Museum's collection), shows a diver being prepared to operate in the flooded floor of a dry dock, probably at Grimsby. It forms part of the 'Submarines' series that Ravilious developed when he was posted to HMS *Dolphin*, the Royal Navy shore station for submarine training at Gosport in August 1940. This gave him the opportunity to capture the claustrophobic atmosphere experienced by both artist and crew in the L-class submarines used for training. In a letter to his friend and fellow artist Helen Binyon, Ravilious described the challenge of 'trying to draw interiors': 'Some of them may be successful, I hope, but conditions are difficult for work. It is awfully hot below when submarines dive and every compartment small and full of people at work.'

Based on detailed drawings, photographs and preparatory studies (such as the sketch shown

above), the 'Submarine' series of lithographic prints represents Ravilious's most coherent group of wartime works. The WAAC considered reproducing the studies as a children's colouring book but the cost was so high that Ravilious published the prints himself.

In 1942, Ravilious was reassigned to the Royal Air Force and that summer went to Iceland, where his aircraft was lost during a rescue operation. He was the first of three official war artists killed on active duty during the Second World War.

1941
Coloured lithograph; 343 × 305 mm
PAD8073

Eric Ravilious

195

The Sailor (Maurice Alan Easton)

Henry Marvell Carr

In the twentieth century, ordinary sailors and their activities provided the focus for artists such as Henry Marvell Carr (1894–1970), marking a significant departure from the paintings of admirals and senior officers that dominated earlier years. Carr's sailor wears the square rig of an ordinary seaman and a naval cap with the anonymous 'HMS' tally band – a wartime precaution to prevent the enemy knowing precise ship movements. On his right arm he wears the radio communicator's badge, which identifies him as a telegraphist.

During the Second World War, efforts were made by the Admiralty to raise the status of those traditionally marginalised in previous conflicts. Thus ordinary sailors and women, whether in the WRNS or other auxiliary services, were photographed by the accredited war photographer Lee Miller, or appeared in portraits commissioned by the War Artists Advisory Committee. Carr was working as an official war artist in Naples when he painted Maurice Alan Easton (1923–2006), a 'hostilities-only' rating who was a railway booking clerk from Oxfordshire in civilian life. An undated clipping from the popular *Sunday Dispatch* (1946)

gives Easton's candid version of Carr's selection process:

> I was staying at an hotel in Naples, waiting for a draft to Corsica, and one day when I walked into the place I saw a line of matelots being inspected by Captain Carr. It looked to me like an identification parade, so I beat a hasty retreat upstairs. I hadn't got very far, when a voice called out "That's the man I want".

Carr exhibited the portrait in the Navy League's post-war Naval Art Exhibition held at the Suffolk Street Galleries, London, in 1946. Entitled simply *The Sailor*, Carr clearly meant to portray a type of 'naval manliness', handsome, professional, direct and steadfast, that would appeal to the British public. The image was also used as a poster for the show, which greatly astonished Easton when he was sent back to London and saw his face on the advertising billboards.

The Museum had no idea who the sitter was until 1975, when an acquaintance of Maurice Easton's sent in the press-cutting mentioned above.

1944
Oil on canvas; 762 × 635 mm
BHC2675

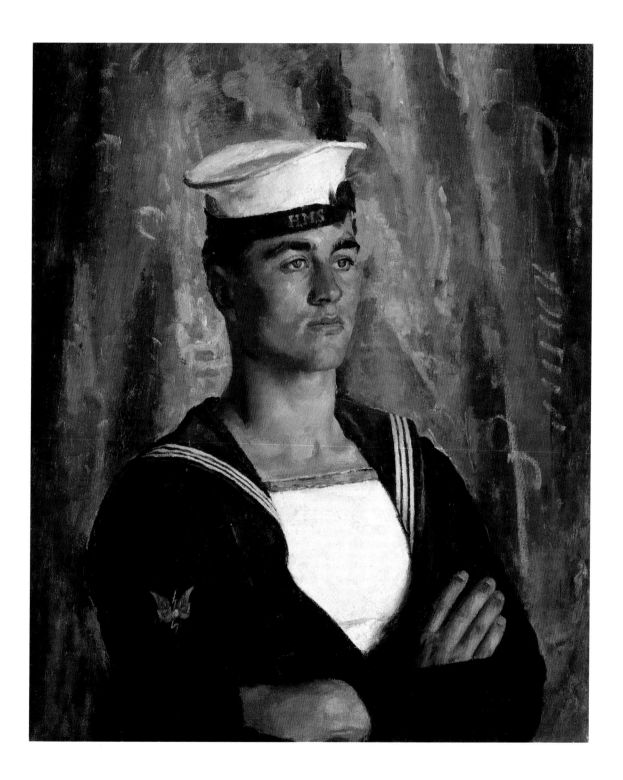

300-Inch Map of the Moon

Hugh Percy Wilkins, 1952

To the naked eye, the Moon appears to be dappled with light and dark markings, but most of its surface detail is invisible without the aid of a telescope. For this reason the science of selenography, or mapping the Moon, only really began in the early seventeenth century with the observations of telescopic pioneers such as Galileo Galilei and Thomas Harriot. The subsequent history of lunar mapping includes some of the greatest names in astronomy, such as Johannes Hevelius and Giovanni Domenico Cassini, but there were also notable achievements by dedicated amateurs. Among them are the eighteenth-century artist John Russell, whose extraordinary lunar globe, the Selenographia, is also in the Museum's collection (see page 108), and Hugh Percy Wilkins (1896–1960), a Welsh engineer and civil servant whose colossal 300-inch map is a high-water mark in twentieth-century lunar cartography.

Wilkins was an amateur in the full sense of the word, with an abiding love of astronomy since his childhood and a particular fascination for the Moon. He became adept at building his own telescopes and by 1924 had already completed and published his first lunar map, showing the lunar disc at a diameter of 60 inches, with a 100-inch map following ten years later. These achievements won him the respect of the astronomical community, including the broadcaster and noted lunar observer Patrick Moore, with whom he worked closely. When Wilkins was appointed Director of the British Astronomical Association's Lunar Section in 1946 he was already planning a new, even larger lunar map, this time displaying the Moon at 300 inches (25 feet/7.62 m) across.

Wilkins's stylised cartography was able to synthesise the results not just of photographic surveys by some of the world's most powerful telescopes but also decades of his own observations and drawings of the Moon, and those of his team of British Astronomical Association volunteers. The 1952 edition of the map, issued as a set of 27 separate sheets, contains over 85,000 individual features. This attention to detail was to prove particularly important in 1959, when the Soviet *Lunik 3* probe sent back the first-ever pictures of the hidden 'far side' of the Moon. Wilkins had included supplements on the 'libration zones' around the edge of the lunar disc, where a slight wobble in the Moon's axis periodically allows glimpses of the far-side terrain, and these were used by Soviet scientists to connect the topography of this mysterious hemisphere to that of the familiar near side. The 300-inch map was also among the resources acquired by NASA to help select the most promising landing sites for the manned *Apollo* missions of the 1960s and 70s.

State-of-the-art lunar maps now include details down to a few metres in size and incorporate altimetric, geological and gravimetric data. But in scale and ambition Wilkins's 300-inch map remains one of the great achievements of lunar cartography and serves as a reminder of the ongoing contribution of amateur astronomers to our understanding of the cosmos.

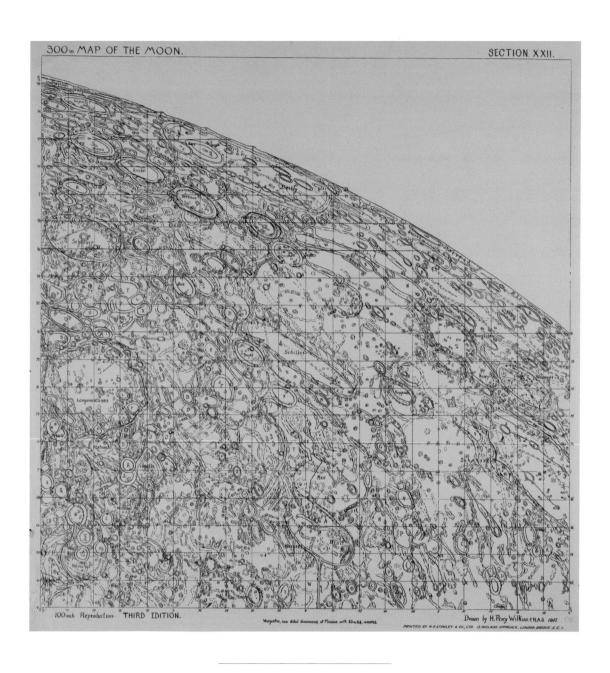

London, 1952

Paper; 27 individual sheets, each 550 × 540 mm

ZBA4573

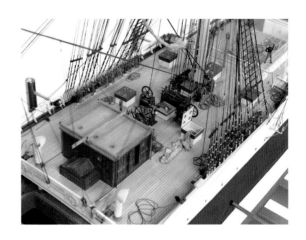

Moshulu, four-masted barque

Kenneth Ross and Donald Bradley

Because Britain does not have a surviving example of a large four-masted steel sailing ship, in the late 1970s the National Maritime Museum decided to commission a definitive scale model that would replicate the materials and methods of their construction. The result is this remarkably detailed model, which took more than 35,000 hours to build over an eight-year period.

The four-masted barque *Moshulu* was eventually chosen, as it represented the pinnacle of design and development of the merchant sailing ship, able to compete on a profitable basis against steamships of the day. Built by Alexander Hamilton & Co. at Port Glasgow in 1904, it measured 335 feet in length by 46 feet in the beam (102.1 x 14 m) and was the largest sailing barque in the world, twice the size of the tea clipper *Cutty Sark*. The hull, masts and yards were constructed from riveted steel supported by state-of-the-art wire rigging. The sail area was a massive 45,000 square feet (more than an acre, or 4180 sq. m) set on 35 canvas sails operated by a crew of only 19. In the right conditions, the *Moshulu* could attain a speed of 17 knots. Furthermore, it had the advantage of giving over all of its hold to cargo, whereas steamers required space for engines and bunkers for oil or coal.

The ship was made particularly famous by one of Britain's well-known travel writers, Eric Newby, in his bestselling book *The Last Grain Race* (1956). He had served as an apprentice in *Moshulu* in 1938–39, and he captured life afloat during one of its last commercial voyages with cargo. Then under the ownership of renowned Finnish shipowner Gustav

Ericson, *Moshulu* won the last pre-Second World War race, setting out from Port Victoria, Australia with 4,875 tons of grain to Queenstown (Cobh), Ireland, taking only 91 days.

The challenge faced by the model makers was to recreate accurately at scale the materials and methods used. First, the hull shell was cast in fibreglass, to which 720 hull plates were attached, complete with over half a million simulated rivet heads – a very time-consuming and complex process. There was also some doubt as to whether the hull was fitted with bilge keels. Fortunately,

Moshulu is still afloat as a restaurant ship in Philadelphia. The model makers contacted the local police department, which sent their divers down, and they were able to confirm their existence.

The masts and spars are made from turned aluminium with simulated riveted plating. The wire rigging was actually laid-up to scale using the correct method of seven strands over one central core.

Birmingham, 1981–88
Metal, glass fibre, steel wire, wood, textile, cordage, paint, varnish; 1650 × 2240 × 1815 mm
Scale 1:48 (¼-inch to the foot)
SLR0357

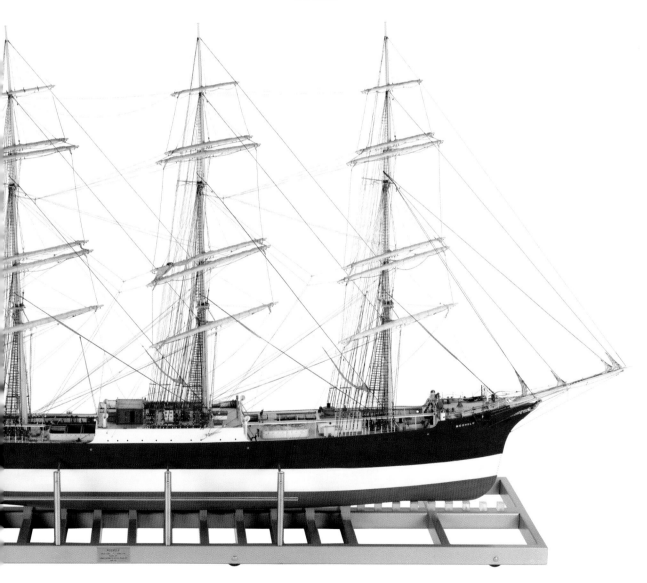

The First of England

Humphrey Ocean

In the 1990s, a number of works by significant artists were commissioned by the Museum as part of an initiative to encourage artistic exploration of Britain's contemporary and changing relationship with the sea.

The First of England is a large-scale oil painting based on sketches and photographs taken by Humphrey Ocean (b.1951) during a ferry trip from Dover on a warm, hazy October day. In Ocean's words:

> I was commissioned to paint a picture about modern maritime Britain and *The First of England* is my response. I imagine a fair proportion of Britons have at one time or another been on a ferry, which is now the extension of the car, as well as being a floating high street. Oddly, while I was doing the painting, I thought quite often of the First World War. The 'moustached archaic faces' from the poem 'MCMXIV' by Philip Larkin, describing a nation of innocents, were brought to mind by my 50-pence-each-way crowd returning to the White Cliffs from a day-trip, neither shattered nor shell-shocked nor dead, fortunately, but bearing a trolley of duty-free lager and three Toblerones for the price of one.

Ocean's *The First of England* acknowledges Ford Madox Brown's famous Pre-Raphaelite painting *The Last of England* (1855, in Birmingham Museum and Art Gallery), which examined the social and national significance of sea travel in the nineteenth century. Significantly, it also represented a common shared experience – that of mass emigration, which took place among the working classes during the 1850s. In that painting we see an artist emigrating to begin a new life in Australia with his wife and baby, with eyes fixed firmly ahead and the white cliffs receding behind them.

Ocean's painting of modern maritime Britain also portrays a collective experience – a shopping trip in France. He comments on the significance of sea travel for the British today, and shows an unromantic image of their relationship with their coastline. The people appear uninterested in their surroundings and oblivious to each other; no-one looks at the figure lying on the bench, not caring if he is drunk, dead or just asleep. In the tradition of post-war British pop art, the artist selects an object that symbolises the everyday: here a polystyrene cup sitting in the emptied-out foreground captures the resignation of drinking stale coffee, whether on a ferry or at a roadside café. Despite their seeming nonchalance, the totemic white cliffs of Dover are still able to claim dominance – a symbol of home and wartime defence.

The original memory sketch (shown above) in which Ocean established the composition, colours and feeling of the final painting is also in the Museum's collection.

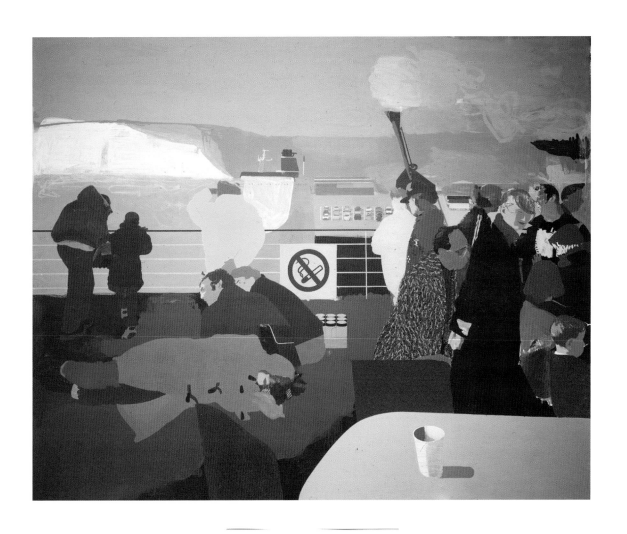

1998
Acrylic on canvas; 2490 × 3100 mm
ZBA0739

Nelson's Ship in a Bottle

Yinka Shonibare MBE, RA

Nelson's Ship in a Bottle draws on the popular nineteenth-century pastime of mounting a fully rigged ship model inside a bottle. The technique of erecting prefabricated masts by means of cotton threads running through the neck of the bottle is no longer a secret. However, as the British-Nigerian artist Yinka Shonibare (*b.*1962) attests, 'A ship in a bottle is an object of wonder. Adults and children are intrigued by its mystery. How can such towering masts and billowing sails fit inside such a commonplace object?' This oversized version contains a 1:30 scale replica of Admiral Nelson's flagship, the *Victory*, on which he died during the Battle of Trafalgar on 21 October 1805. Complete with 80 guns (*Victory* in fact had nearer 100), the ship's 37 large billowing sails are made of richly patterned textiles inspired by Indonesian batik, and are set as on the day of the battle.

Both whimsical and subversive, Shonibare's symbolic 'message in a bottle' alludes to a range of historical, cultural and socio-political issues to blur the boundaries between ethnography, design and contemporary art. The use of richly patterned textiles in place of plain, functional sailcloth creates tension between a visual celebration of Nelson's victory over the French and Spanish fleet, and a political critique of that victory's impact. Indonesian batik, or 'Dutch-wax' fabric, was mass-produced by Dutch traders and sold in West Africa, where the characteristic bright colours and abstract designs rapidly became emblematic of African dress and identity. However, the textiles have also accrued many complex and often ambivalent associations with colonialism, industrialisation,

emigration, cultural appropriation and the invention (and reinvention) of tradition. Tying together historical and global threads, Shonibare considers the legacy of British expansion in trade and empire, made possible through the freedom of the seas and the new trade routes that Nelson's victory helped to secure.

Commissioned by the Mayor of London, Shonibare was the first black artist invited to produce one of the series of contemporary artworks that have appeared on the hitherto empty 'Fourth Plinth' in Trafalgar Square. It was unveiled to huge public acclaim in 2010, which was also the 50th anniversary of Nigerian independence. *Nelson's Ship in a Bottle* began an exploration of Nelson's life, death and legacy that Shonibare has continued in other pieces; it was also the first contemporary public artwork to engage directly with Britain's iconic hero and the history of the square, which is, of course, dominated by William Railton's Nelson's Column (1840–43).

Shonibare's work often questions post-colonialism and the global diaspora. While provocative, *Nelson's Ship in a Bottle* celebrates contemporary multiculturalism and the diversity of British maritime history. Of the 823 men on board the *Victory* at Trafalgar, 63 were not British and included African, Brazilian, Dutch, French, Indian, Maltese and Caribbean nationalities. 'For me,' Shonibare declared, 'it's a celebration of London's immense ethnic wealth, giving expression to and honouring the many cultures and ethnicities that are still breathing precious wind into the sails of the United Kingdom.'

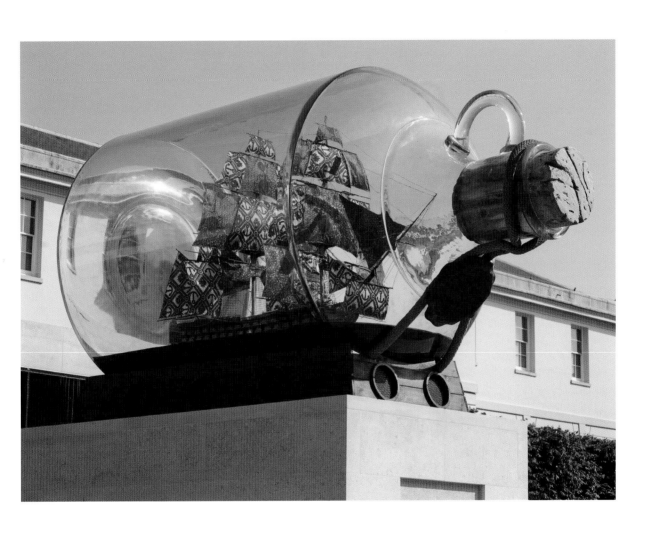

2009
Fibreglass, steel, brass, resin, UV ink on printed cotton textile, linen rigging, acrylic and wood;
2900 × 5250 × 2350 mm
REG10/000343

The Queen's House, Great Hall: Richard Wright's *No Title*

Richard Wright

In 2015, the Museum commissioned Richard Wright (b.1960), a winner of the Turner Prize, to create a new artwork for the ceiling of the Great Hall of the Queen's House. The nine panels originally contained canvas paintings by the Florentine artist Orazio Gentileschi, who arrived in England in 1626 and became a favourite artist of the queen, Henrietta Maria. The ceiling paintings were removed in 1708 when Queen Anne gave them to her friend and confidante, Sarah Churchill, Duchess of Marlborough. The individual panels were then adjusted to fit the hall ceiling of Marlborough House in London, where they remain today.

No Title is one of the largest artworks the artist has ever attempted and the hand-crafted, meticulous and time-consuming nature of his practice demands a high level of skill and endurance. In the manner of seventeenth-century artists and craftsmen who created the original decoration in the Queen's House, Wright employed the painstaking techniques of Renaissance and Baroque fresco-makers. This involved drawing a design on paper and then transferring it to the surface, a stone-coloured painted ground, by pouncing – piercing the cartoon with holes and rubbing chalk or applying coloured water through it – to create, as he describes it, 'the ghost of a work' on the wall or ceiling. The image pattern was then painted with size (an adhesive) and gilded in 23.5-carat gold leaf. Wright and his team of five artisans worked full-time over a period of nine weeks, working from flat beds on a scaffolding platform under the ceiling.

Unlike Gentileschi's original paintings, *No Title* is not confined by the rigid compartmentalised ceiling structure, but continues down the walls of the Great Hall, above the balcony level. As a result, the effect is both decorative and playful, re-imaging the princely magnificence of the Queen's House as envisaged by the architect Inigo Jones and complementing the painted, carved and gilded ceilings of the King's and Queen's Presence Chambers, which adjoin the Great Hall. However, Wright's principal inspiration derived from the ornament incorporated into the handrail of the iconic Tulip Stairs (the earliest self-supporting spiral stair in England) with its decorative scheme of leaves, scrolls and lilies. During his research for the project, the artist was also interested in the stage and costume designs created by Jones for theatrical masques and other court entertainments. He has also drawn inspiration from the work of the neo-classical architect and designer Robert Adam, whose ceiling designs are characterised by delicate ornamentation within geometric forms.

The commission was the centrepiece of the 400th anniversary of the Queen's House in 2016 and remains on permanent display.

2015
Adhesive and gold leaf

Contributors

Entries written indicated by numbers in brackets

Nick Ball, Assistant Curator (15, 37, 40, 42)

Megan Barford, Curator of Cartography (2, 3, 4, 6, 46, 51, 78)

Gareth Bellis, Archive and Library Manager (21, 39, 47, 50)

Mike Bevan, Archivist (5, Behind the Scenes pp.4–7)

Robert Blyth, Senior Curator of World and Maritime History (12, 14, 27, 34, 35, 43, 45, 48, 49, 52, 53, 54, 55, 56, 60, 61, 62, 66, 68, 70, 71, 73, 77, 86, 88, Introduction pp.1–3)

Andrew Choong, Curator of Historic Photographs and Ships Plans (67, 75, 85, 92)

Birthe Christensen, Head of Conservation and Preservation (Behind the Scenes pp.4–7)

Louise Devoy, Curator of the Royal Observatory (1, 7, 26, 38, 72, 79, 89)

Richard Dunn, Senior Curator for the History of Science (20, 25, 64, 74, 84)

Stawell Heard, Librarian, Acquisitions and Cataloguing (47)

Marek Kukula, Public Astronomer, Royal Observatory Greenwich (96)

Louise Macfarlane, Curator, *Cutty Sark* (69)

Rory McEvoy, Curator of Horology (8, 18, 23, 28, 31, 36, 65)

Jeremy Michell, Historic Photographs and Ships Plans Manager (63, 74, 80, 81, 82, 83, 84, 91)

Sue Pritchard, Curator of Decorative Arts (21, 38, 87, 93, 94, 95, 98, 99, 100)

Christine Riding, Head of Art and Curator of the Queen's House (9, 10, 11, 13, 17, 19, 24, 32, 33, 41, 44, 58)

Martin Salmon, Archivist (39, 50)

Simon Stephens, Curator of Ship Model and Boat Collections (22, 30, 59, 76, 91, 97)

Robert Todd, Key Specialist Curator, Historic Photographs (90)

Claire Warrior, Senior Exhibitions Interpretation Curator (57)

Index

Image credits